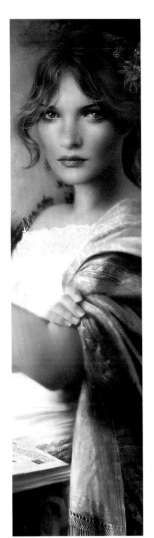
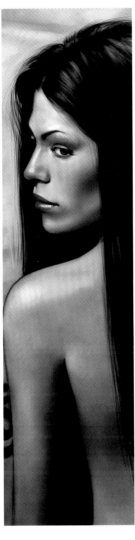
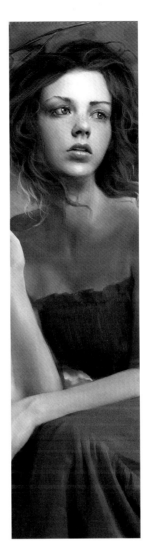
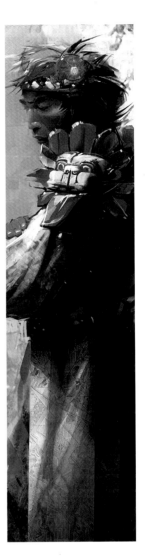

DIGITAL PAINTING 2

d'artiste

DIGITAL ARTISTS MASTER CLASS

d'artiste

Published
by

Ballistic Publishing

Publishers of digital works for the digital world.

134 Gilbert St
Adelaide, SA 5000
Australia

www.BallisticPublishing.com

Correspondence:
info@BallisticPublishing.com

**First Edition published in Australia 2008
by Ballistic Publishing**

Softcover/Slipcase Edition ISBN 978-1-921002-57-1
Limited Collector's Edition ISBN 978-1-921002-56-4

Managing Editor/Co-Publisher
Daniel Wade

Assistant Editor
Paul Hellard

Art Director
Mark Snoswell

Design & Image Processing
Lauren Stevens, Daniel Cox

d'artiste Digital Painting 2 Master Artists
Mélanie Delon, Don Seegmiller, Marta Dahlig, Daniel Dociu

Printing and binding
Everbest Printing (China) www.everbest.com

Partners
The CG Society (Computer Graphics Society)
www.CGSociety.org

Also available from Ballistic Publishing
d'artiste Digital Painting ISBN 978-0-9750965-5-0
d'artiste Character Modeling ISBN 978-1-921002-11-3
d'artiste Matte Painting ISBN 978-1-921002-16-8
d'artiste Concept Art ISBN 978-1-921002-33-5
d'artiste Character Modeling 2 ISBN 978-1-921002-35-9

Visit www.BallisticPublishing.com
for our complete range of titles.

Cover credits

Enigmatic Soul
Photoshop, Painter
Mélanie Delon, FRANCE
*[Front cover: d'artiste Digital Painting 2
Softcover edition], 18-25*

Wind-powered Train
Photoshop
Daniel Dociu, USA
*[Back cover: d'artiste Digital Painting 2
Softcover edition], 186-195*

Journey to the West: Ox King
Photoshop
Wei-Che 'Jason' Juan, USA
*[Cover: d'artiste Digital Painting 2
Limited Edition cover], 201*

/ B A L L I S T I C /

Daniel Wade
Managing Editor/
Co-Publisher

Paul Hellard
Assistant Editor

Welcome to the sixth book in the Digital Artist Master Class series. **d'artiste: Digital Painting 2** showcases the work and creative prowess of acclaimed digital artists: Daniel Dociu, Mélanie Delon, Don Seegmiller, and Marta Dahlig. These four Master Artists have worked on a number of high-profile game projects, how-to books, and teaching posts spanning the gamut of the digital painting landscape. Each artist provides a wonderful insight into their approaches, and thoughts on the direction and challenges of their careers.

In **d'artiste: Digital Painting 2**, each Master Artist presents their digital painting techniques through a series of tutorials which start with the idea and step through the process of bringing the idea to fruition from sketch to finished piece. The book is broken into four sections based around each Master Artist. Artists' sections include a personal gallery, the artist's work and thoughts in their own words, a large tutorial section, and an invited artist gallery featuring work from some of the most talented digital artists in the world.

The d'artiste imprint (pronounced dah-tee-st) means both 'of the artist' and 'digital artist'. Each d'artiste title features techniques and approaches of a small group of Master Artists. The focus of d'artiste series is not limited to just techniques and technical tricks. We also showcase galleries of the artist's personal work and a gallery of artwork created by invited artists. Along with artist interviews this gives the reader a comprehensive and personal insight into the Master Artists—their approaches, their techniques, their influences, and their works.

Ballistic Publishing continues to expand the d'artiste series to encompass all aspects of digital content creation. The d'artiste series already includes: Digital Painting, Character Modeling; Matte Painting; and Concept Art. Look for new d'artiste title announcements on the Ballistic Publishing web site: www.BallisticPublishing.com

MÉLANIE
DELON

DON
SEEGMILLER

MARTA
DAHLIG

DANIEL
DOCIU

d'artiste ™
DIGITAL ARTISTS MASTER CLASS

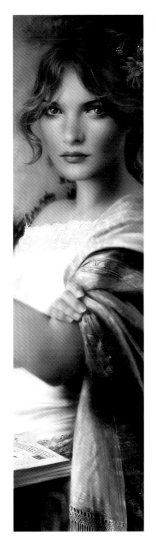
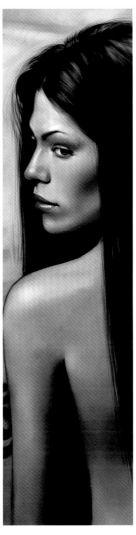

DIGITAL PAINTING 2

MÉLANIE DELON

Born in 1980, Mélanie studied History of Art at The Sorbonne University in Paris. She has always been fascinated by fantastic worlds and classical paintings, so tries to mix those two different subjects in her illustrations to create her own fantasy worlds. Mélanie currently works as a freelance illustrator for several publishing houses, magazines like ImagineFX, and game company Ubisoft. Her first art book 'Elixir' was recently published by Norma Editorial, and Mélanie is currently working on the second volume which will be released this year.

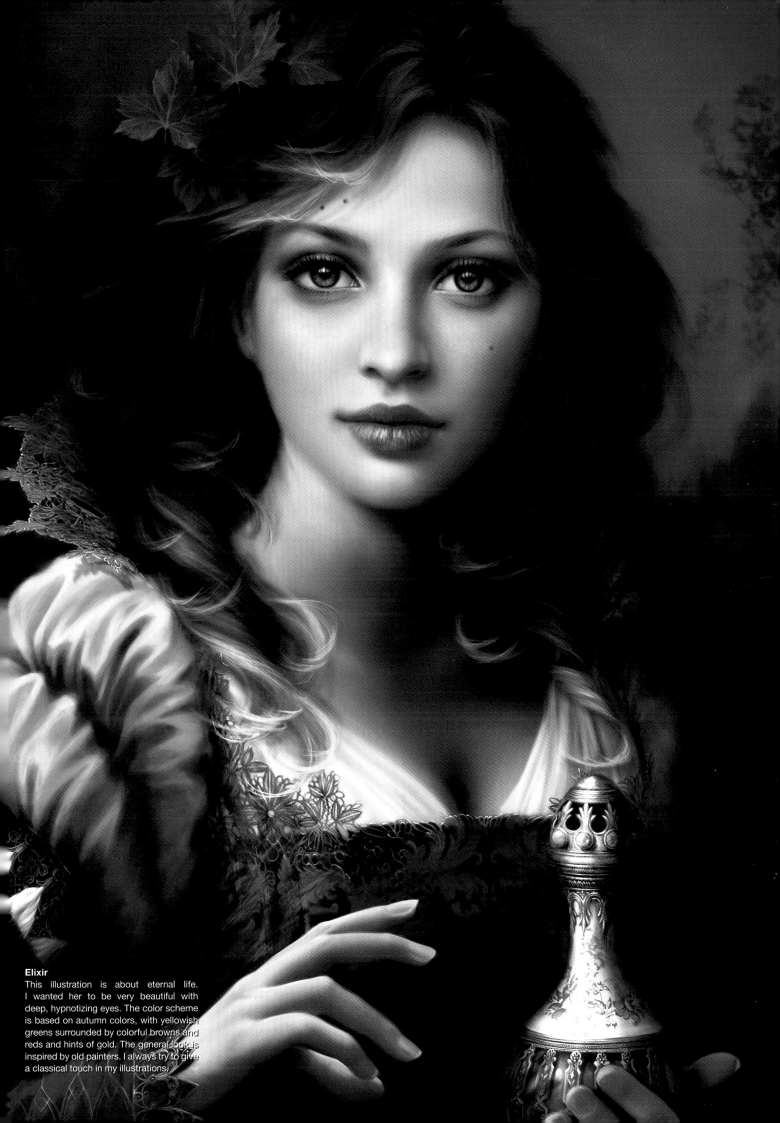

Elixir
This illustration is about eternal life. I wanted her to be very beautiful with deep, hypnotizing eyes. The color scheme is based on autumn colors, with yellowish greens surrounded by colorful browns and reds and hints of gold. The general look is inspired by old painters. I always try to give a classical touch in my illustrations.

CONTENTS

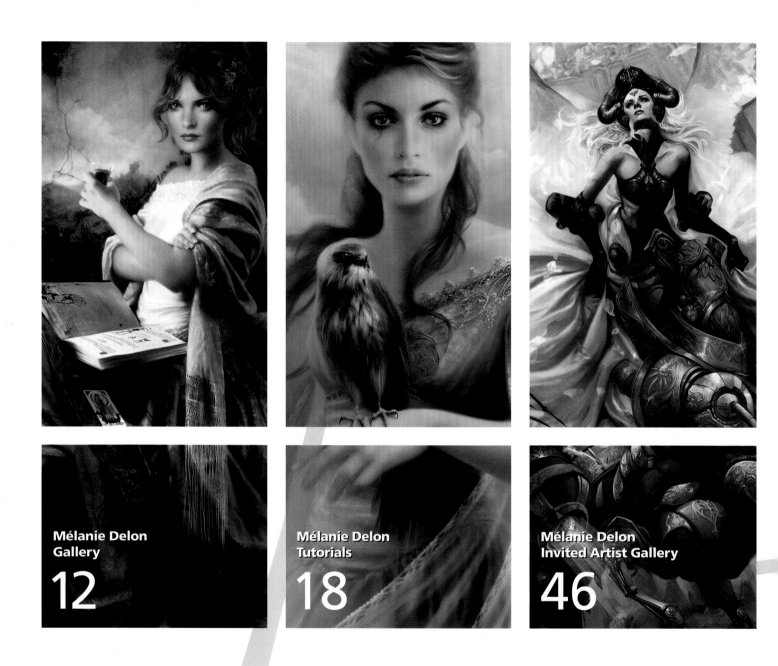

Background

I have always drawn, but it was more for fun than for learning or to make a living. I was very fond of reproducing classical sculptures on paper, I could spend hours doing that. Creation was the most important thing in my eyes. No matter the quality or the medium I needed to create something. I tried a lot of things before digital painting, like designing and making my own clothes, drawing, and traditional painting (even painting my room's wall). I didn't know that I wanted to become an artist. It was more than evident that I couldn't do anything else.

Studies

I went to the University, studying History of Art and Archeology. At this time, I wanted to become an Egyptologist, but found University boring, and was not suited to a life of research. I needed something more exciting, so decided to learn how to create video games and enrolled in a CG school.

This was also a disaster. 3D was absolutely not my thing. I had more fun with the storyboarding course than with the animation or modelling ones. But those two years of 3D were not wasted—it helped me to discover digital illustration through CG forums like CGTalk, and made me realize that digital painting was what I wanted to do. My very first experience with a computer was probably gaming— I'm a video game addict. I started to use a computer creatively while at the 3D course, and I was totally lost. Photoshop was a stranger to me. I wasn't able to even create a layer, and there was no digital painting course at the school— we used Photoshop only to create textures for 3D models. So one day, I decided to buy a graphic tablet and start learning alone how to use Photoshop for my own purposes. My very first CG images were 3D, mainly school projects.

Commercial work

My very first commission was for a little French publishing house, and was also an unpaid project. It was very useful to see whether I was able to work to a deadline. The illustration itself was not perfect, but it was a very good training for future professional commissions. The first real commercial work I did was for Imagine FX. I have since published my first art book 'Elixir' with Norma Editorial, which is the most important project I've worked on so far. It was really exciting, and I'm so happy with the result. It contains around 45 illustrations, along with little stories for each painting. I've also recently worked for Ubisoft as concept artist which is a really an exciting job too! The team was so kind with me, open to any suggestion, a great experience! My next projects are several covers for fantasy books (Tor Books, Random House), and another cover for a French comic book from Barbara Canepa (Sky Doll author) which will be released this year.

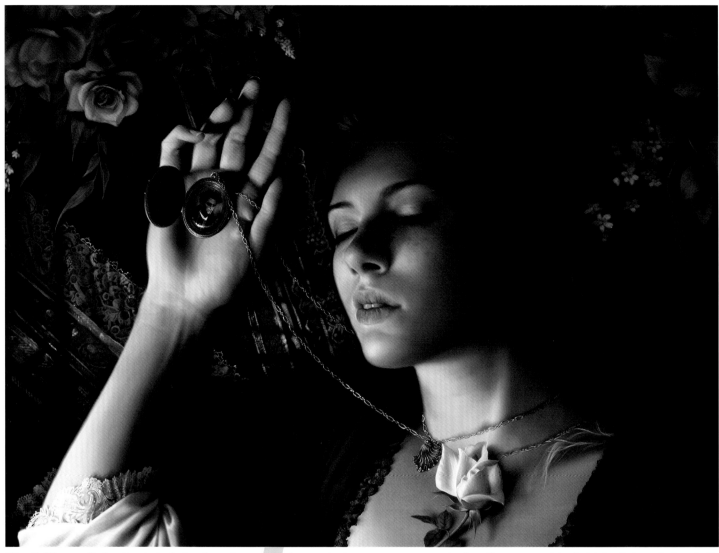

Eternal Silence: She's almost dead, her lover is gone, and now she has no more reason to live. There are a lot of details that symbolize death, like the pale rose and her eyes closed. I also choose some colourful tones to contrast with the sadness of the story.

Photoshop vs. Painter

I started digital painting with Photoshop, as I was not at ease with Painter in the beginning. Photoshop is really precise, but somehow gives a cold render if you don't play with textures. I decided to force myself to use Painter. I had to start from the beginning trying out all of the tools, and selecting a few basic brushes to create my own library. But that wasn't enough, I needed something more personal, and the Painter brush creator gave me that personal touch. It's a powerful complex brush generator which allows a lot of freedom and variations for the brushes. Painter is extremely useful to add more texture, and a painterly feeling to a piece. I could not say which application is better as they are really complementary.

Building skills

I began to really study and improve my technique after finishing my second year of school. I'm self taught, so it was really hard for me to start digital painting. The only thing I knew was how to open Photoshop and create a new document. I'm still learning new things now. I had to learn everything— how to use Photoshop, how to draw with a graphic tablet, and how to use colors. It was a really experimental time. I remember trying and testing each tool in Photoshop, just to know them and see whether I could use them in my illustrations. My technique has been constantly evolving. I always try to improve, search, and try new tools and brushes. I must say that the first months of learning were hard, but

I usually don't give up when I'm in front of something hard to paint. In the beginning, I used to scan my sketches and then color them in Photoshop. I quickly realized that this technique blocked me— I needed more freedom, and so decided to start my illustrations directly in Photoshop without any pencil studies. Emotions are the most important thing to me in a painting. I always try to express something with the characters and their background. That's also why I create a little story for each painting. I think it helps to understand what the character feels and lives. I'm really attracted by complex characters with sad, tragic stories to tell. It's far more interesting for me to paint than a happy character.

I also like a lot symbolism, and so I hide a lot of details which are connected to the story I depict—it's a kind of treasure hunt.

Influences

I'm very fond of the pre-Raphaelite and neo-classic painters such as Waterhouse, and Grimshaw. There is something special in their painting—some kind of unreal feeling, like a dream. I'm in awe in front of their subtle color schemes and lighting— always very well balanced and perfect. Their subjects are also very poetic and romantic. I feel really close to their vision of what a painting should looks like because of that. I really love two particular pieces from Waterhouse: "Circe offering the

Where are you: My favourite illustration. It's a tragic story. I've played a lot with the light which comes from nowhere, but I like this kind of lightning as part of the fantasy style. I'm not very fond of fairies, so I tried to do something original with this one.

cup to Ulysses", and "The lady of Shalott". In the first one the fabric is so very well rendered, with delicate transparency, you can almost think it's real silk. It's really impressive and inspiring. Lady of Shalott, is exactly the kind of piece I would like to paint—full of details, a huge background and a sad story to tell. I also like a lot Alphonse Mucha's paintings, again probably because of the amount of details we can see in his paintings. I'm also taken by his color schemes, which are always full of life. My favorite series is his "Night Stars". In this series he plays a lot with contrast and fabrics. It's absolutely lovely and inspiring. Finally, W. Bouguereau is a real master of light and color. I'm not very fond of his subjects

but on pure technique he's awesome. I'm always referring to his paintings when I need to paint something really hard in terms of color or lighting. I don't try to reach a certain point, I just paint what I want and try to do better each time. I do love the realistic style, maybe because I'm a perfectionist. I can work on a single little detail in the background for hours, which nobody will ever notice, but it's important to me. I also don't try to give an over realistic look to my illustrations— we have photography for that. In fact I just want to paint what I like and be happy—I'm not so ambitious.

Exposure

I started my career on the web in the CGTalk community.

It was extremely useful for me, and it's a great way to get a lot of exposure and feedback. I remember I was really nervous each time I posted a new illustration (I still am), but people were always kind to me always giving constructive critics and useful comments. This really helped me progress in the 2D field. Galleries and my homepage helped me to find commissions and also a publishing house (Norma Editorial) and so was the starting point of my career. I don't think I would be where I am now if it hadn't been for my presence on the web. Now I don't have much time to be online which is a pity, but I try my best to keep my homepage updated and my only online gallery (which is in fact my CGPortfolio currently).

The future

Other than commissions, I'm currently working on my second artbook, which will be released in November this year with Norma Editorial. It will be very similar to the first book. It will contain a lot of new illustrations with their own little stories, but I think Darkness will be the main subject this time! So I guess I'll continue as a painter—I still have a lot of things to learn, to study, to do, and as long as I have fun doing that job I'll continue. I probably would like to do a comic, but not something classical—something very dark and lovely at the same time. I'm not sure about it, but the main character will probably be a little undead girl—I love undead. My dream project would be to work on a Steven Spielberg movie— but that's still a dream!

Pearl
I decided to paint Pearl after watching 'The girl with a pearl earring'. I tried to give a traditional painting look to this illustration, inspired by Vermeer's style. I've played a lot with the light and the shadows, with a touch of fantasy like the sky and the shooting star.
[above left]

Nemesis
The look is inspired by the old masters, like Caravage or De La Tour. The contrast was important here. It reflects the character's feeling with the shadows/light representing good/evil.
[above]

Brume
I tried for something special with the light and color. I love painting unreal lights. This is a great example of how I use two light sources. I decided to choose a tender mauve for the main light, and a not too saturated orange for the second light.
[right]

Hopeless reflection
A magical mirror that reflects dreams. I adore the subject and will re-paint this piece soon. It could be a great experience to see what I could do three years later.
[left]

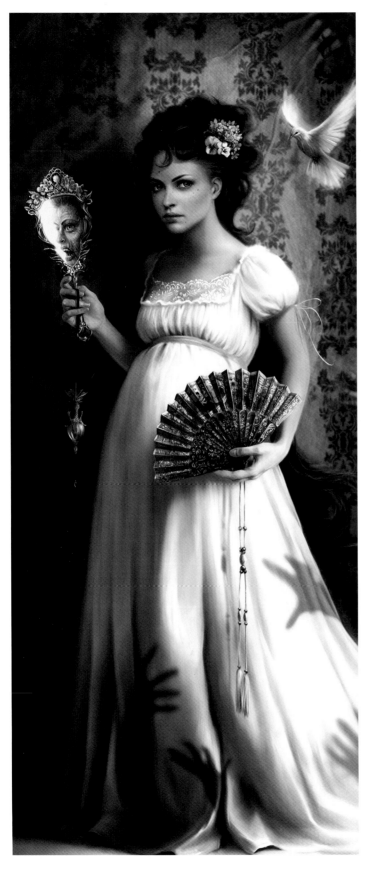

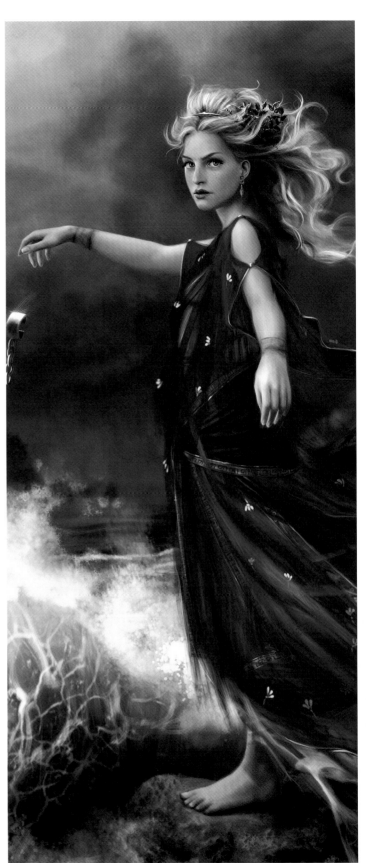

Lya

The story of this illustration is about life and death—there are a lot of symbols hidden in the piece. The light, which splits the composition in two, is light (life) with the dove and the flowers, and shadow (death) with the poison and the mirror. The fan also tells us something—there is a little illustration on it, which represents her life before the death of her husband.
[above]

Déchainée

This painting is about sacrifice and hope. She has to die for her people, but it is more a liberation because her life is hell. I made this illustration for a French novel. It was the first time I had to paint something with a story that did not belong to me. I learned a lot, and it was a great experience.
[above]

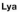

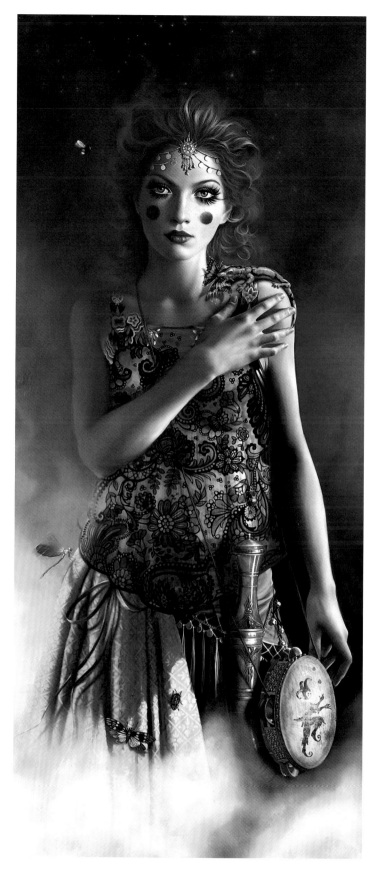

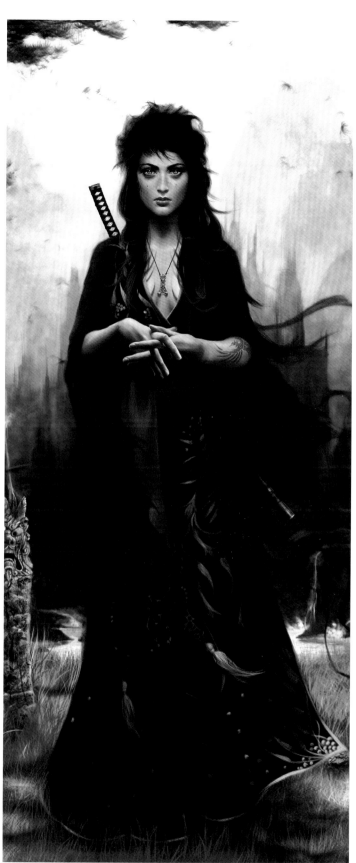

Columbine
A great example about mixing styles. She's a gypsy and each element comes from a different culture. For example, the jewel on her head is Indian, the tambourine is a mix between medieval style and a North African one, and the lace is 18th century inspired (just to name a few).
[above]

All my hate
This illustration is very special to me. I'm probably more in love with the background than with the character. I have tried my best to reproduce a watercolour feeling for the sky and the mountains. I've created so many brushes to get this result, and I'm really proud of the final render.
[above]

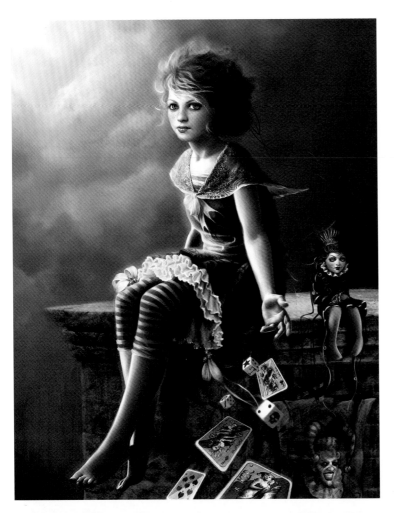

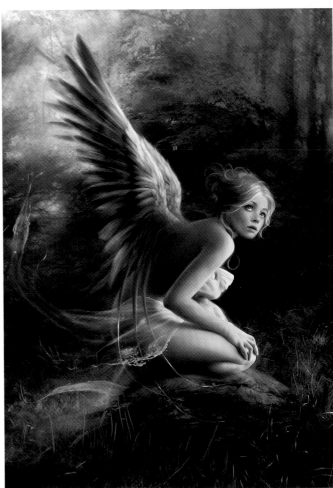

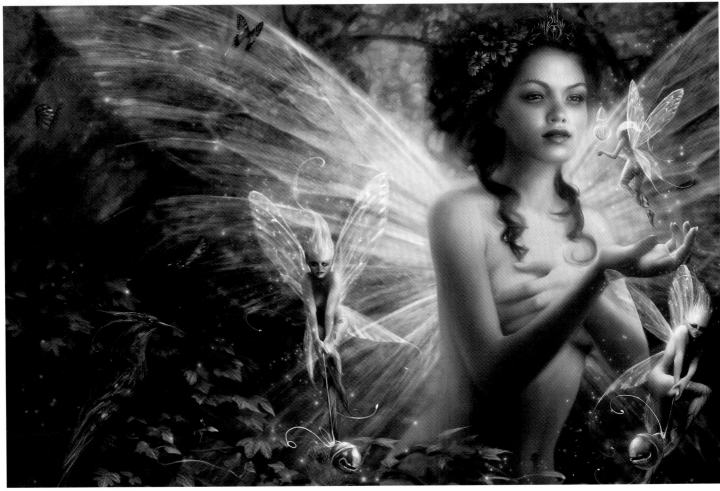

Do you want to play with me?
She's a little devilish genius, and again
details are really important here. The
cards and the dice are very special
and symbolize death. I've painted them
in another file, just to have enough
space to do details. I've also choosen a
complementary color scheme (orange/
green) which suits the story and the
character very well. Because it's
again about life/death, the colors and
light are a part of the story.
[far left]

Beyond belief
A commissioned piece for Imagine
FX magazine. I had to explain how to
paint feathers, so I decided to create a
kind of angel lost in a huge forest. The
subject is not very original, but I really
like the mood of the piece, and the
desaturated color scheme.
[left]

Dust
This is a portrait of a young lady. She's
not posing here—it's a kind of captured
moment in her life. I wanted to push
the detail of her face as far as I could.
I used several references for this portrait,
just to get the facial features right.
I'm pretty happy with the final result.
[right]

Tears of the moon
Another commissioned piece for an
ImagineFX magazine cover. The subject
was Fairies. She's the queen of the
fairies and she's about to receive a
precious gift—the tears of the moon.
The most difficult part here was the
wings—they had to be very delicate
and transparent. I've played a lot
with the layers opacity and mode to
achieve this kind of render.
[left]

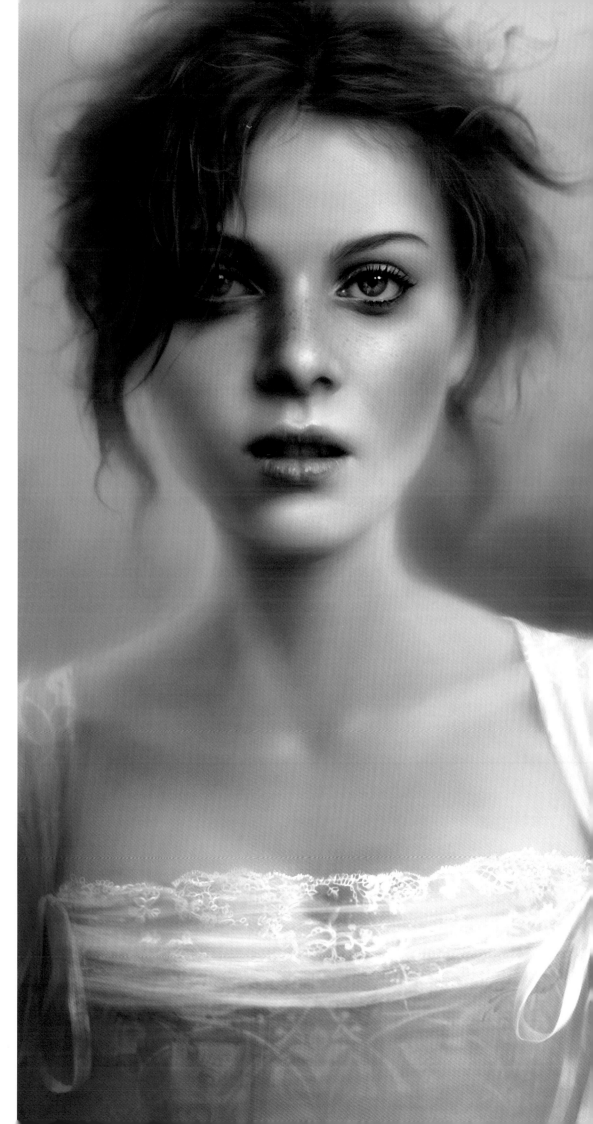

TELLING A STORY: ENIGMATIC SOUL

Telling a story

All of my illustrations have a little story behind them. Sometimes I know what I want to tell before starting the painting, and sometimes I do not. The story emerges along with the image. A story is pretty useful and inspiring. It helps me to find the good composition, details, and colors. Enigmatic Soul is a great example. I started out with colors and a vague idea of a gorgeous character portrait. The only thing I was sure of was that she had to be very attractive and mysterious—a kind of angel or unreal creature. The background will not be very defined because I don't want to overdo the detail. I want to keep the focus on her face. I'll go for something very blurry, and cloudy. Her story is not quite clear in my head which happens sometimes. Some characters don't need a story, or at least don't need to see their story revealed. They are keeping their secrets like a real person.

Inspiration

With this piece, there was no real inspiration to talk about. This illustration came out spontaneously while listening to some music. Sometimes it's pleasant, and refreshing to work an illustration without any particular idea in mind except a certain mood/atmosphere I want to depict. Here, colors and the render are essential as I want something very blurry and green. The face will be the only detailed part as it is the central point of the composition. Working digitally offers the chance to change/move/resize the painting as many times as you want, and so it is really useful when you don't have a precise idea of the final picture. I started this piece only with her face, and as the image evolved as ideas popped into my head. I then resized it and added more elements like the hawk and the hand.

Technique

Painting a face for me is the most pleasant part of a painting, and my favorite elements are the eyes. I can tell so many things through them, like sadness, despair, hope, or mystery. Most of the time they are the central point of my illustrations. I try to give them a natural look, but also a little something that will be very captivating. When I work on a portrait, I always try to focus on details as I'm a bit of a perfectionist. I won't feel satisfied with an illustration if everything is not perfectly rendered. I'm not fond of over photorealistic paintings, but I do my best to get the facial features as believable as I can. The main secret here is to work on a huge canvas size and don't be afraid of spending more than a week of work on the painting.

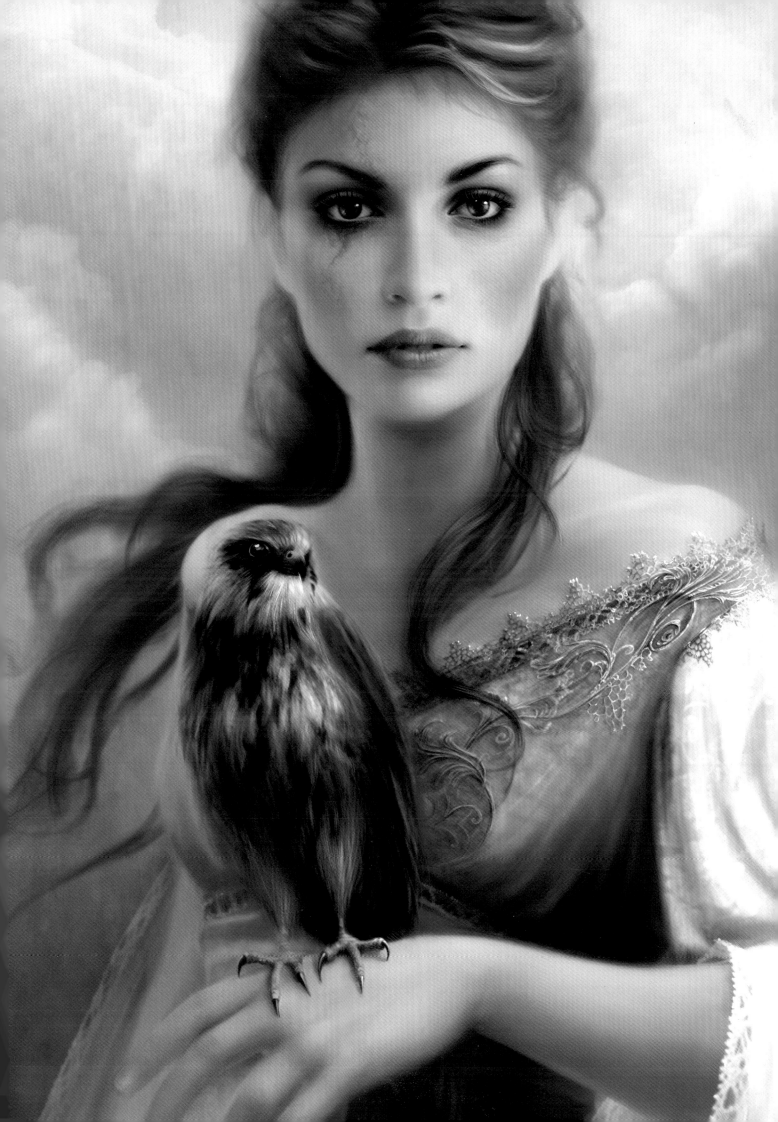

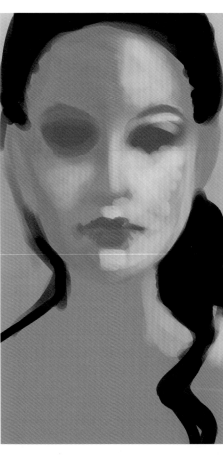

A good base and the color scheme

Before I start the sketch I usually lay down several colors on a new layer and place it in the corner of the painting. As I want the whole piece very soft and tender, I choose very pale tones—a kind of old pink for the shadows which will not be deep, and a cold blue and bright beige for the light. For the skin color, I choose a greenish beige which is a very neutral and desaturated orange to give a more intense look. The lips will be warm, but not too much, so I pick the same tone I used for the shadows. I always start a face by placing the eyes, it helps me to find a good shape for the whole face and place the other features. Once this step is done, I start adding the light. There will be two light sources—one from the right which is the main one, and the other from the left side which will be more diffuse and soft. Having two lights helps to bring more volume and realism to a piece. Ideally, I choose a cold and a warm color—most of the time they are complementary colors.

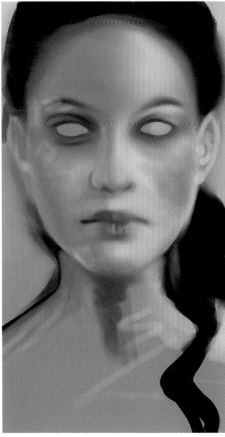

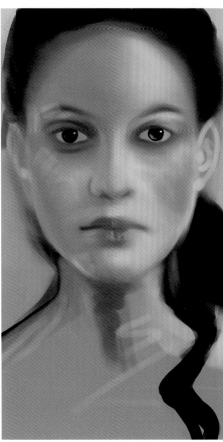

Defining the face features

Now I can define the eyes and the mouth. I sketch the eyelid lines, which softly follow the eyeball curve and add a soft pink shadow in the inside corner of the eye. I never paint the eyeball with pure white— I prefer to paint it with a delicate hint. Here, I choose the same greenish tone as for the background. I slightly shade the eyeball both with light and shadows. I usually work the iris with three colors— one for the base, a second for the light, and a third for color variation and intensity. I choose a dark rich violet for the base, a tender mauve for the light, and a beautiful deep fuchsia that will be added in little dots here and there to add more color variation and intensity. I also add more volume to the lips. I want them to be soft and appealing, so I go for a cold saturated pink for the light and a rich pink for the shadow.

Smoothing skin

The eyes need more contrast, so I pick a dark brown color and with a Basic Round Edge brush I define the eyelids a bit more. I never use pure black to add this kind of detail—it's a lifeless color. The trick is to use a dark tone that is nearly black. Smoothing the skin is probably the hardest and most tedious part of the painting process—it has to be perfect. I usually use the same custom brush which gives me the perfect smoothness. It also adds a very nice color variation for the skin and produces a realistic render. I paint over the base (on a separate layer) with a very light pressure again and again until the brush strokes almost entirely disappear. This is not the final blending, but I need to smooth the skin a least one time before adding texture. I also use a Spackled brush to give more color variation to the skin. I gently follow the face curves, painting over the remaining brush strokes. I repeat this several times on several layers, until I'm satisfied with the result.

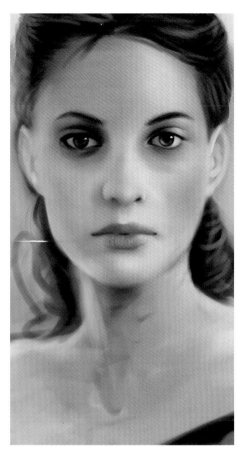

Dress and arm

As it is not a single face portrait, I now work on the rest of the picture. I love painting beautiful gowns with a lot of details and complicated patterns. This illustration will be no exception. For the dress, I choose the same greenish color as for the background. It is really important here to keep the colors very uniform which helps to bring the picture together. I wildly sketch the dress, designing the shape, and defining the shadows and light. Details will come after. I always work the general look with a big sized brush and then progressively go deeper into the details. Digital painting allows many freedoms like color and composition. It's never too late to repaint something or add/delete some element. In this case, I find the character's pose very boring so I decide to add another element to the piece—a hawk. It could be her companion, but also a symbol of her true nature. His feathers should be colored with the same blue as her dress and with some hints of her skin tone.

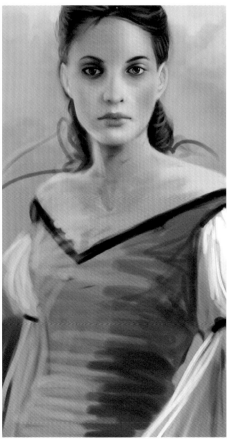
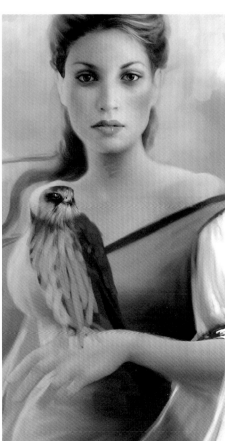

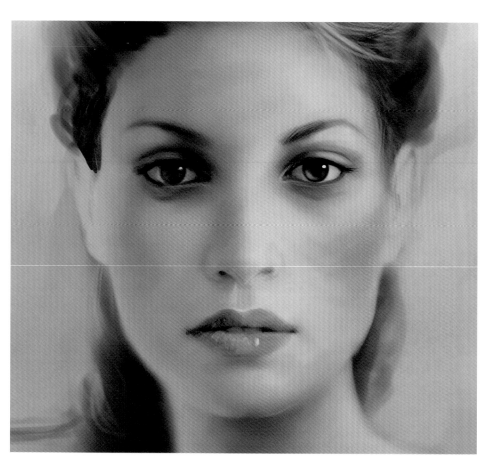

Changing the facial expression

I was not satisfied with the character's expression, so I decided to change it for a little discreet smile which suits her more. With a Sharp Edge brush I draw the inside line of the mouth, which will be slightly opened revealing her teeth. I use a dark reddish pink to bring more contrast to the lips. I also add more shadows in the corners of the lips and darken the left side of the mouth as well (according to the light source). I usually add light on the upper curve of the lips—it's probably one of the sharpest part of a face and so it needs to be very precise. If I forgot that point, there is big chance that the mouth would look flat and boring. Expression comes from the eyes as well. I want them to be wide open, but also mysterious, and realistic. I shadow the bottom eyelid with a dark pink/orange (always remembering that the eye is a ball). I also define the inside corner of the eye with a highlight. I never hesitate to add a lot of color variation here—some little dots of orange, yellow, and even violet will bring a more natural look to the eye.

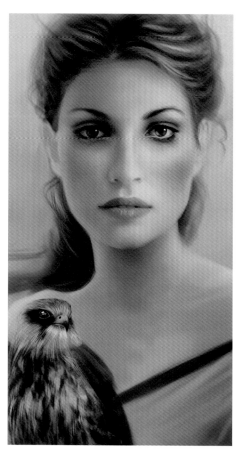

Refining the face and the hawk

The girl and the hawk are connected, and to increase this feeling I make her eyes look like the hawk's eye—very dark and mystical. The first thing I do is add more intensity to them. With a dark brown hue, I paint the eyelids softly but also accentuate the eyebrow with a small Spackled brush. Another important thing is to add light inside the eyelid—it's a little detail I know, but it really helps to bring more credibility and realism to the eye. I pick a slightly less saturated pink and with a Sharp Round Edge brush I draw the inside eyelid line. On another layer, I do the same thing but with a brighter pink—not forgetting to erase and blur the extremities of those lines. I also add more shadows and light to the whole face with a Spackled brush. This brush is pretty handy to introduce great color variation along with a lot of texture. It's especially good for painting the skin. The hawk feathers need more texture and color variation. I paint a few little feathers with a Basic Round Edge brush for the base, and paint over them with a Spackled brush and a Sharp Round Edge brush. I then softly blur the whole result.

Contrast and details

The face is now good. I flip the canvas horizontally to be sure everything is in the right place before I start to work the texture. I do this little manipulation quite often during the painting process—it gives me a fresh look at the picture and helps me to figure out the little issues and fix them quickly. I need to add more intensity to the eye. The iris needs more dynamism and color variation, so on several layers I add a lot of little dots of colors and play with the layer's opacity and blend mode. I don't forget to paint the eyelash, with a Sharp Edge brush (set on Dynamic Shape) with a very low opacity. I try to paint them in a random way, making some cross over each other. This simple detail will give a more natural look to the eye. I also blur the extremities as I want them very soft and delicate. I add a lot of light on the right side, with a lovely soft bright pink. I apply this light like a huge glow, as I don't want to sharpen the edges and have a plastic render. To be sure I get a soft result I slightly blur the whole layer before flattening it. Once I'm done with the light, I add more color on her cheeks—a tender pink will be perfect—which I apply with a Spackled brush with very light pressure. I don't want her to look like a clown, so I softly blur the final result and merge the layer with the main one.

The hand

The hand and the arm are not the central part of the painting, so I don't need to over detail them. I want the hand to be very delicate and soft-looking, so the shadows will be almost absent. I start the base of the hand with a Basic Round Edge brush, picking the same basic skin tone in my color scheme. The hand emerges progressively while I lay down the light and the first hints of shadows. I want them to be very soft-edged, so I use the same brush I used to smooth the face. I blur the first shading step and pick a darker shadow (a greenish desaturated pink), and define more some of the fingers' outlines. The hand will catch the two light sources so I have to take this into consideration. The top of the hand and the wrist are lit by the main light source and the extremities of the fingers by the second cold blue light. The hawk needs work. First I add more shadows and contrast to his whole body. I use a simple Basic Round Edge brush for this step as I'm not working the details. Once this is done, I detail the feathers with a Basic Round Edge brush set to Dynamic Shape. I add some dots of dark blue here and there to create more little feathers and slightly blur the whole thing. Before merging the layer, I duplicate it and set the new one to Soft Light or Overlay, and decrease the layer opacity. This will nicely accentuate the contrast of shading.

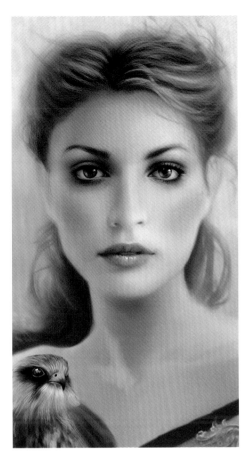
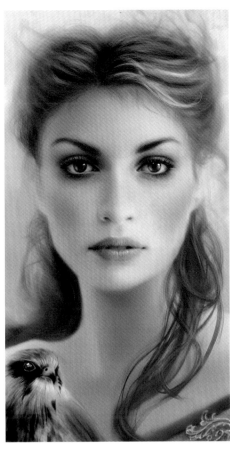

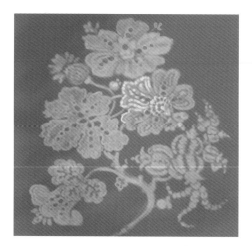

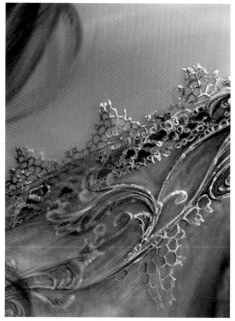

Pattern and lace

I'm a huge fan of dresses, and collect photos of costumes from the middle ages through to the 19th century. I find a lovely flourish pattern and a graphic trim lace that with some adjustments will be perfect. With a custom Soft Edge brush with Opacity Jitter set to 50% and a very light pressure, I paint the two patterns. Once the design is done, I duplicate the layer and place the flower pattern. I play with the size of the pattern to avoid repetition, erase some parts, merge the duplicated layers, and softly blur the final pattern. Now to add the light. I pick out a brighter color than the one used for the base, and paint some little dots of light following the fabric folds. The technique is the same for the golden lace. I start laying down the base color (not too dark or saturated), and add the light and shadows. I duplicate the layer and set the new one to Soft Light with a low opacity. This adds intensity to the gold. I detail an area next to the main subject. The rest of the pattern will stay blurry and not too detailed.

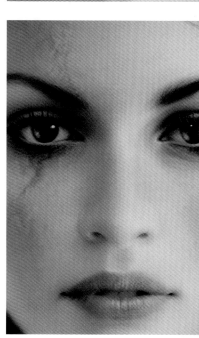

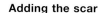

Extra texture

The face is almost done now, so I just need to add a bit more texture—especially on the bottom eyelid. Layer upon layer, I add some small dots of light with a small Sharp Round Edge brush. I blur and erase some parts— the textures don't need to be too obvious. I also add a very pale light on the eyelash, and detail a bit more of the eyebrow. For these kind of elements, I always use a Basic Round Edge brush with Dynamic Shape and Opacity set to 50%. This adds great color variation and more texture. Once this is done, I always duplicate this layer and set it to Soft Light or Overlay with a very low opacity to bring more realism to the face. I do the same thing for the hair. With a small brush, I paint a few wild individual hair strands following the curve/wave of the hairstyle.

Adding the scar

The character is lovely, but maybe she's too perfect. I need to beat her up a bit. At this point I decide to add a scar to her face— a discreet, mysterious one. It may seem crazy to add this, but I do think it's a nice touch and suits the character. She's hiding something and that little detail draws us further into her story. I pick a pale orange/ pink tone and with a Soft Edge brush I paint the scar line. As you can see, it's not a straight line—the general look is pretty much like a spidery vein. I erase some parts and blur some others. I shadow a lot of the area surrounding the eye as it has to be very well integrated with the skin. I also add some hints of light to make it appear more realistic.

Final stage

I'm almost done with this painting. All I have to do now is to check the whole image to make sure everything is in the right place. I usually switch into Painter to give the final touch of blending and to slightly blur some parts like the flowing hair in the background. Once everything is ok, I merge all the layers, and duplicate the final one, setting it to Soft Light (again with a very low opacity), just to bring more intensity to the colors.

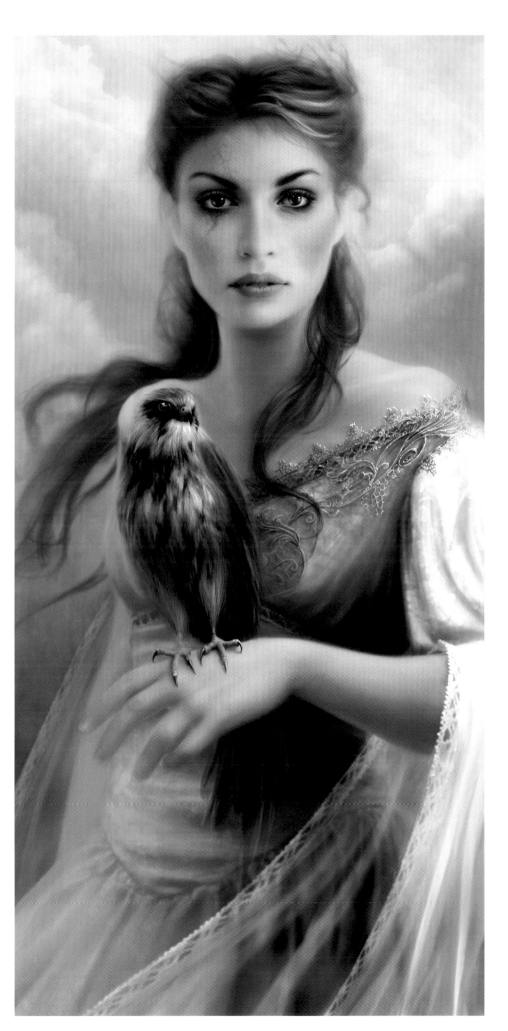

CHARACTER PAINTING: ETOILE DU SOIR

Inspiration

With Etoile du Soir (Night star in English) I wanted to depict a poor little beggar girl completely lost in a huge city. She doesn't know where to go, trying to survive each day. She's like a little animal, afraid, fragile, and alone. I knew before starting the painting how she should look—big eyes wide open, full of emotion. I also decided to paint the whole body of the character, as I need to add a lot of details for the story, like her long dusty dress, naked feet, and the background. For the decor, I wanted a dark mysterious place, lost in time, with huge posters of magic shows and luxury clothes which would contrast with the character's poverty.

Detail

I'm very fond of the movies/pictures from 1920, and while researching some pictures of an old movie I found an image of Dolores Costello from another movie. She was so beautiful, and I instantly knew that someday I'd paint something based on that photo. That is now done! One of the posters is also inspired by the great Mucha, one of my favorite painters. The architecture style is both inspired by the antique temple and 19th century cities. I love mixing different styles to create a place—it gives more credibility to the worlds I create. For the last poster which is half-hidden in the background, it's a kind of tribute to the French magician Robert Houdin.

Technique

Here, the main theme is the contrast. The light should be almost unreal, with deep shadows and aggressive warm light—a kind of Clair/Obscure style. I'm always referring to old great masters when I'm painting this kind of piece like Caravage or Vermeer. They are really inspiring and help me a lot to get this classical feeling right. Light will be very important here, like a second character. I always paint with at least two light sources—usually a cold and a warm one. In this picture, I choose the warmest to be the main light. It will represent hope for the character. She will look where that light is coming from with a little sparkle of hope in her eyes.

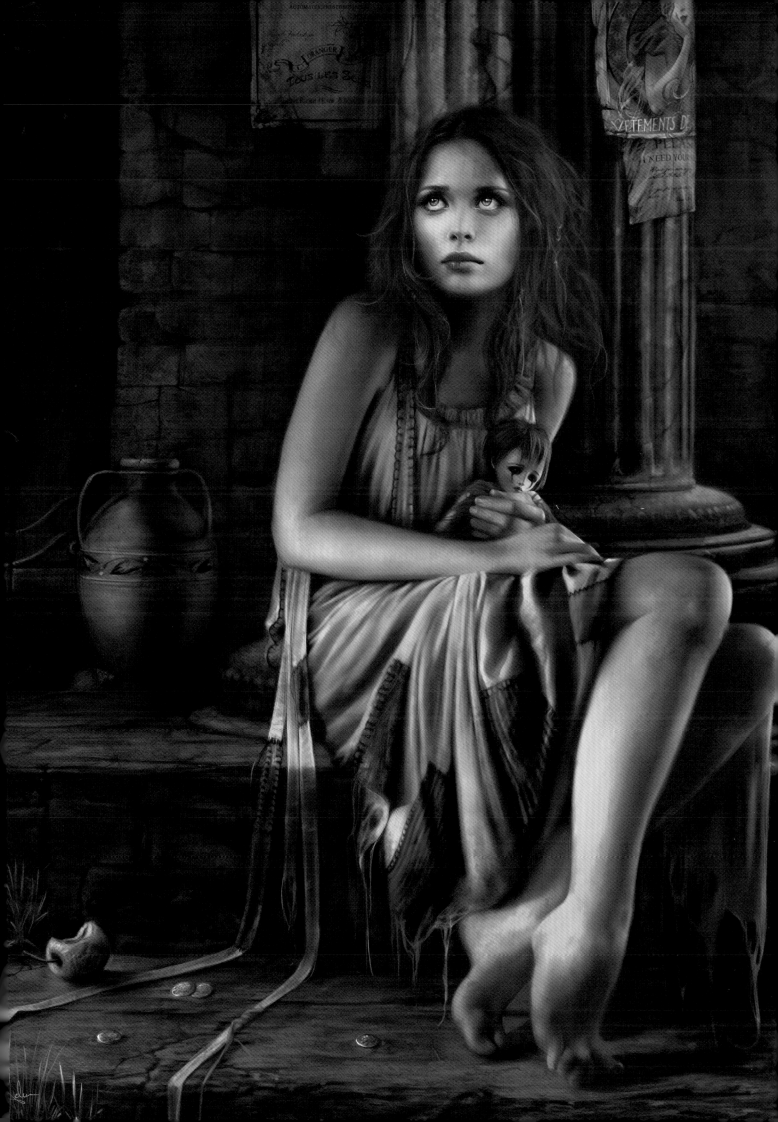

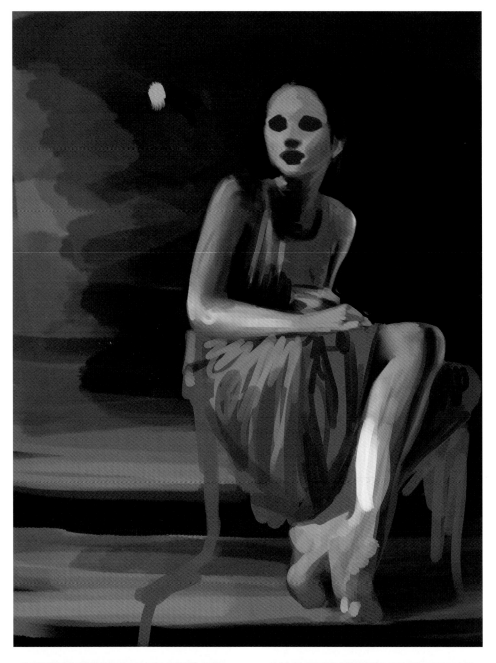

Concept sketch

What I do first is lay down the colors of my first ideas for the composition. I want the character sitting on stairs surrounded by deep shadows, and a kind of warm light coming from the left side of the picture. I usually don't work a lot of my sketches preferring to keep them very simple. With a huge block of color, I can easily modify some parts before going deeper into the details. For this step, I always use a huge-sized brush. I'm not working the details—I just need to narrow the general idea and composition so I can afford to use wide brush strokes.

Light and background

I never work with too many colors at this point. I prefer to keep the color scheme simple and construct a strong base. I'm starting to sketch the face. I'm just trying to find the character, refining a bit the shape of the face and choosing the right colors. This step is my favorite one—the image starts to emerge under my brush strokes, and a lot of ideas appear in my head. Ideas include adding more elements to the background which was a bit empty. I don't want a house or a window. I prefer to go for a closed door, and a huge column that could symbolize or let us imagine how big the city is. I've settled on the colors now—the light will be yellow and orange, and the background will be a kind of dark dusty green mixed with yellow (mustard) too.

Expression

The character's skin has to be the same color as the light—orange/yellow with some hints of red and very saturated salmon for the feet and the hands. I choose a dark brown for the hair base. I never paint hair strand by strand—I first paint a huge block of color which is the basic shape of the hairstyle, and then add some hints of light. Details will come later. I decide to color her lips with a reddish purple. This will be the only feature that is full of life. I pick a greenish yellow for her eyes pretty close to her dress color. I always choose harmonious colors—it helps to bring the picture together. I don't want her to look sad. I'm looking for a mix of curiosity and fear. To get the expression right I look at my own face in a mirror sitting next to my computer—it's pretty handy to get facial features and especially expressions right.

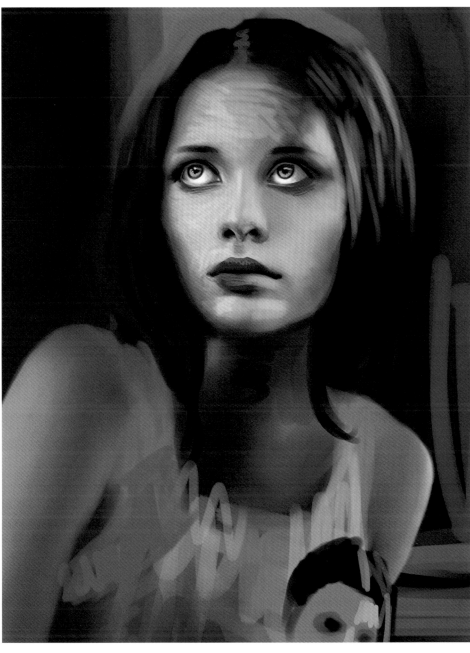

Final composition

The second light has now appeared on the left side. It's a kind of pale desaturated turquoise—a very cold color to add more contrast to the warm one on the other side. That light will be diffuse and soft. I'm now happy enough with the composition and the general lightning that I can go further with details. As you can see, I decide to add some pieces of fabric here and there on the dress. I really want the look of an old dress—dirty and ragged, with some sewing seams visible. I start to define a bit more of the wall in the background. I gently paint the wall stones, changing the size and the shape to give them a more natural, and old look. I leave a huge empty space for the door which will stay in the shadows.

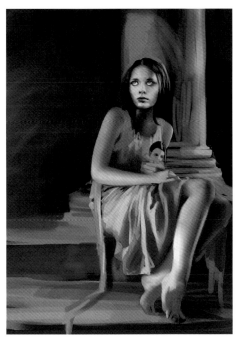 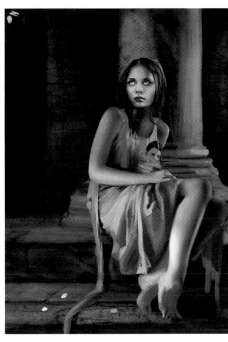

Stone texture

For the texture of the wall and the floor, I usually apply several layers of stone cracks randomly, changing the size and the shape. I erase some parts and add more contrast details on others. I also duplicate the final layer and set the new one to Soft Light with a very low opacity. I repeat this several times until I get a great strong texture base. This is not the final texture as I'll come back to this at a later point. I highly recommend creating a few brushes like this one—they are really helpful when it comes to background textures.

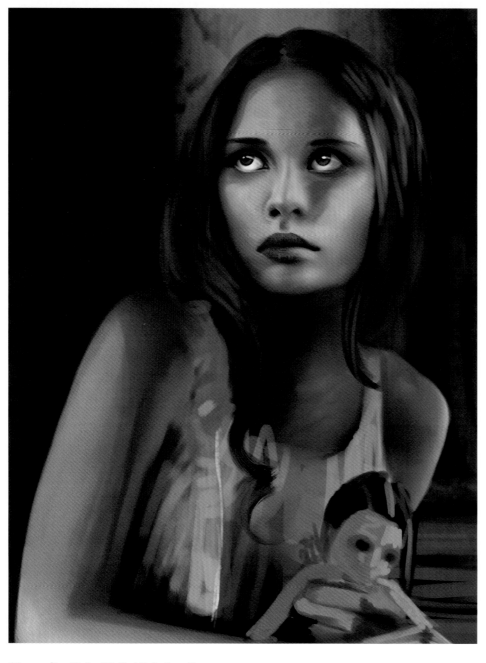

Warmth

Now that the background is looking good, I come back to the face. Switching between elements helps to get a fresh look at them, and quickly figure out the little mistakes or issues. I think the face is too pale, and I'm not satisfied with the colors. I need to bring more intensity to the skin. I pick a saturated orange and on a separate layer I apply it to the whole face. I contrast the eyelids and the eyes with a dark red and green. I'm not painting details—just refineing the general lighting color. With the same orange, I add light on the hair with a Basic Round Edge brush with Opacity Jitter set to 40%. This will add nice color variation, and you can use this little setting for a lot of things like backgrounds, and patterns. I need to add more light on the right side of the face to increase the warmth of the main light and add more contrast to the whole piece.

Lots of details

The decor has to reflect the city life, like the rotten apple, the old poster, and the big jar. I change the column for a fluted one. As it's dirty and old, I need to add a lot of texture with a few cracks. With a basic Soft Round Edge brush I add some dots of light to increase the feeling of old stone. I'm not satisfied with the general texture of the background—it needs a lot of contrast and more color. With a huge brush, I'll bring more shadows to the stairs and the column. I never use pure black to add shadows because it's a lifeless color. I choose a very dark orange brown for the darkest parts. I find the right side a bit too desaturated, so I pick a rich green and apply it to the cold blue light and then set the layer to Overlay with a low opacity. This is useful when you think you've lost your colors and want to bring them to life. I do the same for the legs, but with a reddish orange tone. I add more pieces of fabric with different colors, randomly all over the dress. This will add more credibility to the character regarding her story and life.

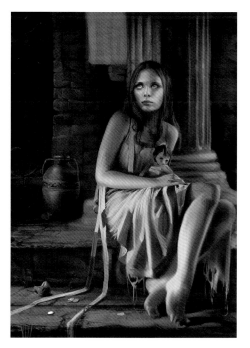 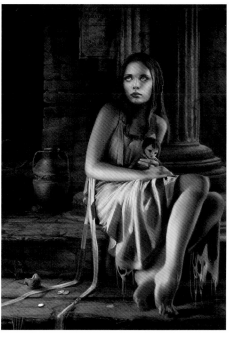

Finishing the face

I'm ready to smooth the skin and add details to it. To get perfect skin I use two brushes—a Spackled one and a custom soft one. With the Spackled brush I'll softly paint over the skin in every direction until I get something clean. This kind of brush adds a lot of color variation which is extremely useful to add realism to the skin. Once this step is done, I'll smooth the skin again with the custom brush but not everywhere. Only features with soft edges will get treatment like the chin, cheeks and forehead. The eyes are the most important part of the face, so I add some dots of very saturated green in the iris and more sparkles of light. I also blur some parts of the face with the Blur tool. Switching to the hair, I define the hair strands one by one using a very small basic brush with Opacity Jitter set to 30%. I do this on several separate layers, and blur the extremities of the strands. I repeat this step over and over again, while changing the colors. You can probably see that the light is different on the two sides of the head. On the right I used a cold blue and on the left a kind of yellow/orange. I keep in mind that she's poor and doesn't have the means to get a nice haircut, so it is important to give a messy look to the hair. For that I paint a lot of random single strands all over the head and slightly blur the final result.

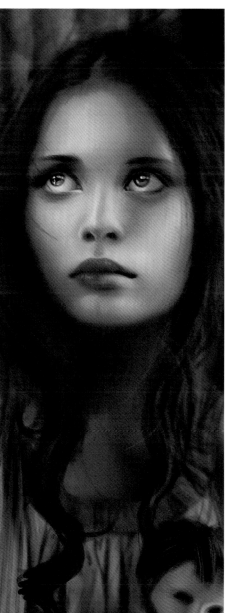 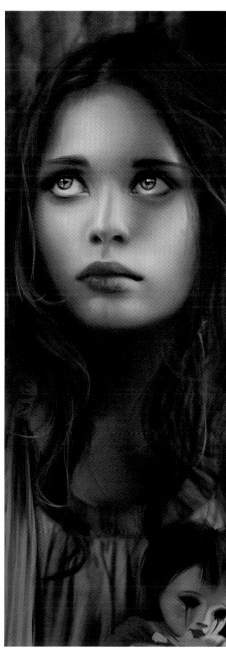

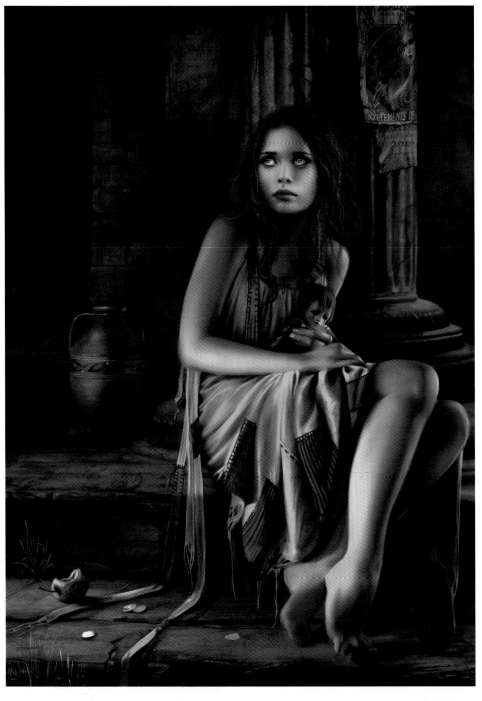

Refining details

I'm ready to refine the painting including adding texture, little extra details, and more contrast. I decide to add some patterns and sewing lines to the pieces of the dress to give it a more patchwork look. The dress has to reflect the character's poor life, so I don't hesitate to damage it. I usually work the details with a Sharp Round Edge brush instead of a basic one—it's far more precise, and really useful to accentuate the edges. As I mentioned earlier, I consider the light as a character, so it will interact with all the elements in the composition. I push it as far as I can, playing a lot with the contrast and the colors. This will bring more life and presence to the light.

Fabric

I usually start by quickly sketching the folds, following the curves of the body. I always use a Soft Edged brush, because I need to have a nice soft texture for the base. Once I'm done with the first folds, I switch to Painter to get the blending right. I use a lot of custom brushes in Painter—most of them are Camel ones—which give a fine painterly result and help a lot with the blending and texturing process. After smoothing the folds in Painter, I switch back to Photoshop to refine the whole thing. With a Spackled brush I gently follow the curves to add more texture to the fabric. I erase/blur the extremities of the brush strokes before merging the layer. A tip for painting fabric is to add color variation. With a Soft Edge brush I'll randomly paint brush strokes all over the fabric's surface, then set the layer to Soft Light or Overlay and lower the layer opacity.

Posters

I love mixing things—it creates a special atmosphere, and a nice touch. The background has a strong antique feel, and needs to be balanced with more recent elements like the Art Nouveau posters. The poster on the column is highly referenced to Alphonse Mucha's works—a deliberate, tribute to this exceptional artist. The poster you can see on the wall in the background is inspired by the great French illusionist Robert Houdin (the father of modern magic), and more precisely on one of his magic tricks called "L'oranger merveilleux" (The Orange Tree). This is something I usually do when I need to paint another piece inside the main illustration. I paint it in another file, and when it's done I import the layer into the illustration and resize/modify the lighting to make it suit the composition. At this stage I add more and more contrast to the walls, column and stairs. I often switch to Painter to fix and blend the textures.

Refining the hands, doll, and the feet

I'm ready to refine and finish the little doll. She doesn't need to be overly detailed because she's not the main character. I add some small holes in her clothes and make her look sad. I also add more contrast to the dress, mostly on the folds. To do this I shadow them on another layer and then duplicate it and set the new layer to Soft Light with a low opacity. I'm really happy with the colors—the orange skin tone is exactly what I was looking for when I started the painting, and the greenish blue light brings a nice balance to the general warmth of the piece. The only part I'm not satisfied with is the feet. They are not saturated enough and lack shadows. I pick a reddish orange and apply it on the extremities of the feet (toes, heels). I also add more deep cast shadows on the floor. Those little details are really important as they help to bring the picture together.

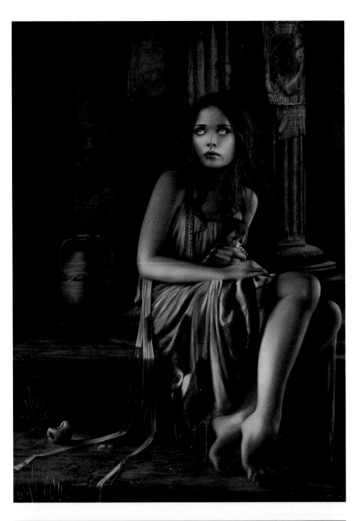

Fixing little background issues

It happens sometimes, even after so much time spent on a painting—I realize that the perspective is not good. Hopefully it's never too late to change or modify some parts with digital painting! To fix this little issue, I select the part I want to modify, and duplicate it. Once this is done I resize it, and erase the borders to make it fit with the main background layer and then merge it. The details are now finished. I can merge the character's layer with the background and add the last touch of contrast. For that I simply duplicate the final layer, and set the new one on Soft Light or Overlay, and change the opacity to avoid an over-saturated render.

Dirty skin

The character is looking good now, but maybe too clean for a poor girl. I decide to add some dirt to her skin and her dress. I pick a dark brown (the same color I used for the shadows), and with a textured brush I paint random stains of dirt all over her—on her dress, her skin, and even on her face. Once this is done, I erase some parts and blur others. She now seems to be covered with mud which I don't want. I prefer the stains to be very delicate—something not seen at first look. I softly erase again and again until I'm finally satisfied with the result. Everything seems to be ok now. I switch into Painter to give a last blending touch here and there. I blend the dirt stains with the skin a bit more and check everything is well integrated. I also slightly blur some parts and add some extra touches of textures before saving the final image.

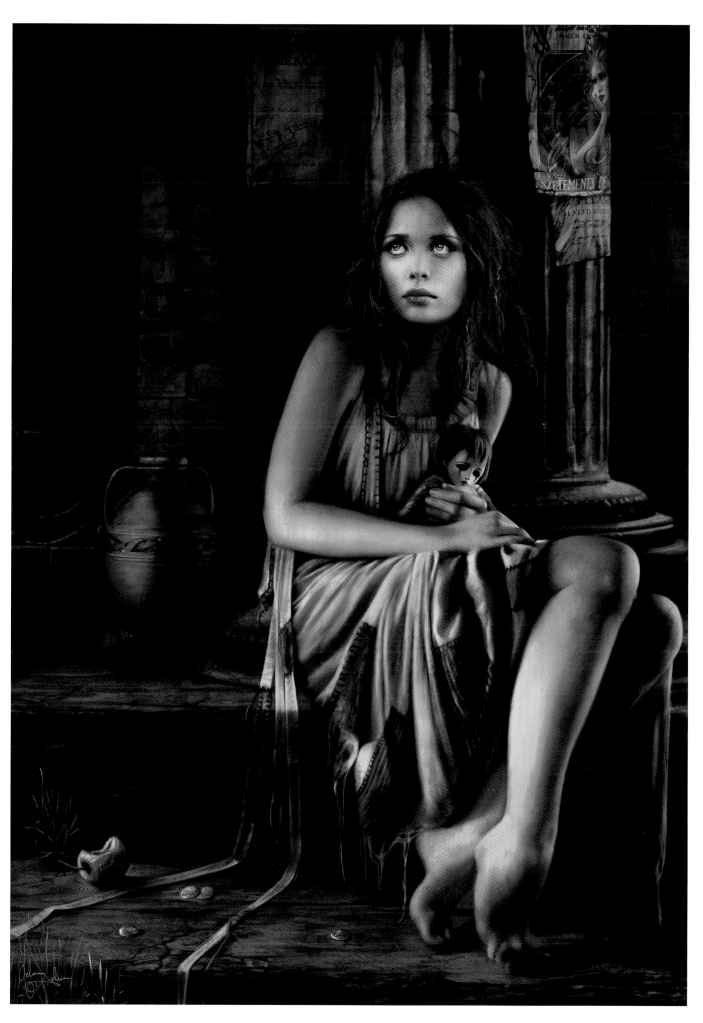

HOMAGE TO MUCHA: WITHIN DREAMS

Inspiration

Within Dreams represents a sad love story between the sun and the moon, condemned to live apart from each other forever. She's the sun, and she dreams of the day she could finally be with him. This of course will never happen so they can be together only few minutes in the day when the sun fades and leaves the world to the moon. For the characters, I knew that she would not wear a golden dress—this illustration is about love so I wanted the piece dominated by a lovely old pink and tender mauve. The moon would be like a ghost, almost ethereal. Some unreal light will illuminate from him such as a very pale blueish mauve. The background must be a part of the story too. I wanted to paint a landscape mixed with a dark forest. The landscape will be huge fields that could represent hope and the twisted forest their curse. The general idea was inspired by A. Mucha—particularly the female character

who is floating in the air with yards of fabric around her. The man is inspired by the gods of antiquity, with a kind of toga and a Greek look. I don't want him to be like a warrior in armour—that's not my style. I prefer to represent man with more grace and soft-looking instead of a big brute. I'm attracted to tragic stories—there are so many things to tell, and it's really inspiring. Forbidden or impossible love are probably my favorite subjects. Writing stories and painting them give me the same pleasure. It helps me a lot with the composition and the inspiration. For the background, the idea of a huge field comes from my travels a few months ago. It was early in the morning, and the land was covered with some morning mist with dark trees emerging from it. It was so beautiful, and I knew that I had to use it in one of my future paintings.

Technique

When I paint a full scene with characters and huge background, I must be very organized in my workflow. I need to know where I'm going and what kind of render I want for the final image. I always try to refine all the elements as a whole piece instead of working them one by one. This helps me to bring the picture together. I decide to color the second light in pink. I know it's not absolutely realistic, but I need to add a touch of fantasy in the piece which will contrast with the coldness of the main light while staying in the basic color scheme and general theme of the picture. The vegetation is also an important part of the painting. I want it to be luxuriant, full of life and color. I won't paint each leaf of every plant and tree. I'll just work the forest and the grass as a whole element, and progressively detail selected parts. The general trick here is to not stay focused on a single particular element, but work the piece as a whole.

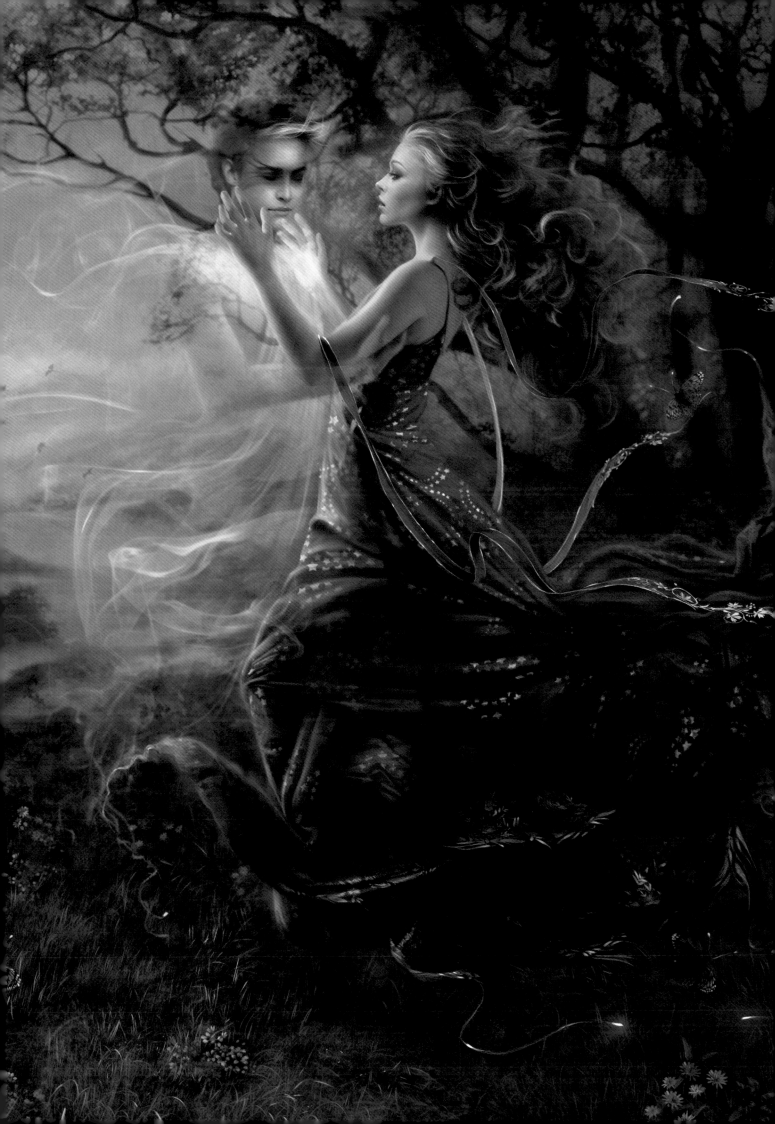

Starting point

For my first sketch I experiment with colors, and I try to find the picture—a good composition, and the general mood. This is a really quick step. I don't need to paint details—just huge blocks of color. I usually paint everything on the same layer with a big sized brush with Opacity set to Pen Pressure. I also start to select some colors for my color scheme. As I want the pink to be the main color, I build the rest of the color scheme around that tone. Her skin tone will be a mix between pink and a desaturated orange—pretty close to the sky color.

Adjusting the anatomy

Now that I've settled on the general idea and composition, I can go on with refining and adding the base for the future details like the forest or the character's hairstyle. I always try to add a bit of texture at the very beginning of an illustration—that's why I use this kind of brush instead of a Basic Round Edge. This brush is pretty easy to create and provides nice color variations when you're working on early stages. It is also extremely useful when you want to paint huge landscapes.

Refining in Painter

After refining the trees, and adding more pink light on the right side I decide to move into Painter to do a first general blending. I use a Palette Knife and do the blending on another layer. If I'm not happy with the result I can erase some parts of the blending before merging the layers together. I delete the character's crown. I prefer to keep her very simple, without intricate jewelery. The illustration is about love not gold. The male character who will be a light source will be between her arms and so his light will affect a lot of her upper body. I need to push a lot of the light on her. You may notice the saturated orange on her fingers. This is a little trick to paint translucent skin. I apply that tone where the skin is really thin, like between the fingers and also on the extremities of them.

First branch, and face

Working on the character's face, I pick a very pale mauve for the light and a dark reddish pink for the shadows. The shadows do not need to be very deep as I want the piece to be very soft and not so contrasted. Her hair will be colored with a tender gold, and will be curly and messy. For the tree branch in the background I usually use this kind of custom brush made only to paint foliage base. Painting branches one by one would take an eternity, so it's helpful to create a few brush like these to increase your painting speed. Once I'm happy with the base, I blur some parts (always with the tool not the filter), and erase some others to make it fit with the background.

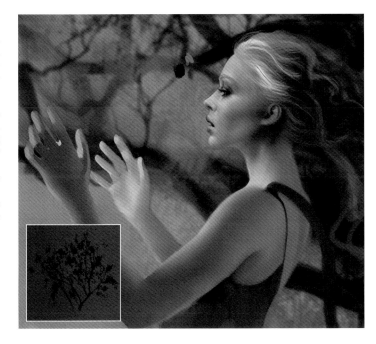

Landscape

I switch to working the fields. I want them to look peaceful and calm. The main color will be mauve and violet with some hints of green and deep blue. I know it sounds weird for painting vegetation, but this is the feeling I'm working towards. I try to keep in mind that a landscape is not the same color shade everywhere. To recreate a depth of field I need to desaturate the part that is the farther away from the foreground and darken the area closest to the characters. The brush you can see here has been created using Painter. I use it for almost everything—it is a nice alternative to the Basic Round Edge brush, and adds a lot of texture at early stages. With this brush, I paint the little hills and mist in the background. To paint the little trees I use the same brush as I used for the previous branch. I blur the whole thing once it's done.

Leaf brush

Painting leaves could be a really painful task if you had to paint them one by one. To avoid this I create a few brushes like the one shown here. I set it the Scattering to 20% and the Spacing to 30% with Opacity set to Pen Pressure. I pick a dark green and paint the first leaf on a new layer. I then pick another green brighter than the previous one and paint more leaf upon the first ones. Finally, I repeat this a third time with another brighter green. I erase and blur some parts and then merge the layers. I do this several times until I'm satisfied with the result.

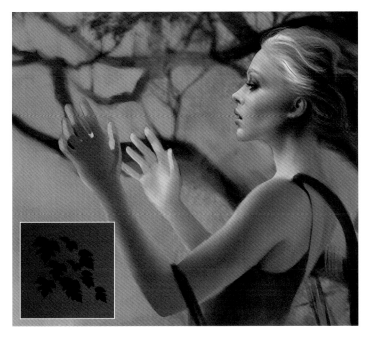

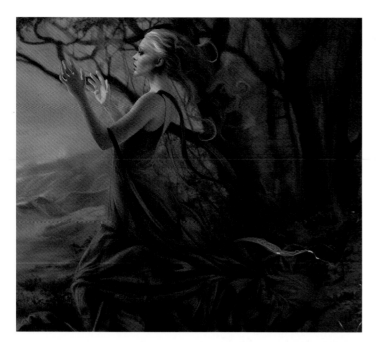

Designing the dress

I want the dress to be very simple on the top and completely messy on the bottom. The first thing I do is to quickly paint huge folds of fabric with the aged mid-pink tone. I add both lights (the blue one and the pink one), and start to bring more volume to the dress folds. Usually, fabric folds follow the curves of the body or the element behind it. Here, I can paint them without any constraint, so I can let my imagination flow and go randomly with the dress shape.

Refining the dress and vegetation

Now it is time to switch to Painter to do the first blending of the folds. I want them to be messy but not this messy. I use two different brushes—a Palette Knife and a custom Camel Hair. I gently smooth the folds while following their shape. I do not smooth the fabric too much—I prefer to keep some brush strokes apparent so it doesn't appear plastic. For the vegetation, it's mainly myriads of dots of various shades of green. I'm not going to detail each leaf or little plant. This is not the goal and would take ages.

Golden pattern base

To paint the pattern, I usually create it on a new layer. I try to make it the best I can, then I duplicate the layer and place the new one where I want it on the fabric. I repeat this until I've totally covered the surface. Here, the star circle will be placed randomly all over the dress and the flower pattern on the bottom border. I need to deform/erase some parts to make sure that the pattern suits the folds and the dress shape.

Working the pattern

Now the base of the dress pattern is ok, I can refine it. I erase some parts (those on the darkest parts of the dress), and add some golden light. I also decide to add some color—a blue one on the flowers. There are no special tricks here—painting patterns is a long and tedious task. Sometimes I duplicate the whole layer and set the new one to Soft Light (with a low opacity) just to bring more intensity to the colors.

Refining the face

Moving back to the Sun Goddess, her face needs to be refined and her skin smoothed. With a custom Soft Edge brush, I softly paint over the skin, trying to blend her skin as well as I can to perfect it. I add more light on her lips with a tender pale pink. The only part of her face which will be covered by makeup is her eyes. I want to keep her lips very pure and simple. I noticed that the line of her profile is too sharp, so I soften it a bit with the eraser and the Blur tool.

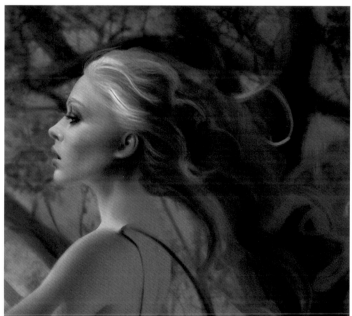

Hairstyle

Hair can be hell to paint. The secret is not to paint the hairs one by one (like foliage), but to paint in strands and highlights over the base color. For the base, I use the same brush as the initial hair blocking. I pick a mid-tone because it's easier to work with. With the same brush and a slightly brighter color, I define the first strands that will catch more light and do the same for the shadows. The hairs are not straight here and are being affected by the light, wind, and the curly style. I add a lot of light to the top of her head as this is affected by the main light source. I also add discreet hints of pink light on the extremities of the floating hair. To add color variation I use the brush you can see here. I set the Opacity Jitter to 50% and paint over the strands with a bright tone using a desaturated gold. I softly erase the extremities of the brush strokes and blur some parts. I repeat this over and over on several layers, setting some to Soft Light or Overlay until I'm satisfied with the result.

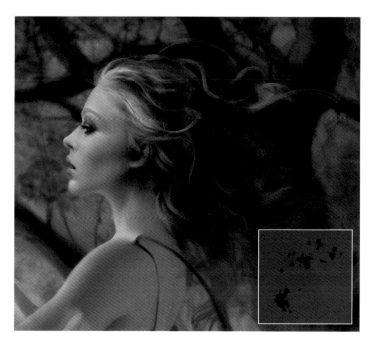

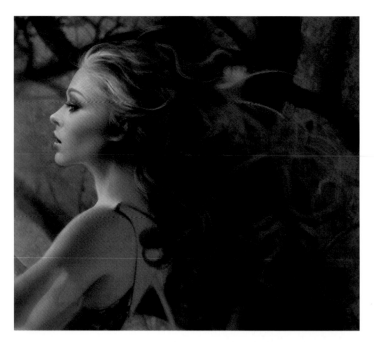

Finishing the hair

I add more curl and contrast to the hair and pick a very dark red brown for the shadows. I use the same brush as in the previous step as I need a lot of texture and color variation at this stage. The hair is in motion so I have to keep this in mind to avoid a static look. To increase this feeling, I add a glow all around the hair, and don't work the details too much. The final render will be very blurry and messy.

Light and transparency

I return to the dress now. Switching between different elements of the piece gives me a fresh look at the whole image. Some parts of the dress have to interact more with the ambient light. So I pick a saturated pink, and with a Basic Round Edge brush I gently apply the tone all over the extremities of the flowing fabric.

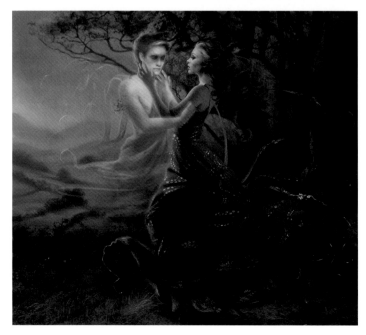

The ghost

The Moon God is a kind of unreal entity— I want him to be transparent and made of light with some smokey light all around him. The light will come from the top of his body and be a cold one. To paint this character I create a new layer—this way it will be easy for me to play with the opacity, or modify, and erase some parts. I decide to close his eyes—daylight is still here so he's not awake, and can't interact too much with her. As you can see I used almost monochromatic color to paint him. This helps a lot when you want to paint a ghost or dead people. I won't accentuate a lot of the shadows—only the ones that are essential, like the ones on the facial features. The general look will be extremely blurred. I really want to increase the feeling of a ghostly dream as much as I can.

Unreal light

Now that I'm happy with the male character, I duplicate the layer, and set it to Screen mode. I have to accentuate the cold blue light. On another layer and with a Soft Edge brush, I pick a very bright mauve tone (almost white), and softly add more light on the character's face and chest. While I'm doing this, I also paint a soft glow all around the character. That glow will also affect the face and the upper body of the Sun Goddess.

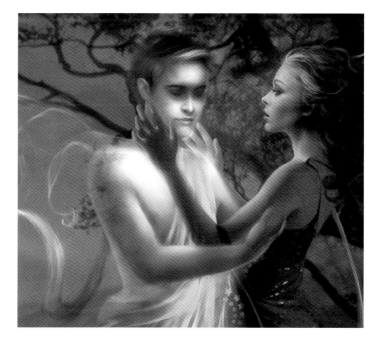

Painting the grass

I now bring my attention to the grass. There are no secret tricks here—the painting process is quite similar to the hair. First, I lay down the color using a desaturated mid-green and add a block of light and shadows. With a Sharp Round Edge brush with Opacity Jitter set to 50%, I paint a single strand of grass. This step takes a lot of time, but the result is always believable. It's important to remember that grass is really messy—each strand must have its own direction and shape.

Color variations and details

The star pattern needs to be refined and lightened, so I add more dots of golden light here and there to give a more magical look. I also refine a bit more of the ribbon, creating a discreet silver line on the borders of it. I add more color variation to the Moon God—some bright pink and yellow. It is very subtle, but it adds a nice touch and adds interest to the character.

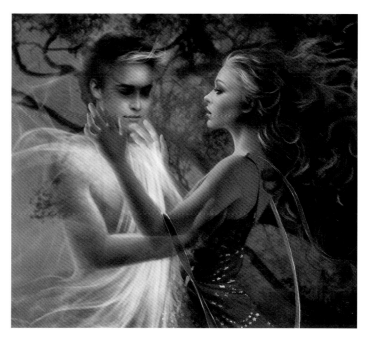

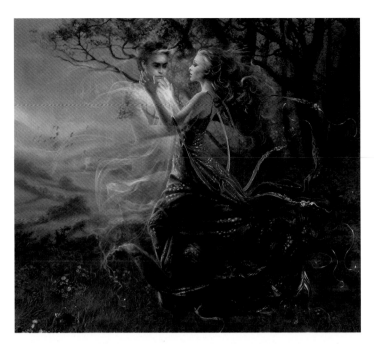

Vegetation and background

The image is almost done now. I just need to add more details to the background. The main theme is love, so I thought flowers would be a nice element to add in the empty grass. They will be colorful and placed in no particular order. I choose two main colors for painting them—yellow and bluish violet. I won't over detail them so they are more dots of color than real painted flowers. I also accentuate the mist in the background, and add some flying birds (vaguely sketched).

Flower and grass

Let's look at the grass and flower in detail. On the base I painted previously, I add some dots of light with a Sharp Round Edge brush set to Wet Edges. This setting is pretty useful when you want to have a nice watercolor effect. I add light to several strands of grass, then I slightly blur/erase the extremities of the brush strokes. Another touch I usually add when I paint grass or plants, is to paint wild huge brush strokes on a new layer with a Soft Light blend mode set at a low opacity. This will add more intensity and color variation to the grass.

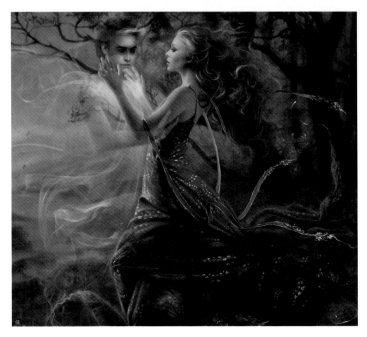

Blue glow

I switch to Painter to finish the blending, making all the elements fit together. I check the light, the shadows, and all the little details. It is also at this stage that I decide to blur or sharpen some edges. The image is almost finished, but I see the areas that need to be refined. The last step will be done in Photoshop. I choose a huge sized Soft Round Edge brush, pick the blue cold light color, and apply it to the parts of the goddess that are near the Moon God. I then blur the whole thing. This extra touch of light will finalize the connection between the both characters.

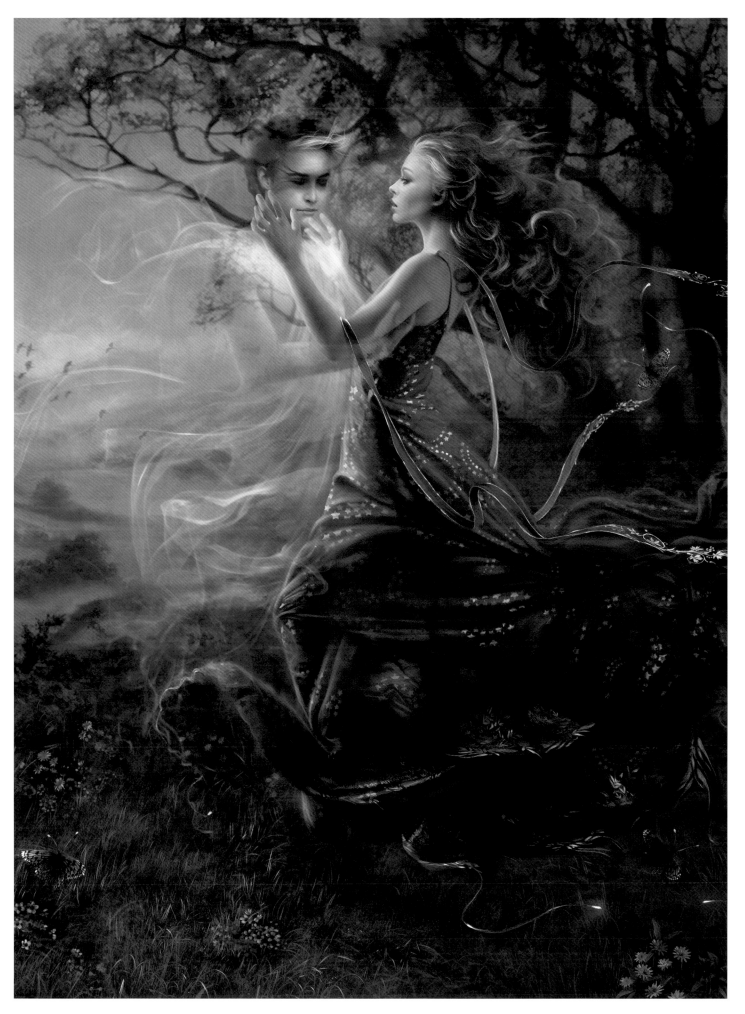

krk
Photoshop
Falk,
GERMANY
[top]

Mélanie Delon
This piece is really captivating, the color choice is great and adds something special to the image. I also love the woman's expression—she seems to have a strong character.

Seemonster
Photoshop
Daniela Uhlig,
GERMANY
[above]

Mélanie Delon
This character is hypnotizing and so cute. I adore the way Daniela has used the red color—around the eyes and the mouth—it brings something special to this little underwater tentacle creature.

Gueule de Bois Hangover
Painter, Photoshop
Marc Simonetti,
FRANCE
[top]

Mélanie Delon
Awesome character! Wood is usually pretty hard to paint, but Marc did the texture so well. The eyes of the robot are amazing—really deep and full of life.

Horned God's Daughter
Photoshop
Client: Triton
Michal Ivan, SLOVAKIA
[right]

Mélanie Delon
Exactly the kind of piece I would like to hang on my walls. The lighting and color choice are perfect, and the confident expression and the dynamic pose of the Horned god are amazing.

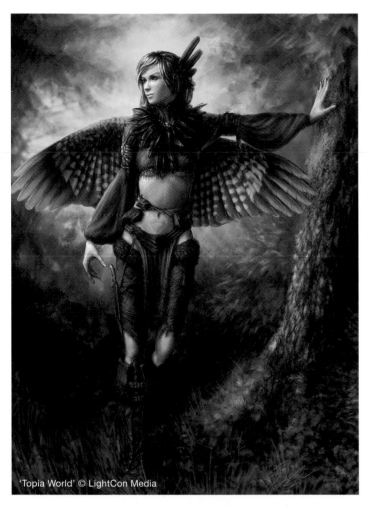

'Topia World' © LightCon Media

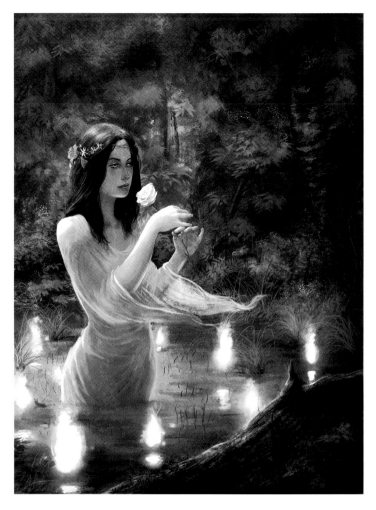

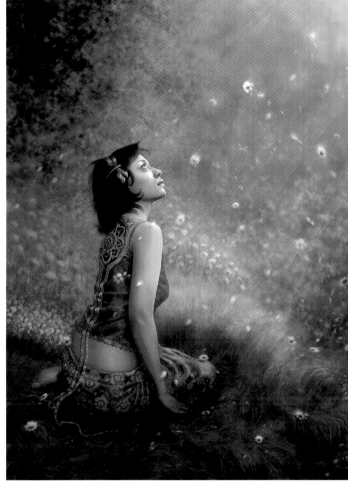

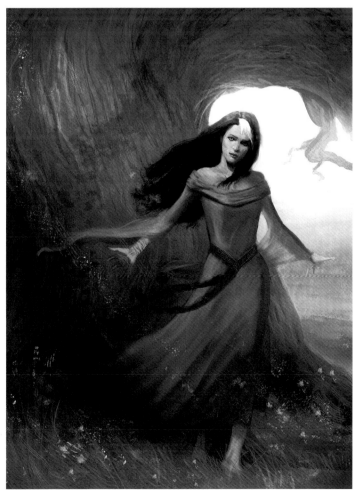

Glory Winddancer
Painter
Client: LightCon Media
Liiga Smilshkalne, LATVIA
[far left]

Mélanie Delon
Lovely character design and the colors are extremely beautiful—especially the green light that comes from behind the character. The wings and the details of the costume are well painted too. It's a beautiful piece.

Blindman's Buff
Photoshop
Daniela Uhlig, GERMANY
[above left]

Mélanie Delon
I love the fairy's expression and pose, and the little cartoon character in the foreground is very cute. The colors are splendid—very summer like. I just want to jump into the painting and play with them!

Nomad
Photoshop
Michal Lisowski, POLAND
[left]

Mélanie Delon
I'm in love with this painting. The huge background landscape and creature are amazing. The dark smoke with the devilish head captivates my attention. It's the kind of detail that makes me want to know more about a painting.

Hour of the elves
Photoshop, Painter
Client: Pocket SF
Marc Simonetti, FRANCE
[above]

Mélanie Delon
I'm usually not fond of elves, but this piece really caught my eye. She's absolutely adorable and seems so delicate. The little flames all around her add a nice touch of fantasy.

Tomorrow Today
Photoshop
Doris Mantair, NETHERLANDS
[above right]

Mélanie Delon
Everything in this illustration is poetic and romantic. The tender green of the grass mixed with the lovely violet produce a lovely dreamlike mood. I love the little flowers that are flowing all around her. An enchanting piece.

Polgara the sorceress
Photoshop
Client: Pocket SF
Marc Simonetti, FRANCE *[right]*

Mélanie Delon
The tree is my favorite part of this illustration. I love the twisted design of the trunk with the light coming from behind. The character is very enigmatic too. Her white strand of hair and the sparkle of light add a lovely magical touch.

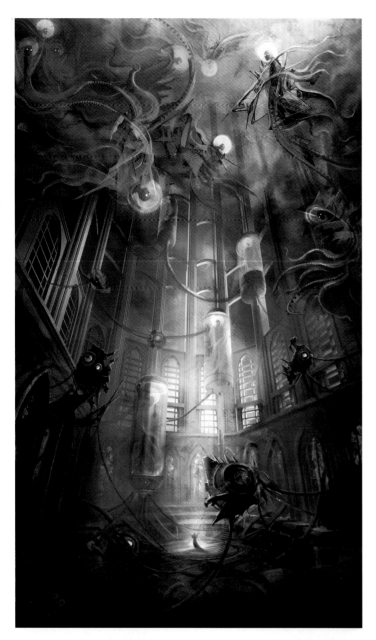

Heaven 2.0
Photoshop, 3ds Max
Nicolas Ferrand, CANADA
[far left]

Mélanie Delon
A breathtaking piece. I love how Nicolas has used the blue and yellow. Primary colors are not easy to work with, but here is a real success. The little figure surrounded by a huge ray of bright light increase the feeling of greatness.

Relic of the Dragon
Photoshop
Hong Kuang, SINGAPORE
[left]

Mélanie Delon
There are incredible details in this illustration, and the dragon skull is impressive. What I love most here is the character's look. It is really eye-catching, and I want to know who that guy is and what he's about to do.

Tec opera
Painter, Photoshop
Chen Wei, CHINA
[right]

Mélanie Delon
Splendid painting. The dress and the crown are so very well done—full of details and believable. The dragon is just perfect. I love the mix between classical fantasy elements and the industrial ones.

Starmaker
Photoshop
Nicolas Ferrand, CANADA
[left]

Mélanie Delon
I'm a big fan of sci-fi landscapes, and this piece is a great one. Colors and composition are just stunning. I wish I could paint this kind of subject one day.

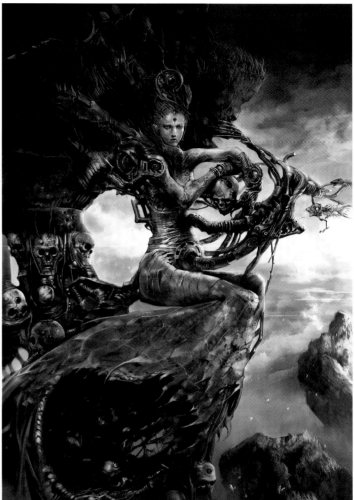

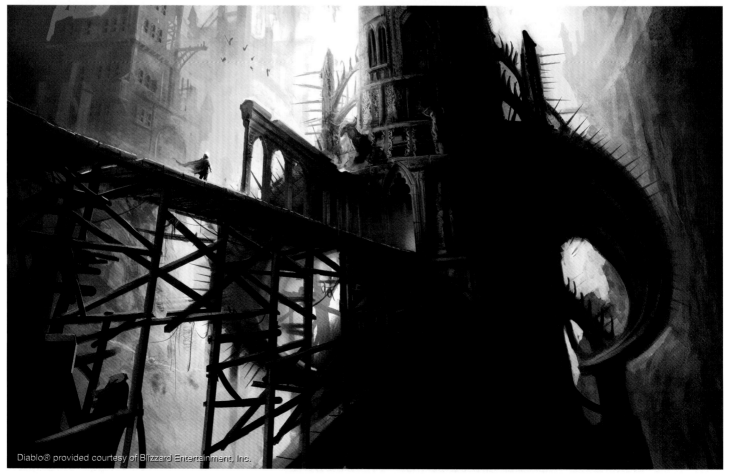

Diablo® provided courtesy of Blizzard Entertainment, Inc.

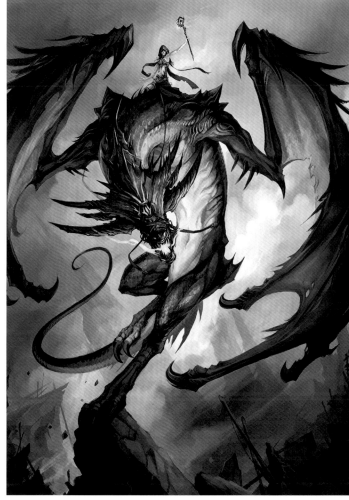

The Queen of Ultima
Photoshop, Painter
Chen Wei, CHINA
[far left]

Mélanie Delon
Awesome illustration. She deserves the royal title. The composition is very well balanced between the sky that seems to be heaven and the waterfall ground which seems to lead into hell.

The Dying Dream
Photoshop
Hong Kuang, SINGAPORE
[above left]

Mélanie Delon
Warm colors as if the background was on fire. The character is really intriguing, and the atmosphere is chaotic. A pretty disturbing piece, but also very well painted!

Diablo horns tower
Photoshop
Marc Simonetti,
FRANCE
[left]

Mélanie Delon
The tower is really frightening. I would not like to be with the little character on the bridge! The architecture and the lighting are just amazing. A powerful piece.

Jungle Queen
Painter
Patrick J. Jones, AUSTRALIA
[above]

Mélanie Delon
Lovely pose and character. I'm in love with the color scheme—especially the golden green used for the light. The snake adds a nice mythological touch to the composition.

Wyrm
Photoshop
Sandara Tang, SINGAPORE
[above right]

Mélanie Delon
I just love this painting! The lovely pale turquoise of the light and the dark green of the dragon are simply perfect. The pose of the creature and his overall style are incredible.

Shadow Zone
Photoshop
Client: Ojom GmbH
Daniela Uhlig and **Kai Spannuth**,
GERMANY
[right]

Mélanie Delon
Very well-executed painting, I love the red hair of the character and her victorious pose. I'm really wondering what she is doing here.

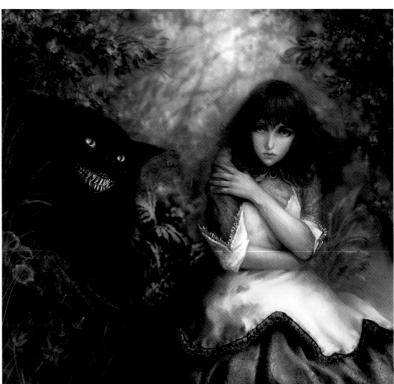

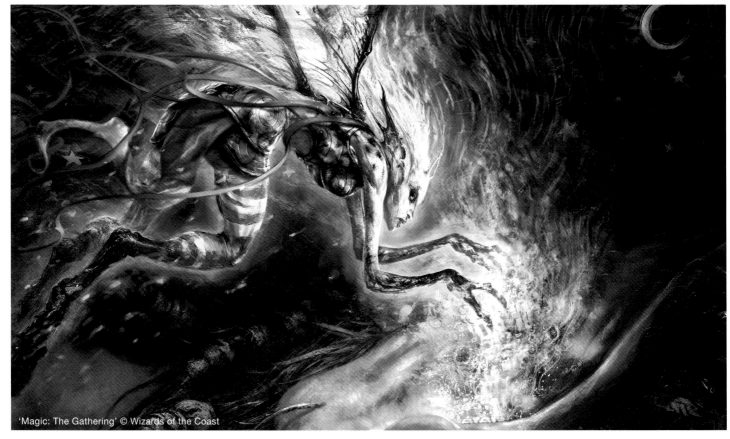

'Magic: The Gathering' © Wizards of the Coast

La Sorciere de Darschiva
Photoshop
Client: Pocket SF
Marc Simonetti, FRANCE
[top]

Mélanie Delon
I've always liked witches, and this one is beautiful and mysterious. Nice contrast between the snow and the character. I just love her dress which is simple but complicated at the same time.

Magic: The Gathering (ThoughtSeize)
Photoshop, Painter
Client: Wizards of the Coast
Art Director: Jeremy Jarvis
Aleksi Briclot, FRANCE [above]

Mélanie Delon
Aleksi's style is amazing. I'm a big fan of his work. What I like the most here is that we can only imagine what the little creature is doing. Maybe he's stealing the elve's dream. Very well painted.

Wonderland
Painter
Client: The Penultimate Truth
Eva Soulu, RUSSIA
[top]

Mélanie Delon
I let my imagination flow when I see this kind of painting. The little girl looks so fragile and lost in those woods, and the cat next beside her seems so devilish! This is a beautiful painting.

The Atonement
Painter
Hong Kuang,
SINGAPORE
[right]

Mélanie Delon
Tortured piece. I'm usually not fond of blood in a painting, but here it's justified. The character looks like a fallen angel or demon. The details appear after a certain amount of observation.

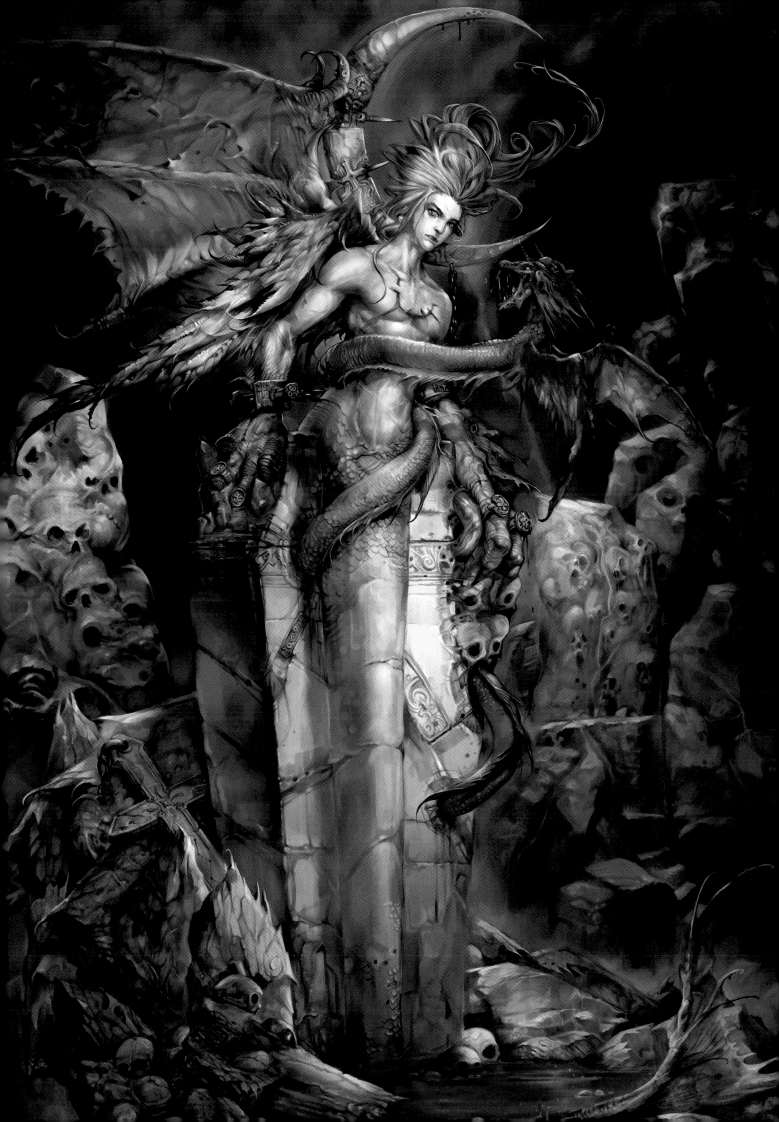

DON SEEGMILLER

Don was born in Provo, Utah in the US and attended Brigham Young University graduating with a Bachelor of Fine Art in Graphic Design. His work has been displayed in major art galleries from England to Hawaii, and he's completed over 900 paintings held in many private and public collections. Don currently teaches senior Illustration courses, traditional head painting, figure drawing, and digital painting for the Department of Visual Design at Brigham Young University and also teaches figure drawing at Utah Valley University. He was previously art director at Saffire Corp. for six years and is an acclaimed author in digital character design and painting with several books to his credit.

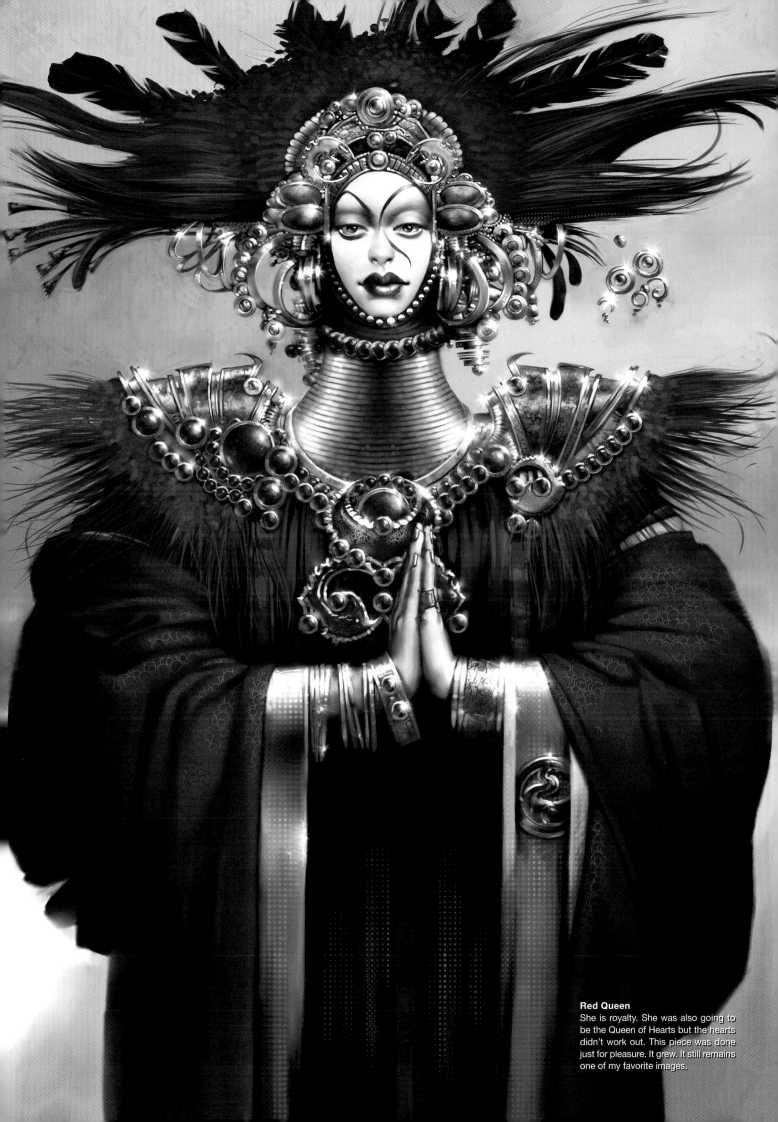

Red Queen
She is royalty. She was also going to be the Queen of Hearts but the hearts didn't work out. This piece was done just for pleasure. It grew. It still remains one of my favorite images.

CONTENTS

Beginnings

I was born in Provo, Utah in 1955. I grew up in both California and Colorado. I remember from a very early age drawing on anything that was available. I was actually a rather shy boy and used my drawing to break the ice with new classmates. I developed one nasty habit in these early years that continues to this day—I have a tendency to stick out my tongue when I am concentrating over a painting or drawing. My wife constantly teases me about it, but I think it is one habit that I will not be able to break. One of the first times that I remember being the center of attention because of my art was in 6th grade in elementary school. I was chosen to make a poster for my spelling bee team. We were the Pink Elephants! I went home and did the best poster that I possibly could. I remember drawing the elephants from the character in the Dr. Seuss book 'Horton Hears a Who'. We tacked them to the wall, and the teacher accused me of having my mom do the poster. I was devastated. It took a visit from my mother the next day to convince the teacher that I had indeed done the work.

Art studies

I graduated high school with no intention of going into art. Since I was not a scholar, I relied on art to apply for a scholarship at Brigham Young University. To my surprise, I actually received an art scholarship. Of course, the university expected me to become an art major. University studies were another beast altogether. I was not the best student. It was not until my junior year when I got married and had a panic attack that I decided to either to get going or get out. I had a wife, rent, bills, and a parakeet. I needed either to make a serious effort or move onto something else. I did get serious and worked as hard as possible those last few years. I had several teachers who influenced me greatly. The most influential is the marvelous artist, William Whitaker. He paints the human figure as well or better than any other artist I know of. I learned more by watching him paint than from all my other teachers combined. I owe him a great deal of thanks. I am glad to say that we are still close to this day. The second artist is James Christensen. He is a fantasy artist of the highest caliber.

He taught me to paint with acrylic, and showed that whatever you choose to paint, if you do it well, and with conviction, your audience will respond. I graduated with a Bachelor of Fine Art degree with an emphasis in illustration. I became a fine artist and made a living as a gallery painter for 15 years. My daughter got to school age, and I needed to level out my income a bit. I got a job at a small multimedia company. I didn't really know what they did, but they needed artists, and I figured I could draw well enough to try it on the computer. I worked on several Game Boy games—an eye-opening experience. I found that I was pretty good at drawing on the computer too and became the Art Director at Saffire. Saffire was a very good game developer in the mid-1990s. I had the privilege of working on several very successful games over the years. Saffire is no longer around but the experience of working there was irreplaceable. At the same time I was asked to teach a few courses at my former school, Brigham Young University. It's interesting how things come full circle like that.

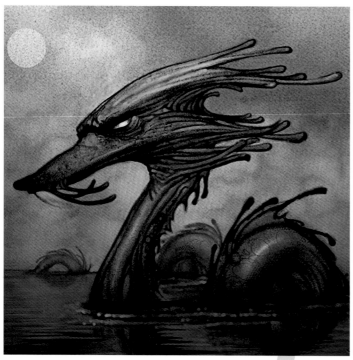

Sea Serpant: The sketch basis for a tutorial in my next book, released this summer.

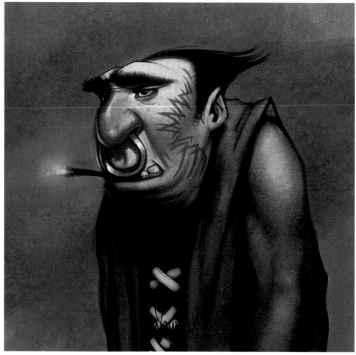

Ogre: A painting tutorial from my Photoshop CS3 book released in 2007.

Becoming a digital artist

When I was in school there was no such thing as digital art. The game pong was the pinnacle of cutting-edge graphics at the time. Over the years things got better. Eventually my computer monitor would display 16 colors. Oh the beauty of it. Then there were 256 colors and high res 640 x 480 pixels. Today it doesn't even compare. Now I have 16 million colors to play with. Many of my original digital paintings were done just because I wanted to paint on the computer. Unfortunately, as time went on most of my work has gone from painting because I wanted to, to painting because I was doing a job for someone else. Of course, I shouldn't complain. I started out as a traditional oil painter, and my subject was the figure. Above anything else the human figure fascinates me. I love the difficulty of capturing the subtly of the human form and how very different something that we are all so familiar with can

look so unfamiliar under different circumstances. Give me a figure and a lot of fabric to paint and I am a happy man. Making the transition from the traditional oil painting world to the digital world was really not that difficult. I believe that if you have the artistic skill and knowledge to make a painting with traditional materials you can also make a piece of art in the digital world. The problem seems to arise because of several reasons. First, you have to have the computer to work with as well as software. Nowadays this is not nearly as much a problem as it was in the past, but computers and software still do cost a fair amount of money. As time goes on, the computers and software continue to come down in cost as the power and features increase. This is a great scenario for the artist. Second, you have to learn at least one program. This is for some people a very intimidating thing, but it is really

no different than having to learn the technical aspects of any of the traditional media. Third, the computer is a pretty unforgiving medium. There has been the perception that a computer will do most of the work for you when creating digital art. This may be true if you are running a program that makes fractals or any other program that makes images based on some sort of formula. Otherwise, the computer is only as good as the artist using it. If you can't draw or paint the computer will not compensate for that lack of skill. Anyway, there are a number of valid and good reasons to paint on the computer: speed— I am significantly faster when painting on the computer; Undo—it is a lot harder to undo when you are standing in front of a painting that has taken a wrong turn somewhere earlier in the process; the ability to save multiple versions—this strength cannot be over stated. Everyone

should get in the habit of saving different versions of their work as it is developed. Fortunately, the tool I use, Painter, makes that task very easy with its Iterative Save feature; it is a clean medium—you can leave it out on the counter without worrying about the kids eating it. There are also a couple of disadvantages to digital painting: you don't have an original that you can hold. This becomes an issue with collectors sometimes; you have the whole art store at your disposal—many digital painters feel that because they have the whole art store, they need to use it. You also don't need to use all 16 million colors in every image; you are subject to the whims of nature—there is nothing that can end a digital painting session as quickly as a thunderstorm. So with all this in mind, I made the transition from traditional oil paint to the world of digital paint. I still oil paint but virtually all of my commercial work is

Color Wizard: My first Photoshop book cover, and a subtle dig at modern art.

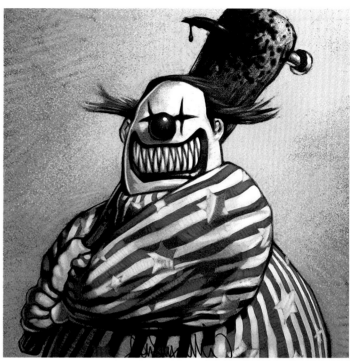

Grinning Clown: Clowns are always a bit creepy. I did this as a demonstration.

now digital. It is interesting that I use the computer to design and color comp my traditional oil paintings. The transition did not mean though that I would change my chosen subject and I still enjoy painting the human figure more than anything else.

The painting process
For many artists, the painting process is kind of an evolution. You start with an idea. Some ideas are definitely more concrete and better than others. As you begin painting, your idea evolves, develops, and often mutate into something that is similar but different from the original. You find yourself having to make adjustments to the painting because of this. Sometimes the adjustments have to be because the artist just does not have the skill to successfully execute what his mind originally envisioned. Sometimes the artist will view any new idea as a brilliant stroke of genius and jump whole

heartedly into perusing it. The painting process is usually very fluid, and there is room for these changes. Occasionally the new ideas will lead to dead ends but every so often the ideas will work and improve the image. It is all a very normal part of the creative process and rarely will the finished painting look like the original vision. It can also be a rather frustrating process.

Pencils to pixels
Many of my digital paintings begin as sketches from one of my sketch books. In fact, my first forays into the digital painting realm were based on pencil sketches. There is something very organic about drawing with a pencil on paper and many times my sketches tend to be very loose and leave lots of room for experimentation. I simply love drawing in sketchbooks. My favorite pencils are black Prismacolor pencils and Stabilo 8046 marking pencils.

These pencils make it almost impossible to erase so as a result, I don't use an eraser. I love to draw on heavy 110lb cover stock with about 20 pages placed in a clipboard. Truth be known, I will draw on just about anything at hand. I carry a sketchbook with me everywhere. Most of my digital painting is done using Corel Painter. I would guess that I use Painter for about 85% of my work. I use Photoshop for maybe 13% of the rest of my painting tasks and I use a few other programs occasionally. The programs I will use once in awhile are: Art Rage—a very inexpensive yet very capable painting program with what I consider to be the best digital pencil of any program as well as some absolutely fantastic digital oil paint; Twisted Brush—which is about mid range in cost and really kind of quirky in its interface; and ZBrush which is mainly a 3D tool, but I still find uses for it in some of my 2D work.

Hardware setup
The most important thing about my computer setup is that I use dual monitors. I could not go back to a single monitor. My monitors are Samsung 245bw models. These are 24-inch LCD monitors, and I love them. They have great contrast and very clear colors. They have good color controls, and I keep them calibrated using a Spyder Pro software and hardware. I also use a Wacom Intuos III 6 x 8 tablet. Everything else is pretty standard. I have a Dell workstation with lots of memory, hard drive space, and dual processors.

Teaching
I currently teach senior level Illustration courses, traditional head painting, figure drawing, and digital painting for the Department of Visual Design at Brigham Young University. I also teach figure drawing at Utah Valley University and have authored several digital painting tutorial books.

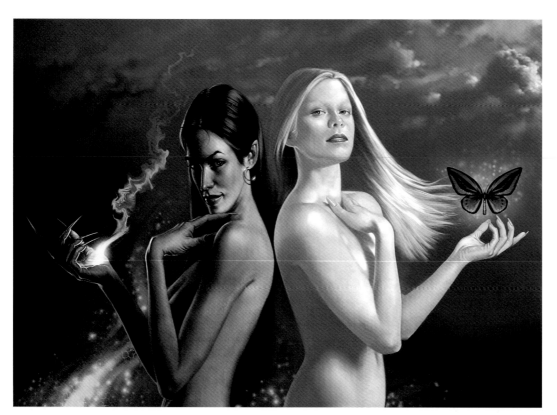

Heaven and Hell
This image was done for an online art contest years ago where the theme was Heaven and Hell. I was fortunate to win the contest. This piece has been stolen and abused more than any other that I have ever done. The same model was used for both girls.
[left]

Laurie
Another painting done for pleasure. I was trying to simulate the look of traditional oil paint. This painting merges my two favorite subjects—fabric and flesh.
[right]

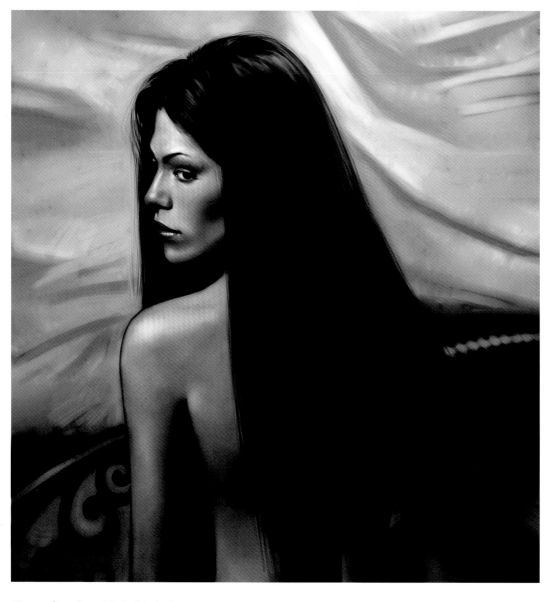

Profile
This painting was done in Photoshop as a tutorial about painting hair.
[left]

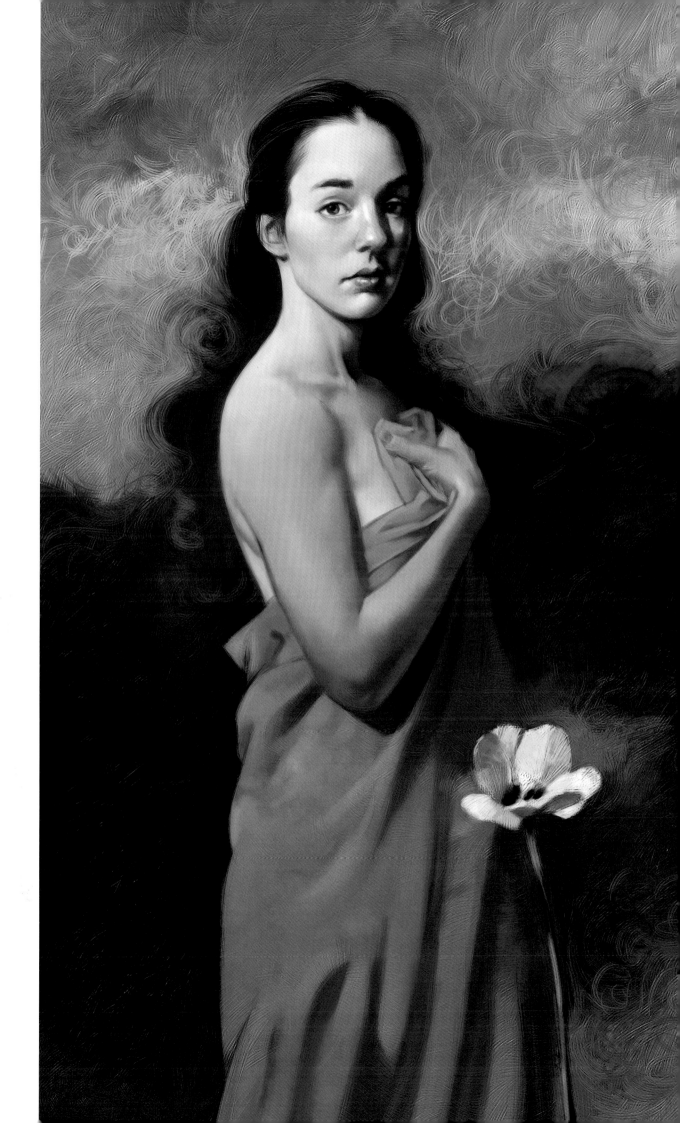

Blue Hunchback
A painting created for Corel Corporation for the release of Painter 8.
[top]

Dragon Lair
A Photoshop painting done from a sketch for a tutorial in my 'Digital Character Painting Using Photoshop CS3' book.
[above]

The Professor
A cropped version of one of the tutorials in my last Photoshop book. The original idea was a silly graduate student scientist who had accidentally created the ultimate death ray.
[top]

Critter in a tree
Promotional and tutorial piece done
for the promotion of Painter 6.

Chupacabara
Painting done in Photoshop for another tutorial in my 'Digital Character Painting Using Photoshop CS3' book.
[left]

Koma
A character concept for a comic book that never panned out.
[right]

Desolation
This painting was done as I demonstrated in Corel's booth at the 2006 SIGGRAPH convention. It was about three hours of painting along with a lot of talking to people wandering by.
[left]

CHARACTER DESIGN: THE GREEN MEANY

Inspiration

There is usually some sort of story behind most of my sketches, but sometimes I can't remember what the inspiration was at that moment. There is a bit of story behind the painting in this tutorial, and I do actually remember it. This sketch was done in October 2006. When the season approaches Halloween my sketchbooks take on a decidedly ghoulish theme. This painting was done at SIGGRAPH San Diego in early August, 2007. I was with the Corel Painter team doing demonstration paintings in their booth. I actually really enjoy doing the demo paintings and talking with the people walking by all day. Anyway, I generally try to do something a little different each day so it attracts a different audience and at least doesn't look like I only know how to paint one subject. I will usually take a number of scanned sketches to use if I don't have a brilliant flash of inspiration when the day begins. This day was monster day.

Tools

Many of my digital paintings begin as sketches from one of my sketch books. My first forays into the digital painting realm were based on pencil sketches. There is something very organic about drawing with a pencil on paper, and often my sketches tend to be very loose and leave lots of room for experimentation. I simply love drawing in sketchbooks. My favorite pencils are black Prismacolor® pencils and Stabilo® 8046 marking pencils. These pencils make it almost impossible to erase so therefore I don't use an eraser. I love to draw on heavy 110lb cover stock with about 20 pages placed in a clipboard though I will draw on just about anything at hand. I carry a sketchbook with me everywhere. The following demonstration was painted from a sketch. Most of my digital painting is done using Corel Painter. In this case, I was using Painter X. I would guess that I use Painter for about 85% of my work, Photoshop for maybe 13% of the rest of my painting tasks, and I use a few other programs occasionally. The programs I will use once in a while are: Art Rage—an inexpensive yet capable painting program. It has what I consider to be the best digital pencil of any program as well as some absolutely fantastic digital oil paint; Twisted Brush—a mid range app with a quirky interface; and ZBrush—though mainly a 3D tool, I still find uses for it in my 2D work.

Method

This particular painting is pretty controlled in that I did start with a sketch as the foundation and should be pretty easy to follow. When painting digitally without a sketch to work from the process is a lot more convoluted and sometimes pretty messy. Messy in the sense that often I will change my mind, back up to an earlier saved version of the painting, and head another direction.

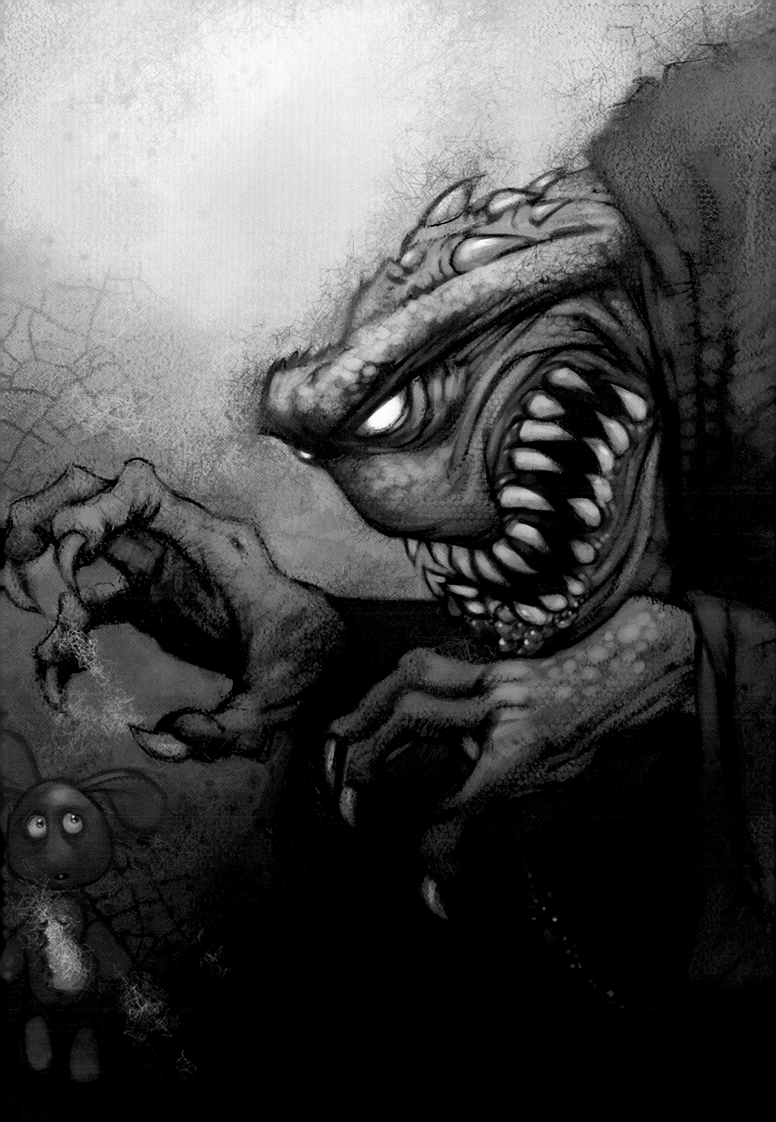

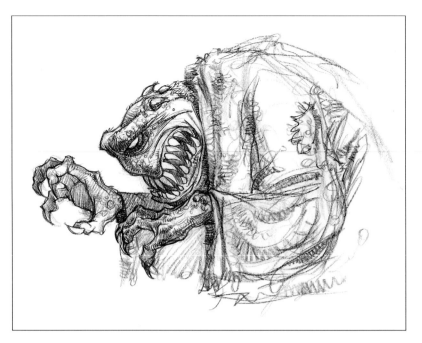

Original sketch

The original sketch is scanned at 300dpi and saved as a TIFF file. I generally scan in color because the paper I am drawing on will often have small colored speckles or is actually a color itself. I scan at 300dpi to get an image that will print 100% of the original size. I find that the full-sized sketch is usually a bit too large to comfortably paint on so I will reduce its size a bit. I never reduce it more than half the original scan size and generally find that two thirds to three quarters is a good starting place. Another reason to reduce the size is simply a matter of speed. It is much easier to quickly block in the initial colors of a painting on a smaller image than on a large one. As I paint the piece, I will gradually increase the size of the painting until the final details are painted on an image that is pretty close to the original dimensions.

Blocking in colors

I save the original using Painter X's Iterative Save feature (Ctrl + Alt + S), which saves a new version with a numeric suffix. I don't have a particular method to begin every painting. One thing that holds true is that I am trying to establish both the colors and values of a particular painting as early as possible. I try to stick to these initial decisions with little variance as I paint. I am quite careful with the initial choices I make. The first step is to decide on a color scheme. Usually, I like to use split complementary color harmonies. The colors that I decided to use were based on what I wanted to do with the character. I knew that I wanted to paint a green character, so I used a brown color as a complement for the costume. The gold background will go well with both the green monster and his rags. The second step is to establish the values of the painting. In this particular piece I decide to make the monster darker than the background. I accomplish the initial block-in of the colors and values by pasting a copy of the sketch layer, then changing the Composite method of the new layer to Multiply. I then create a new layer below the sketch layer to paint the initial colors. I use a custom brush that is about 20% opaque so that my colors will visually blend and mix with each other as the strokes overlay without a lot of fuss or additional work.

Just the color

Here's the same image with the sketch layer hidden. You can see how general the colors are laid down in the painting.

Darkening the background

Looking at the painting I decide to darken the background around the monster a bit more. These decisions are very easy to make at this stage of the painting so go ahead and experiment.

Textures

Once the colors and values are established, I try to add some visual interest to the painting using textures and brushes. One of the strongest benefits of Painter is the ability to integrate either hand-drawn or photographic texture into the painting process. Very complicated effects can be quickly created which would be difficult to paint with a more traditional approach. There is a danger when you begin to use multiple textures and brushes that your image will become a jumble of unrelated visual clutter. Never allow textures or brush strokes to become more important than your subject. My favorite brush to paint texture is the Variable Chalk brush found in the Pastels category. Using this brush and a custom paper texture made from a photograph of some crackle in a ceramic glaze, I paint some cracks around the monster into the background. I use the paper texture to paint the actual cracks and then invert the texture to paint some of the areas between the cracks. There is really no right or wrong amount of texture to paint as long as it does not become the center of interest. You can also vary the scale of the paper texture if you want more variation. Switching to the Variable Splatter brush I paint in some spotty colors over the monster and into the background. This brush is a variant in the Airbrushes category and is a great brush to add distress to any object.

Painting details

Once the colors, values, and some texture are added to the painting it is time to start to add a few details. Details are added carefully though always working from the larger shapes and colors to the smaller and more specific areas of interest. I will usually work from darker colors to lighter colors. This is a carryover from my traditional painting technique in oil paint and, while not necessary in digital media, is a good way to work. I use the Variable Chalk brush in conjunction with the Basic Paper texture. This paper texture gives a nice pastel feel when used with a lighter stroke. Before painting the details I save the image once again. I will almost always save an image before any major change or after a major change. I select both the sketch layer and the colored layer and collapse them together. Eventually, all of the original sketch will be covered.

Getting under a monster's skin

At this stage I select most of the colors to paint with from within the image itself with the exception of the mouth, teeth, and eyes. In this painting I decide on a light source that is from the top and slightly left of center of the image. Every monster needs a nasty skin texture so texture is added using the same chalk brush and a custom paper texture I created to resemble reptile skin. The texture is scaled both smaller and larger to give variation to the skin. I create a new layer upon which the scales will be painted. With the Variable Chalk brush I paint a lot of textures over the skin area. Often, I vary the darkness of the color being used from quite dark in the darker areas of the monster to about a mid value in the lighter areas. I vary the size of the paper to make the scales either larger or smaller where it would make sense on the creature. I make larger scales on the top of the head and smaller scales around the features in the face and on the hands. Unless I am really careful, there will be a number of scales painted into the background or over the rags on the monster. Using the Eraser tool I erase any wayward scales that are not covering an area of skin. I then reduce the opacity of the scale layer to a level so the scales are just visible on the skin.

The scales

The scales add that special something. This is an effect that would be very tedious to paint if you tried to draw each scale.

Fleshing out the rags

It is time to move onto the rags that the monster is wearing. Since an accurate representation of the folds and fabric is not necessary the strokes will be larger and quite loose. All of the colors that will be used in the fabric are selected from within the painting itself and not from the color wheel. This is done for two reasons: it is much faster to select colors from within the painting using the Dropper tool than to go to the color wheel; and by picking colors from within the image you guarantee maintaining a color harmony. The painting is done using the same chalk brush and on the canvas layer. Where the rags are closer to the background, more gold colors are used in the strokes. In the other areas of the rags the colors will be selected from those colors that are closest in either the background or the character itself. Some softening of the background is also accomplished using the same brush and painting lightly with large strokes over some of the background textures.

Hell glow

Overall the painting is coming along quite nicely. The colors are working together well, the values are holding up, and the textures are adding interest without being distracting. It is about time to add some additional details and to brighten a few colors here and there. Switching back to the brush that I was originally using to lay in the color, but now in a much smaller size, some of the outlines of the horns on the creature are redrawn along with some of the creases in the face. I darken the colors in the mouth, and the gums are painted in more detail with brighter colors. It bears mentioning that the Glow brush (in the FX category) is one of my favorite tools in Painter. It is so seductive in its effect that if I am not really careful I really overdo its use. This is definitely a case where less is more. I select a nice saturated red-orange color, and using the Glow brush paint the monster's eyes. A nice glowing red color bleeds out into the surrounding greens while intensifying the yellow in the eye. All of a sudden the monster has a nice "hell glow" from within.

Drawing the viewer's eye

As a general rule, and you will notice it in this painting, the brightest colors are in the face which helps make it the center of interest. It is usually a very good idea to use only a few very saturated and bright colors in any given painting and use them where you want the viewer's eye to be drawn first. The image is feeling a little heavy on its left side to me. Everything interesting is happening on the left, and the right side of the painting is pretty boring except for a few holes in the shirt with some green scaly skin showing through. To remedy this I add some green fins/scales/backbone to the back of the monster. This is done quickly with the same brush that is being used to paint the details in the face. The green helps visually balance the painting and may make the viewer wonder what they are looking at. A few additional refinements are added to the teeth and horns.

Enter the Nervous Pen

I had been standing and painting for about four hours at this point, and my feet were getting tired so I thought I would call this one good. I did want to add just a few touches to finish it off and make it look just a bit grubby. To add these final touches I would use another of my favorite brushes, the Nervous Pen. This is a great brush for making very random and chaotic strokes and will work perfectly to add that bit visual dirt to my monster. With the Nervous Pen brush, I created a new layer, selected colors from the edges of the monster and painted some random and somewhat hairy looking brush strokes around the creature. Finally, I reduced the opacity of the layer so the brush strokes were not too noticeable—but still present.

Just add drool

Finally finished! I stepped back and looked at the monitor thinking I was done, and then it hit me. There is really something else I can do to make it look just a bit better. There is a dangerous saying out there. It goes something like this, "Wouldn't it be cool if...". Most artists do this to themselves when they look at something they have created and then realize that there is just a one more thing that will really make the image come alive. The problem is that there is always one more thing. I decide to add big bubbly drool hanging out of the monster's mouth. If I am going to add drool then I really should also add some highlights to the gums to make them look wet too. It really won't be hard, and I hope it will add that extra something that will elevate the painting above the average. I created a new layer and using only one brush I paint a big bubbly mass around the teeth on the lower jaw with colors from the surrounding gums, skin, and teeth. The drool is a bit harsh so I reduce the opacity of the layer by about 50%. Done! Now the painting is finally done. The drool looks pretty bubbly and gross which goes well with the overall feel of the piece.

Where's the cute?

It has been a fun piece to paint. It is not too labored and maintains a bit of the freshness of the original sketch. Overall, I feel pretty good about the effort. While I am standing around talking to some people that have stopped by the booth one of the Corel people walks over, stands silently, and looks at the painting I have finished being displayed on the monitor behind me. When the people I have been talking to leave, he looks at me and asks a question. The question is this: "How come when digital artists paint they always do monsters, or chicks with swords and hardly any clothing? How come you never do anything cute?" Of course, I said that we often do cute things, and to prove it I said I'd immediately paint something cute. I created a new layer on top of my finished monster painting, and using the same brush that I started with, began to paint something cute.

The cute bunny

I switched brushes only once as I added the cute portion of my painting. When the pink bunny was complete, I changed to the Nervous Pen to paint his stuffing. While I am not sure this is what he had in mind, I had fun painting something cute for a change.

CHARACTER PAINTING: CREEPY GIRL

Inspiration

I started out as a traditional oil painter. My subject was the figure—above anything else the human figure fascinates me. I love the difficulty of capturing the subtlety of the human form and how very different something that we are all so familiar with can look so unfamiliar under different circumstances. This particular painting was a joy because it is one of those infrequent times when I did something just because I wanted to. The painting is based on a reference photo that I took a number of years ago. The model is one of my favorites, and appears in many of my paintings both digital and traditional. When using photo reference it is important to use a photo in the correct manner. It does the artist little good to just copy a photo since the copy will never be as good as the original. I am almost never concerned with likeness unless I am specifically doing a portrait.

Method

This painting is the least technical of my demonstrations. While things like layers, custom brushes, and custom textures were used, the painting process is pretty straight forward and fairly closely imitates how I would work with traditional mediums. When I start a painting like this, there is a danger of me never finishing it. While the final image in this demonstration is finished, I have the tendency to continue to revisit the painting and change things. You may see variations of this piece somewhere down the road with significant changes. Maybe someday I will learn when to say I'm finished. I do have a tendency to lean the whole piece into a bit of a strange direction. I do this even when not purposefully distorting the figure itself. While this is a pretty traditional figure painting, the girl's appearance is not completely conventional.

Tools

The most important thing about my digital painting setup is that I use dual monitors— I could not go back to a single monitor. My monitors are Samsung 245bw models. These are 24-inch LCD monitors—and I love them. They have great contrast and very clear colors. They have good color controls, and I keep them calibrated using a Spyder Pro software and hardware. I also use a Wacom Intuos III 6 x 8 tablet. Everything else is pretty standard. I have a Dell workstation with lots of memory, hard drive space, and dual processors. This painting was done using Painter X. This is my first choice for digital painting. My second choice is Photoshop and beyond that I use a handful of other applications depending on the task at hand, including Ambient Design's Art Rage, Pixarra's Twisted Brush and Pixologic's ZBrush.

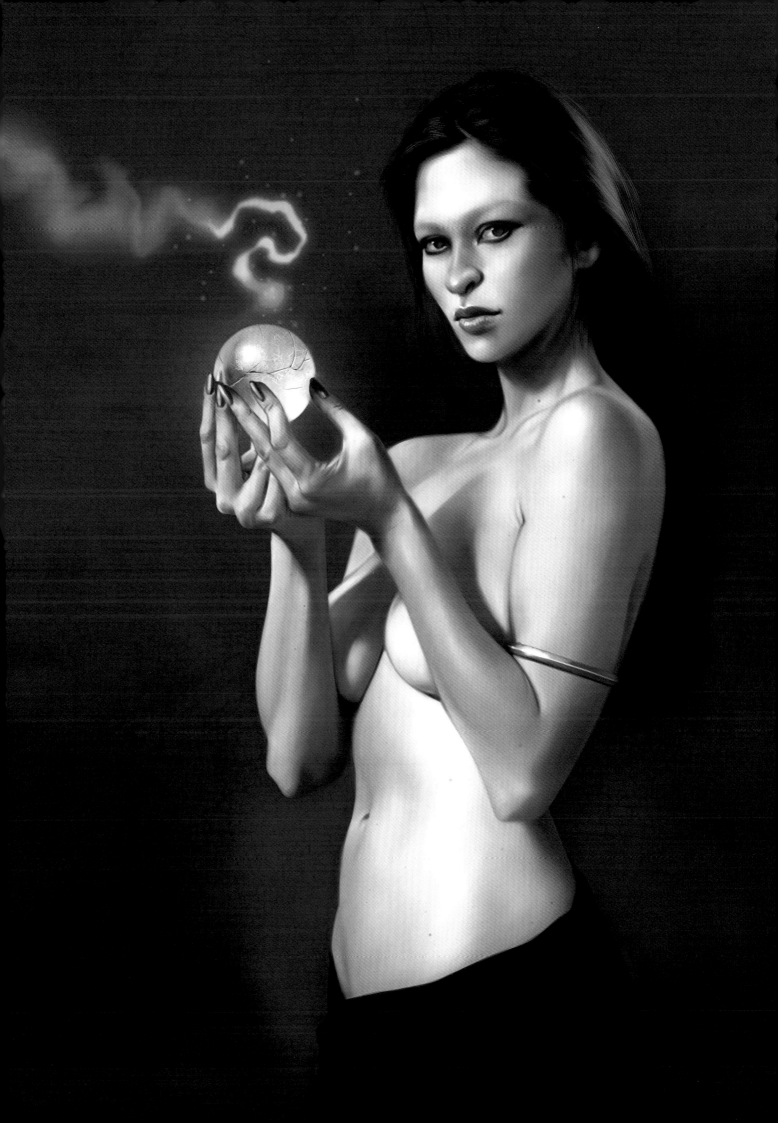

The initial sketch

The first thing I do is start Painter and create a new image. This image started at 1,200 x 1,200 pixels in size. This is small enough to work the initial image out quickly. As I continue to paint, I will increase the size of the painting. In this case, it ended up double the original size at 2,400 x 2,400 pixels. After creating the new image I create a new layer. When the layer is created, I make sure that the 'Pick Up Underlying Color' box is checked. This will make the brush interact with the transparency in a much more predictable way. Unless I am bringing in a scanned drawing, I almost always will start with a sketch. I sketch the figure on the new layer. It is a very quick process, and I am not really concerned with small details. I use a Grainy Pencil variant of the Pencils category and pick a light gray color. As I draw the strokes overlap they become darker.

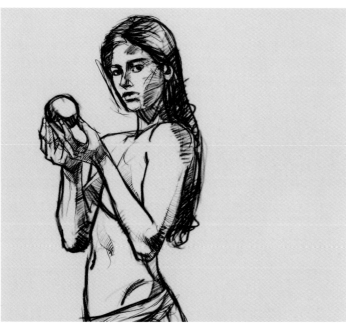

Coloring the background

I never paint on a white background. The reason is that all color will look dark against the white, making it harder for me to judge my values correctly. I tone the background with either a mid-value color or a mid-tone gray. At this point, I fill the background with a mid-gray. Because I am already thinking of what the color scheme for the painting will be, I color the sketch to get rid of the black outline. If I were thinking far enough ahead, I could have just set the color of my pencil. To color the sketch I create a new layer, and fill the layer with a mid-value red color that is not too saturated. I change the Composite method of the filled layer to Colorize, pick the sketch layer, and load a selection based on its transparency. I then invert the selection, select the colored layer, and delete. I now have a colored sketch that will work with the colors I envision.

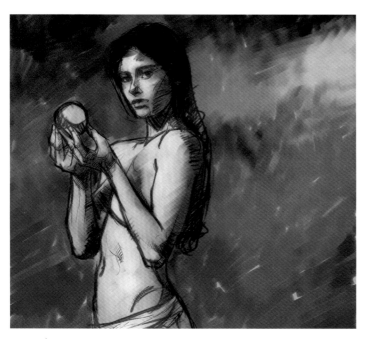

Experimentation

Picking the Variable Chalk variant from the Chalk category, I paint in the background colors. This point is as much experimentation as really knowing where I am heading. I have also changed the Composite method to Gel, Gel Cover, Multiply, or one of several other methods, and lowered its opacity to around 50%. By doing this, the colors of the sketch interact with the background colors helping define a color scheme.

Blending

I drop the sketch layer onto the canvas. Picking the Grainy Water brush variant from the Blenders category, I smudge and mix all the colors on the background. The Grain Water brush is probably my favorite blending brush in Painter. It interacts nicely with whatever paper texture is active and when set to a lower opacity will not obliterate the original drawing. Blending the colors helps me evaluate the overall look and feel of the painting.

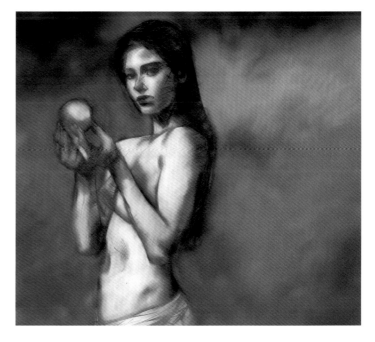

Red eye

I use the Variable Chalk brush to add color, and the Grainy Water brush to blend those colors as I continue to paint the figure. It is at this point that I decide to give her red eyes. Nope, I can't explain that decision. It just seemed like the right thing to do. Most of the original sketch is pretty much covered at this time.

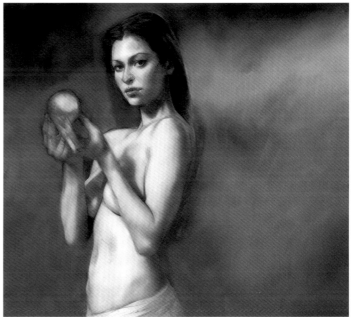

Major change

Here is one of those major changes I was talking about. I decide that the composition of the painting will be stronger if I move the figure to the right side of the image. It is a simple matter of making a selection around the figure, copying the selection, and pasting the figure back onto the canvas. I use the Layer Adjuster tool to move the figure into position. I have made a major change to the face by narrowing the chin. I make the eyes much redder. Much of the painting is being done with a custom brush I created simply called "Don's Brush". It is a very good brush at painting a lot of color very quickly.

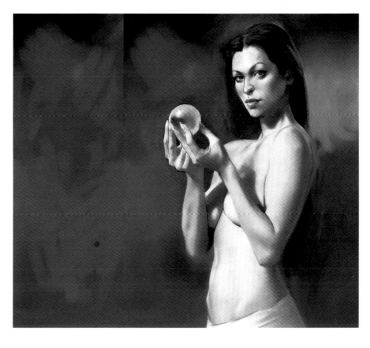

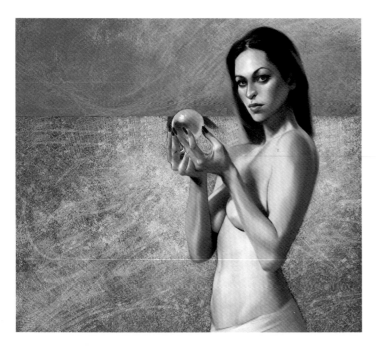

Texturing the background

I change my mind once again and make a major change by deciding that the background would look better if covered by texture. I create a new layer and cover it with textures created using custom paper textures and custom brushes. I also think that the composition would be stronger if I break the vertical flow of the painting by creating a horizontal edge at about chin height in the figure.

Texture detail

Here, you can see a close-up of some of the textures in the background.

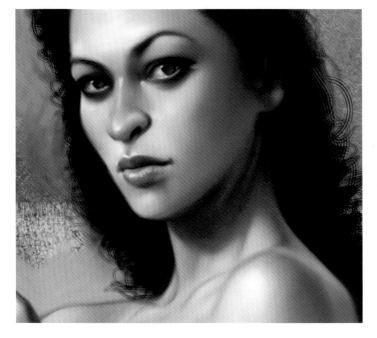

The complexion

At this point, I have decided how I want the figure to look. I want to paint a very pale complexion but use lots of different colors in the skin tones. I switch to a variant of the Opaque Round brush that is found in the Oils category. I have customized the brush so it blends the existing colors with the picked color a bit more than the default brush does. I paint with the brush at a low opacity of 20 to 30%. I like the brush because it uses lots of small bristles which paint somewhat like a traditional brush.

Redhead

The figure is nearing finished at this point while the background is still very rough. While painting the figure, I will also paint a small area into the background to help me control the edges where the two meet. I have also decided to make her a curly redhead and begin painting the hair using the Scratchboard Rake variant found in the Pens category of brushes.

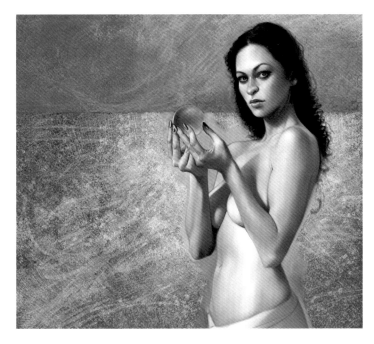

Working in the details

I experiment with the length and size of the hair as well as how bright to make it. I don't want it so bright that it competes with the red eyes. I create a new layer and experiment with the color of the skirt and add a belt. I paint the crystal ball with complementary colors to contrast the red in the figure. For just a bit of interest, I add the bracelet on the arm. All of this painting is done using the Opaque Round brush, and variants based on it.

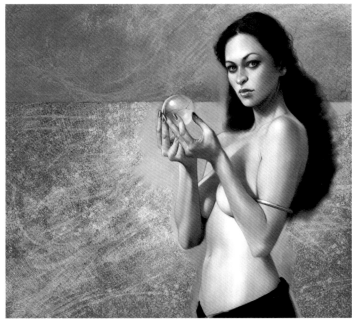

Simplifying the background

I continue to change my mind and decide that all the texture in the background is competing with the figure. I just decide to paint it out though and keep the horizontal division of the picture plane intact. The figure is finished at this time, but the hair still has a lot of work to go.

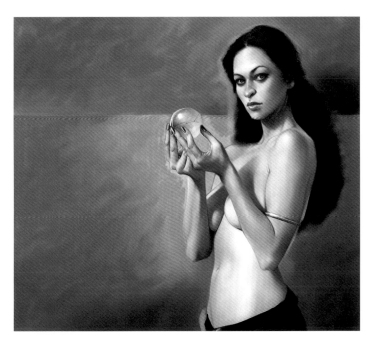

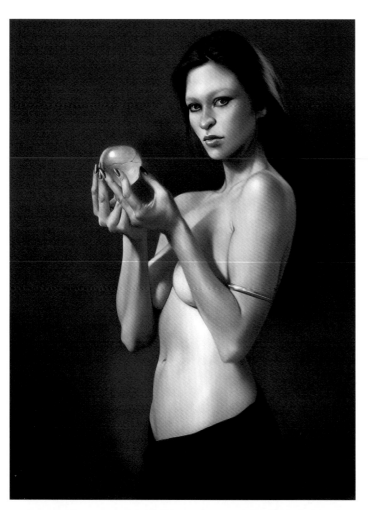

Hair straightening

I am now in the finishing stages of the painting. After wandering a bit trying to figure out where to go with the image I have settled into the final composition. I have decided to keep the figure front and center by darkening the background significantly. This also will make it possible for me to add a lighting effect to the crystal she is holding. The curly hair was going nowhere so I repaint it straight. I still want it red but not nearly as intense as earlier experiments. I paint some of the reflected light that is hitting the shoulder into the hair. When the major masses of the hair are painted, I create a new layer and add a few wispy strands. I decide to leave the skirt red, but remove the belt. It was not adding anything to the painting, and was becoming a distraction. Finishing touches are made to the figure. Removing the eyebrows was a passing thought, but added strangeness to the figure that I liked. You should notice that I have used a lot of the darker red color from the hair in the background. This is intentional and helps unify the figure with the background. The painting is finished except for painting the crystal that she is holding.

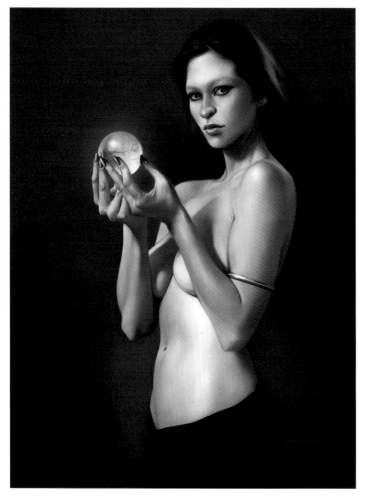

Crystal ball gazing

I finish painting the crystal ball using the Opaque Round brush and a touch of Nervous Pen. The Nervous Pen is used to add some imperfections to the interior of the crystal like you often see in a natural crystal. While I like the tone of the background, it is just a bit boring. To make the background more interesting, I create a new layer and fill the layer with a crackle pattern. I then change the Composite method of the filled layer to Gel Cover and reduce the opacity of the layer until the pattern is just barely visible. Using the Glow brush I add a small twinkle to the bracelet. On a new layer, I add a few subtle freckles to the figures skin.

Flames and smoke

Some colored smoke is added coming off the crystal to add to the sense of fantasy. The smoke and flame are easily created by first creating a new layer for the blue-green flame. A small curving flame is then painted from yellow near the crystal to blue at the far end using the Digital Airbrush in a smaller size. I blur the flame using the Soften effect found in the Effects/Focus menu, then switch to the Turbulence brush (in the Distortion category) to twist and twirl the flame giving it a nice random appearance. I duplicate the flame layer and blur the bottom flame so it appears as a glow for the top flame. The smoke is painted in much the same way as the flames. Finally, I add a few sparkles around the crystal ball using the Variable Spatter airbrush.

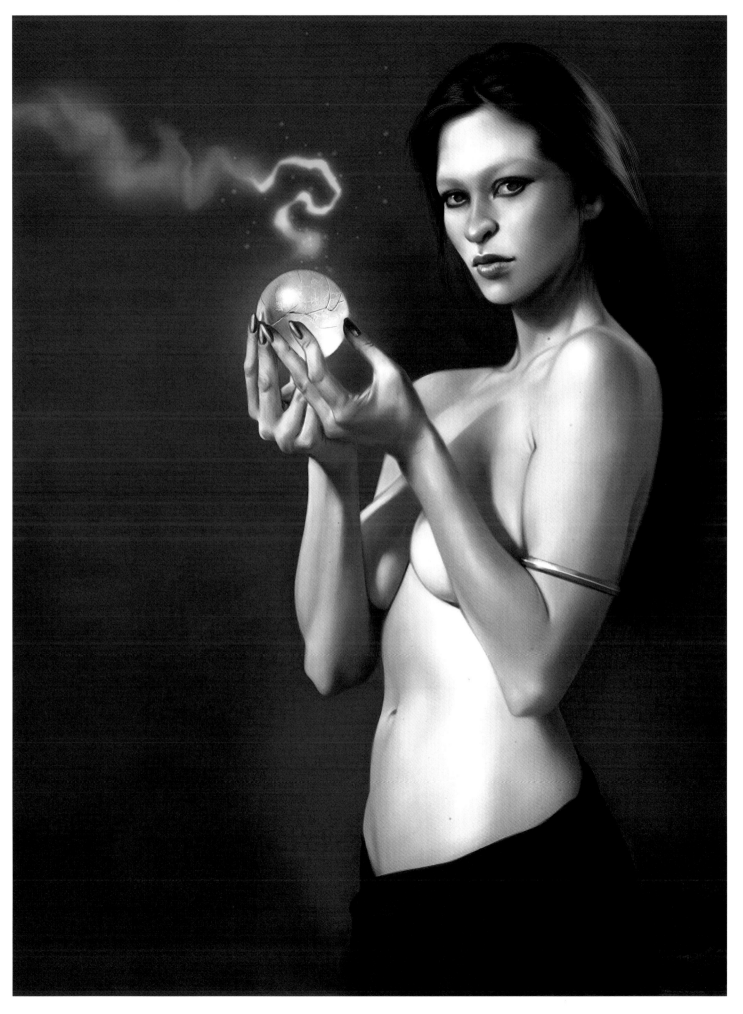

CREATURE PAINTING: THE WINGED BEASTIE

Inspiration

This painting was done as a video demonstration for my 'Monster Painting' workshop for CGSociety's CGWorkshops. The focus was to show how to paint a translucent wing, so what better way than to show a monster with the moon behind his upraised wing. Once I finished showing how the main subject was painted, I ended the video and shelved the painting. A few months after the end of the workshop I was cleaning out some junk on the hard drive and found the painting. I thought that it maybe had potential to develop further. This tutorial is the result.

Method

For many artists, the painting process is kind of an evolution. You start with an idea. Some ideas are definitely more concrete and better than others. As you begin painting, your idea evolves, develops, and often mutates into something that is similar, but different from the original. You find yourself having to make adjustments to the painting because

of this. Sometimes the adjustments have to be because the artist just does not have the skill to successfully execute what his mind originally envisioned. Sometimes the artist will view any new idea as a brilliant stroke of genius and jump whole-heartedly into persuing it. The painting process is usually very fluid, and there is room for these changes. Occasionally, the new ideas will lead to dead ends, but every so often the ideas will work and improve the image. It is all a very normal part of the creative process, and rarely will the finished painting look like the original vision. It can also be a rather frustrating process. In many ways, this tutorial shows exactly the kind of changes and side ideas that may arise. Unlike my other demonstrations, this painting did not start with a sketch. This time I really had only a vague idea of where I was heading knowing only that I needed a pair of wings with a moon behind them. This painting was done mainly in Painter X though I do jump back and forth between Painter and Photoshop.

The brushes

In this tutorial I use multiple brushes. Several of them are custom brushes that I have created, and the rest are default brushes that ship with Painter. The default Painter brushes that I use are: the Scratchboard Tool variant (in the Pens category); Variable Chalk variant (in the Pastels category); Variable Splatter variant (in the Airbrush category); Grainy Water 30 variant (in the Blenders category); and the Glow variant (in the F-X category). The custom brush that I use for most of the work is made from the Fine Tip variant (Felt Pens category). To create a brush that will work in a similar fashion to the one that I am using just change the Method of the brush to Cover and the Subcategory to Soft Cover. While I have done some additional tweaking to get the brush to behave just like I want, these simple changes to the default Fine Tip brush will give similar results. Most of the paper textures are custom-made, so you will have to find substitutes. I do hope this example is clear enough that if you want to follow along you will be able to.

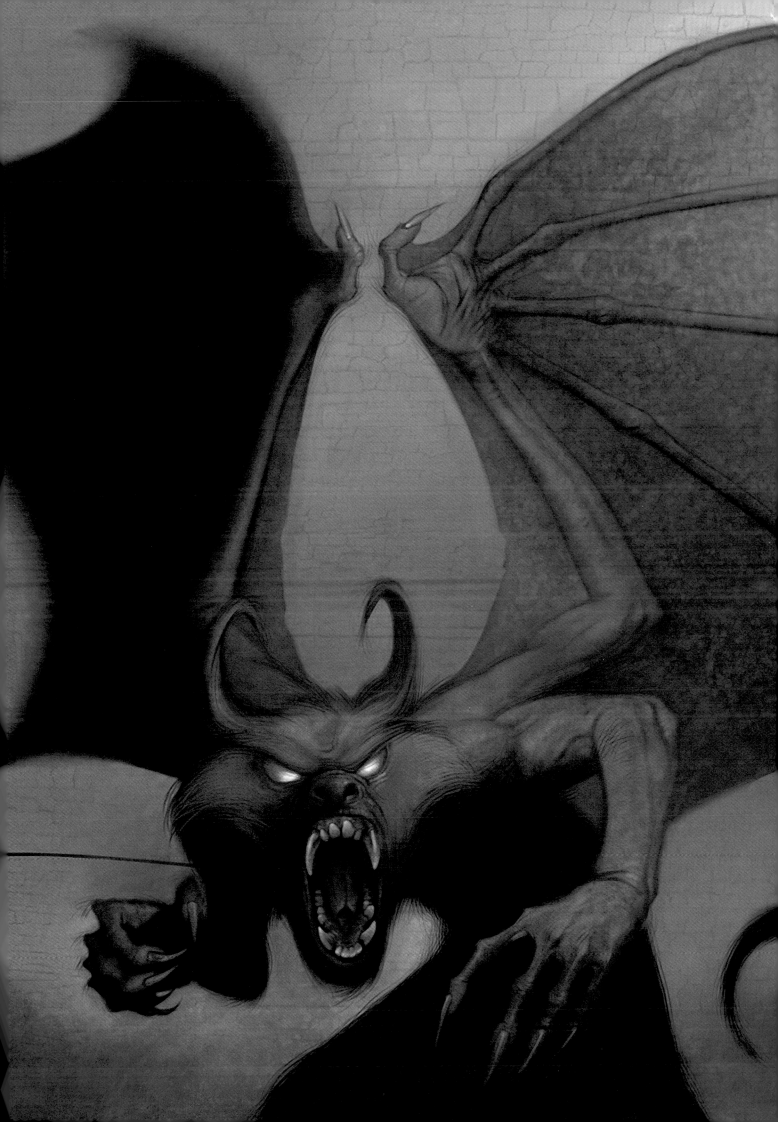

Starting out

Because there is not a preliminary sketch to be used for the monster, the initial drawing will be done on a new layer. The main shapes of the monster are quickly painted using my custom brush—designed to paint with large shapes very quickly. The opacity of the brush is set to about 20%. I choose colors that are somewhat complementary to the background. I use the Eraser brush as much as the regular brush to help draw the shapes. The brush size is varied as I paint using the Ctrl+Alt keys and the Alt key to pick different colors. Getting into the habit of using keyboard combinations to perform simple tasks can greatly speed up the painting process. Soon, I get a pretty definite idea of the character. I don't try to get too much detail into this stage of the painting as things need to be kept fluid and easy to change. There is a definite tendency to not want to correct problems in a painting if too much time has been spent working in any particular area. For some reason, we fall in love with our work—even if it is wrong.

Duplicate layers

Notice how loosely the one hand is indicated at this early stage. A bit more work has been put into the face and closest hand as these areas will be the center of interest. The creature is sketched slightly hunched over to give more room for the wings. No portion of the painting is so finished that I would hesitate to move it or even erase and start over. I am always looking for ways to save myself work when I make mistakes. One of the ways I do this is to create duplicate layers in the very early stages of a painting to work with instead of painting on the original layer. This of course depends on the original layer being good enough. I duplicate the layer on which the very rough monster shapes have been painted and make several duplicates. Using the same brushes that I used in the original sketch, but in smaller sizes, I try to refine the forms in the monster. Each layer is drawn slightly different. I also decide at this point the direction of the light entering the scene.

Photoshop's Liquify filter

I move the image into Photoshop for one of my favorite techniques—Liquify. I use this filter to take my sketch or painting and try different distortions that will change the look. Sometimes I am able to create a variant image that is completely different from what I originally started. Starting with a duplicate layer, the Liquify window opens with a number of different options. I like to keep this part of the process pretty quick and generally only change the Brush Pressure, Brush Rate, and Brush size. I don't use any masks, and I use the Forward Warp Tool for about 90% of the work. With my stylus, I quickly distort and move different areas of the monster painting. The majority of the changes are concentrated around the face and hands. When I have made a few changes, I exit the filter and make the duplicate layer visible and invisible quickly to reveal the changes. I continue making duplicates of the painting and try further Liquify distortions. The Liquify filter is a great way to see what variations may work better than the original drawing.

Liquify variations

I create variations on each of the duplicate layers. The best layer is selected, and I delete the others. As you can see, the Liquify filter is a very powerful tool and can be used to create a multitude of variations to the original theme. I use it extensively when doing character design and concept work. The problem with the Liquify filter is that it is fun. It can burn a lot of time very quickly if you are not careful. I move the painting back into Painter. I create a new layer and using the Variable Chalk brush I add some color roughly into the background. The goal with this background block-in is only to establish the colors that will be used during the development of the rest of the painting. I create another layer and using the same brush, but changing the paper texture to one that looks like cracked mud, I add some texture over the creature's wing. This is simply an experiment to see whether this paper texture will simulate the veins and folds that might be visible in a wing membrane stretched tightly.

Expanding the value range

I often find that I paint the values a bit closer together than I would like, and sometimes the color saturation is not as rich as I'd like. If this happens there are a number of different methods that can be used to both increase the saturation and expand the value range of the image. I select the entire image and copy and paste it into a new layer. I then change the new layer's Composite method to either Gel or Multiply. The entire image becomes very dark so the opacity of the top layer is reduced. The amount of reduction depends entirely on the individual painting. Somewhere around 50% opacity is a good starting point. All the colors in the painting are now much richer, and the whole thing is a bit darker. I use the Eraser brush to carefully clear away some of the top layer in the light areas revealing the original layer. The areas of the original layer that are visible are lighter than the combination of the multiply and original layers. This is a great way to lighten any areas that might have gone too dark.

Moonlight

It is time to try to make the monster's wing look translucent. I create a circular selection on a new layer and fill it with a lighter green than the background. I duplicate the moon layer twice and use the Soften filter from the Effects menu on the top layer with a default setting of 3 and change the opacity of the layer to 40-50%. Moving down to the next layer I change its Composite method to Screen. I use the Soften effect again with an amount of 10-15 and set the layer opacity to 50%. For the bottom moon layer I change the Composite method to Luminosity and use the Soften effect at 30-40. I change the opacity of the layer to about 50%. You would expect that a bright moon would shine some moonlight onto the monster so I add some rim light to the wing areas on a new layer. The lighting effects are painted stronger where it is closer to the moon. Some splotches are added to the wings on a new layer using the Variable Splatter airbrush. Any wayward splatters outside the wing are simply erased.

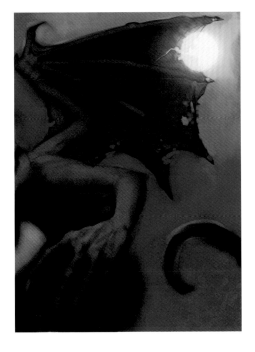

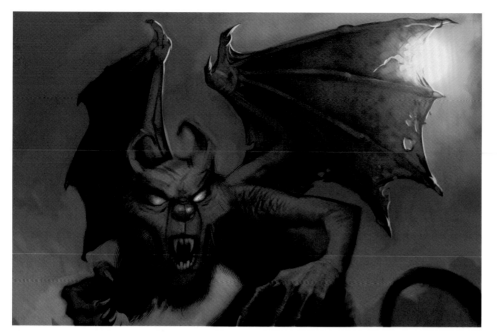

Detailing the face

Since the creature's face is really going to be the center of interest, it is where most of my effort will be spent. If too much attention is given to the face or any other area in a painting, there is a chance that I will not be able to create a consistent look and feel to the rest of the image. Using my original custom brush, I add detail to the face and hand. The brush is set to a small size and an opacity of 20%. Controlling the contours is much easier when you use both foreground and background colors. I decide that I like the look of fur painted with the Scratchboard tool and use it to add fur to the face. The left hand is too large so I use the Free Transform command to scale the hand layer down to a more acceptable size. The Free Transform command is found in the Effects menu under Orientation. A few, rough mountain shapes are painted behind the monster using a combination of brushes including Variable Chalk and my custom brush. I also add some glow to the eyes.

Bigger wings

This was the point I finished the painting for the CGWorkshop. A couple of months ago while cleaning out some junk files I came across my monster again. As with most of my drawings and paintings, absence does not make the heart grow fonder and I will frequently see ways to improve a piece. Sometimes it is not worth the effort to rework a painting, and sometimes it is. I liked this painting enough that it is worth a second look. The first thing that I wanted to change was the size of the wings. They feel very cramped in the picture plane, and they are too small. A bit of experimentation is in order to find a more suitable size. I take the image into Painter and do some quick adjustments to see whether I can find a size that works better visually. In the Canvas menu I select Canvas size. In the options box I double the size of the canvas at the top of the image. Selecting the wings using the Lasso tool I copy and paste several copies onto new layers. With the Layer Adjuster I move the wing layers on top of each other to see if taller wings would look good.

Refining the wings

Making the wings taller improves the image. I drop all the wing layers and using my custom brush I paint them together into a cleaner shape. Not only are they taller, but I make them wider. Just as I would begin a painting, the initial resizing of the wings is very quick and meant to just find the correct size and placement. There is no worry about any detail at this time.

Wing widening

The wings are definitely looking better, but I feel they are too narrow. The left wing is receding and can be left thin but the right needs to be wider to balance the character. Once again I use the Canvas Size menu item but add space only to the right of the image. When you add additional canvas space to any painting the new space is the original canvas color. I will use a combination of copying and pasting from other background areas and painting to cover this empty space. With the background filled I add width to the wing. While I could copy, paste, and transform the original wing in a horizontal dimension to gain width, I find it generally easier to just quickly paint in a new shape. In some cases, I will do this on a new layer and sometimes just on the canvas. In addition to widening the wing, I draw in a hand with the fingers forming the struts of the wing. Unfortunately, the hand is huge in this initial attempt.

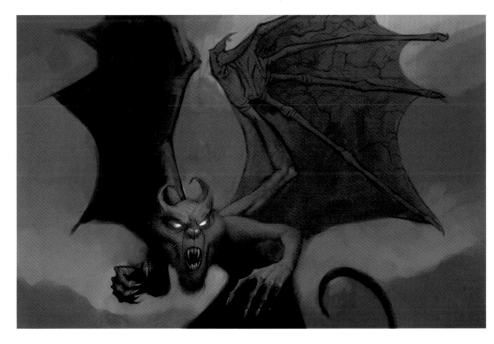

Texturing the wings

This is still experimental, but I am heading in the right direction. I select the hand and a bit of the surrounding wing, and using the Free Transform effect scale it down to a reasonable size. I create a new layer and using the Variable Chalk brush and custom paper textures I paint texture into the wing and shoulder areas to imitate the look of leathery skin. Usually, I paint with a color that is lighter than the surface I am painting. In this case, that would mean that I use various light brown and orange colors. I will then invert the paper texture and paint with colors that are darker than the object. These darker strokes will paint in the areas between the lighter strokes. Lots of variation in the surface as well as depth to the textures can be created in this manner. I use the Effects/Soften command to slightly blur the textures over the wing giving the painted flesh a more realistic appearance. Finally, I adjust the Opacity of the layer. A subtle amount of texture is often very convincing at imitating the look of flesh.

Grainy water brush

My favorite blending tool in Painter is the Grainy Water brush found in the Blenders category. I like this brush because it interacts with the paper grain as it blends the colors in the image. By changing the paper texture as you blend, some subtle and very attractive surfaces can be created. I find that using the brush at a lower opacity setting of around 25% gives me the best results. Using the Grainy Water brush and the Regular Fine paper texture I blend out the ragged strokes in the background of the painting.

Bringing back the texture

I love using texture in my work and generally don't need an excuse to add more. The previous step removed the ragged strokes, but also blended almost all of the texture away. I want to add some back. I use the same blending brush, but change my paper texture to Pavement (a default paper texture that ships with Painter). I blend the image again. Where different values meet at edges in the image the Pavement texture appears as I brush.

A scarier face

The right elbow of the monster is too low making the arm appear short and stubby. I select the right arm from the shoulder to the wrist and rotate it until the elbow is higher and the forearm is longer. A new and muscular arm is painted giving better proportions to the figure. The arm in the wing is also painted with the same muscular feel. The mouth and nose don't look too frightening, so I repaint them making the tongue forked. Using my custom brush in smaller sizes and with opacities varying from 40-70% I paint a new mouth. I try to show lots of teeth. By painting the mouth so large I have to shrink the nose, but this is not a problem. The mouth is painted to 95%—I normally don't finish a single area this much ahead of the rest of the painting, but I want to make sure this mouth works. I start to clean up the edges of the monster, wings, and background using blending brushes along with my normal custom brush. I define the edges by painting both the background and foreground at the same time.

Lighten up

The painting has gotten too dark, so using the Contrast/Brightness adjuster (Effects menu > Tonal Control) I increase the brightness of the image and decrease the contrast. One of the results of increasing the brightness and reducing the contrast is that I can see how uneven the colors are in the darker areas. Sometimes if the image is too dark to see these uneven areas, the image will be printed and the darks will look really spotty. I will fix these as the painting progresses. I clean up the edges of the wings. I want to begin adding detail into the wing on the right side of the painting. I am not concerned with the wing on the left because it is in shadow and will stay dark. I create a new layer, and large veins are painted over the right wing. The painted veins are blurred using the Soften effect. The opacity is reduced until the veins fit visually on the wing.

Composite methods

The vein layer is not dropped onto the wing because additional textures are going to be added. I want the ability to change where the veins are placed in a stack of layers. I also want to change both the Composite method and Opacity of vein layer if needed. Several new layers are created to add more texture to the wings. Using the Variable Chalk brush, some custom paper libraries, and the Variable Splatter brush, I paint texture onto the new layers. Once the layers are painted, I change the Composite method of each layer to see the overall effect. The most used methods are Soft Light, Hard Light, Screen, Overlay, and Gel Cover. There is no formula to use every time you arrange multiple layers trying to build up textural effects. Eventually, you will become familiar with the changes that each Composite method makes when applied to a layer. For the beginning artist, I would recommend that you limit the number of layers being used to simplify the whole process.

Seeing the light

I want to bring back the moon in the upper right corner of the image. While I have mainly been painting and working on the monster the moon has been lost. The background has become relatively even in value. The sense of light coming from the upper right is gone. I need to re-establish the light in the top right of the painting. An easy way to start to add back the light is to use the Apply Lighting effect. This effect is found in the Effects/Surface Control menu. When the effect is selected the options box appears and you can control virtually any aspect of the lighting effect. You can scroll through the default lighting schemes to see what is available. As each scheme is clicked, the preview image is updated showing the resulting effect. The small bars with circles on each end are used to adjust the position or each light in the selected scheme. The larger of the circles is used to move the light and the smaller is used to change the light direction.

Splashy Colors

I select the third lighting scheme from the Apply Lighting dialog called Splashy Colors. I move the lights slightly down and toward the corners. An additional yellow light is added by clicking in the preview window. I change the new lights direction so it is coming into the painting from the lower right corner. If you accidently add a light, you can remove it by using the backspace key. Finally I apply the effect. Because the dialog preview is so small, it is hard to accurately gauge the full effect, and sometimes it is not quite what I anticipate. In most cases, it is too intense and tends to burn out some of the light details in my painting. Instead of using Undo and going back to the Apply Lighting effect to try again I usually use the Fade command in the Edit menu to soften the lighting effect. Using the Fade command I soften the effect by 50%.

Showing movement

I want to add a little bit of movement to the painting to give the illusion that the monster is turning quickly toward the viewer. To get the effect I add a bit of motion blur to the left wing. I make a rough selection around the entire left wing and Copy/Paste In Place the entire wing. In the Effects/Focus menu I select Motion Blur. I move the Angle slider until the blur appears to be coming in a roughly horizontal direction. I move the other sliders as needed to set the width of the effect. When I am satisfied with the effect, I apply it to the wing layer. Using the Eraser I carefully erase the blurred layer on the right side of the wing layer. This erasing helps strengthen the illusion that the motion is just starting. Essentially, I am trying to show that a small amount of quick motion at the leading edge of the arm translates into a lot of motion at the wing's trailing edge.

Moving out of the graveyard

I decide that the graveyard idea is stupid and paint out the sketched headstones. I still want to add the moon back into the upper right corner of the painting, and need to change the colors in the wing to begin the process. I create a new layer and change its Composite method to Overlay. Using the Digital Airbrush I paint a large and roughly circular area on the new layer in a light green color. Using the Focus effect I blur the corner. I use a large amount of Soften to really spread the painted corner into the wings.

More mountains

I am now into the finishing portion of the painting process. Hopefully, this is where all the ideas and changes of direction come together to produce a good painting. Using the Scratchboard tool I paint the fur and some hairy knuckles on the monster. I finish painting sharp fingernails on the hands. For the most part, the monster is finished at this point. Moving into the background and using the Variable Chalk brush I decide to add more mountains in the background. I rough in the shapes quickly leaning them in slightly to draw the viewer's attention to the monster. I pull some of the textures I am painting in the mountains up into the sky for added visual interest. Using the same process I described earlier in the demonstration to add the moon to the painting, I add a new one in the upper right corner.

Unsmoothing

I continue to paint the mountains but resist the temptation to add too much detail which would detract from the monster. One of my biggest complaints about digital art is that it is too smooth and finished sometimes. I think that this image is generally too smooth. To add a bit of roughness to the image is not hard and easy to control. I create a new layer. The new layer is filled with a pattern. In this case, the pattern is custom made from a photograph of some rough concrete. The Composite method of the layer is changed to Gel and the opacity is lowered to a point where the texture is just barely visible. Using the Eraser I erase different areas of the texture including large sections of the sky where the moon is painted, and the mouth and nose area of the creature.

Crackle patterns

I am now down to the final touches to finish off the image. For some reason, I have a fondness for crackle patterns. I will often add them to a painting at the very end to simulate a cracked paint surface or glaze. I can't resist doing the same to this piece. I create a new layer above the canvas. This new layer is filled with one of the many crackle patterns I have created over the years. All of the patterns that I create are seamless. Seamless means that the edges of the image are retouched so they will merge into each other without a visible edge. The crackle layer is changed from the default Composite method to Multiply. The Opacity of the layer is lowered until the texture is visible, but not too distracting to the entire image. The brightness and contrast of the texture layer are adjusted to fine-tune the effect.

Finishing touches

The moon feels a bit lopsided, and I want to even it up. It is very easy to do by simply adding another round moon layer. I create a new layer and make a round selection. I fill the selection with the light green color of the moon, change the Composite method of the moon to Overlay and adjust the Opacity. I create a new layer and paint a long drip coming from the corner of the monster's mouth. This reinforces the illusion of movement in the painting by suggesting the monster's head has flipped around quickly leaving a drop of blood flying in the air. It also adds a subtle story to the painting. What the story might be is not of concern to me, and most viewers will fill in plot themselves. The painting in now finished. The thing I hope you take away from this is that even if you do change your mind or you feel your painting is not heading in the right direction all is not lost. You can almost always still create a painting that you can be proud of.

Divine Mother Ayahuasca
Painter
Andrew 'Android' Jones, USA
[far left]

Don Seegmiller
Andrew is one of my favorite digital painters. His creative use of materials, textures, shapes, and patterns is second to none. I like the symmetry, color scheme, and simple yet sophisticated use of shapes in this painting.

Shanghai
Painter
Andrew 'Android' Jones, USA
[left]

Don Seegmiller
Another beautiful painting that blends the feel of the old and new. The use of the symmetrical background figure gives a feeling of the traditional with an overlay of the modern bustling city shapes. A very dynamic and lively image.

Opium
Photoshop, Painter
Wen-Xi Chen, GREAT BRITAIN
[right]

Don Seegmiller
I am entranced by good figure work. Great color scheme with the brightest accent colors placed right where you want the viewer to look.

Red Forest
Painter, Photoshop
Lukasz Pazera, GREAT BRITAIN
[left]

Don Seegmiller
A traditional landscape executed on the computer. Very nice use of value. The large and freely painted shapes give the impression of an autumn landscape without painting every leaf. Definitely one of my favorites.

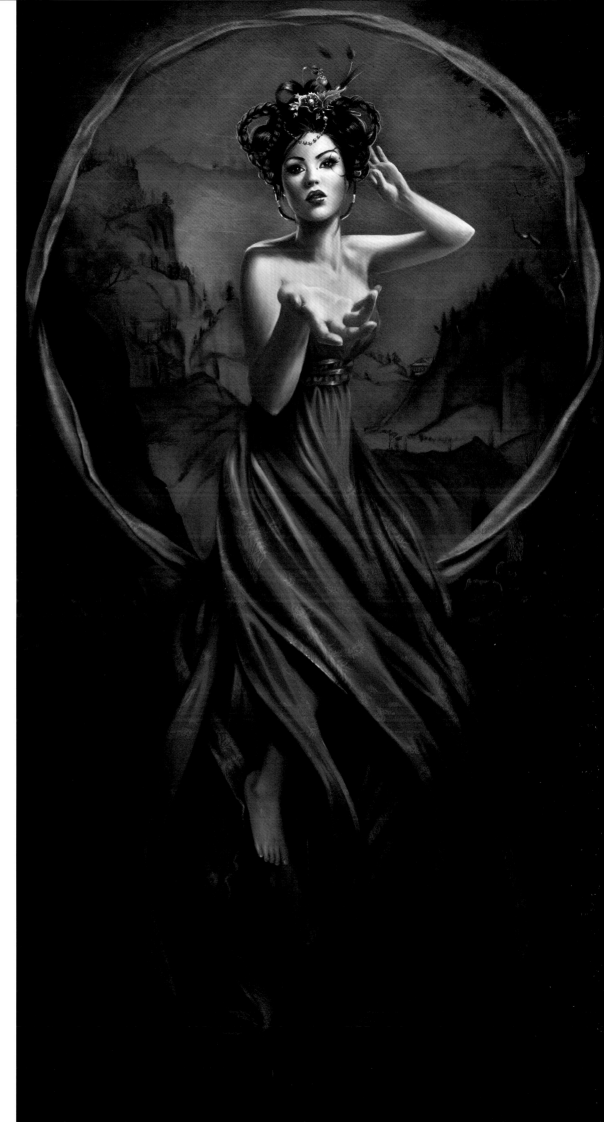

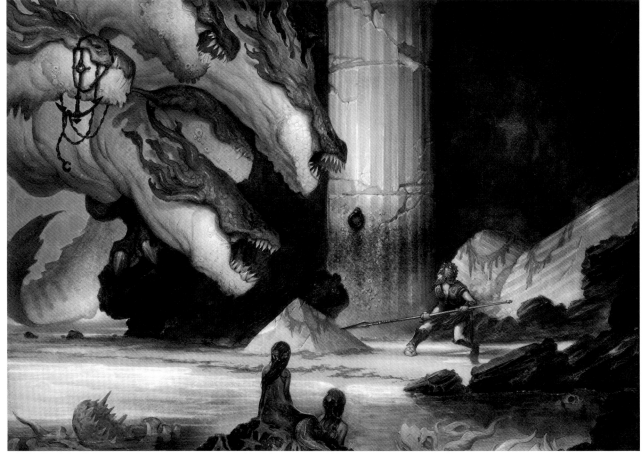

Grimble Crossing the Alps
Photoshop
Cory Godbey, Portland Studios, Inc., USA
[top]

Don Seegmiller
What an entertaining piece. Fun to look at and well executed. The humor is a bit dark and the characterizations perfect. I just don't want to be interviewed by this guy.

The Hydra
Photoshop
Justin Gerard, Portland Studios Inc, USA
[above]

Don Seegmiller
Justin's use of color and value is top notch. He knows where to concentrate the detail and where to let the viewer fill in. This piece is a perfect example of a complementary color that works.

Theseus & the Minotaur
Photoshop, Painter
Justin Gerard, Portland Studios Inc, USA
[top]

Don Seegmiller
It takes a very good artist to place the center of interest at the center of the composition and have a painting that is not static. Justin succeeds admirably.

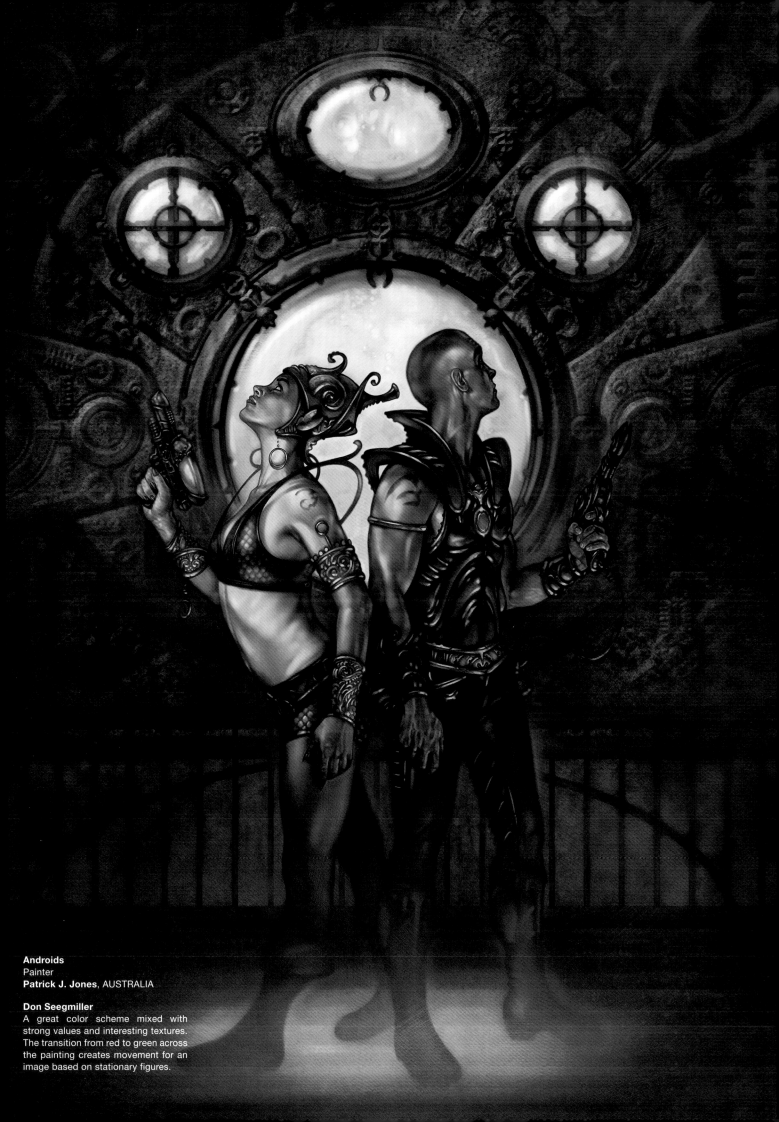

Androids
Painter
Patrick J. Jones, AUSTRALIA

Don Seegmiller
A great color scheme mixed with strong values and interesting textures. The transition from red to green across the painting creates movement for an image based on stationary figures.

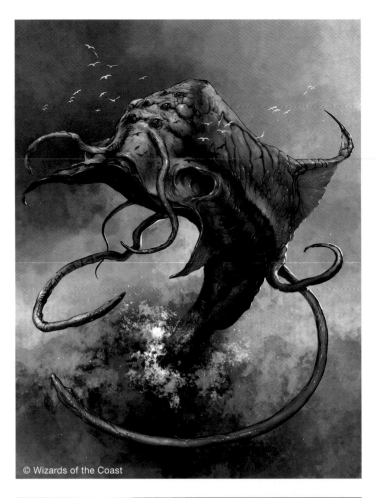

© Wizards of the Coast

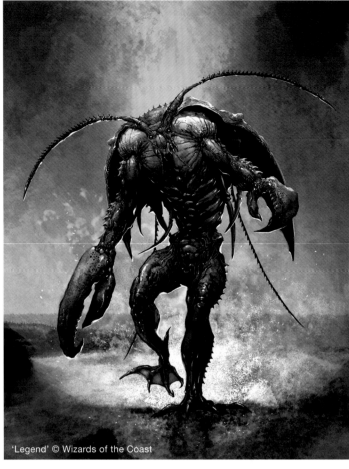

'Legend' © Wizards of the Coast

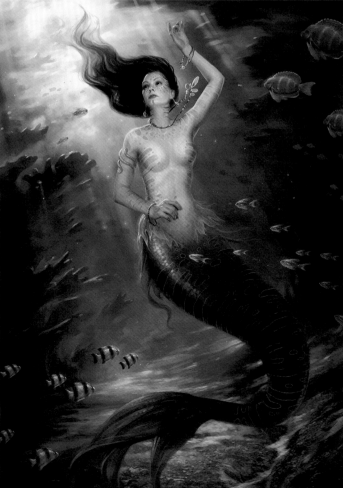

Aboleth
Photoshop
Client: Wizards of the Coast
Francis Tsai, USA
[above left]

Don Seegmiller
Who doesn't like a good monster? Nicely rendered, and the flock of birds is perfect for giving a sense of scale to the creature.

Legend: Ripper
Photoshop
Client: Wizards of the Coast
Francis Tsai, USA
[above]

Don Seegmiller
Another great monster. Wonderfully creative, a great color scheme, and very well paintied.

Underneath it All
Painter
Howard Lyon, USA
[left]

Don Seegmiller
Mermaids have been done and overdone so often that seeing one painted this well is a welcome relief. Lovely color scheme and the transition from fish to female is very well done. I love the subtle patterning on the female portion.

Restoration
Painter
Client: Wizards of the Coast
Howard Lyon, USA
[top right]

Don Seegmiller
Howard is a classically trained painter, and it comes through in all his work. This landscape would feel at home in a Bouguereau painting. Great color scheme and use of value. The runes on the rocks really do glow. You can feel the wind through the figures hair. Beautiful painting.

The Final Blessing
Painter
Client: Wizards of the Coast
Howard Lyon, USA
[right]

Don Seegmiller
Not sure if the priest is about to get eaten or if he is sending the dragon on an errand. Nevertheless, another very fine painting by Howard. Wonderful sense of light coming from above.

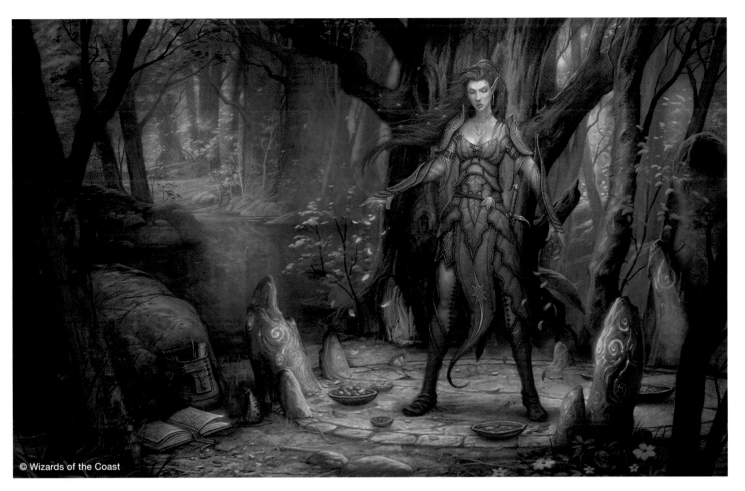

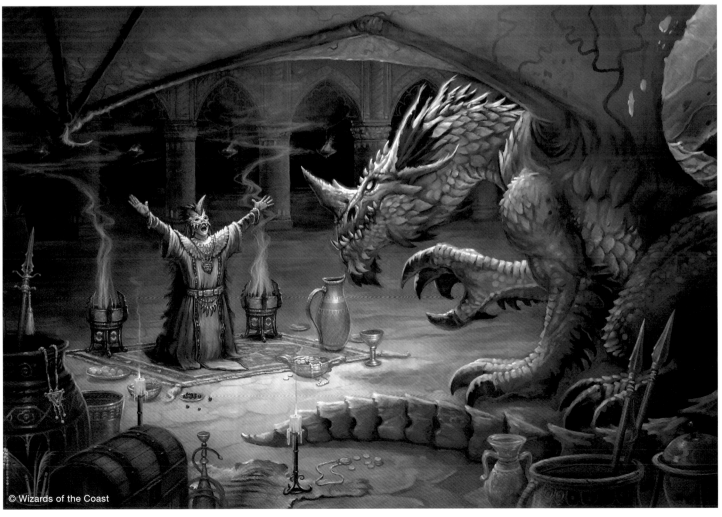

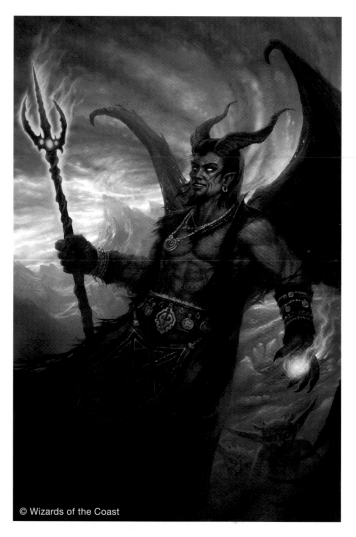

Mephistopheles
Painter
Client: Wizards of the Coast
Howard Lyon, USA [top]

Don Seegmiller
The look on his face is priceless. I have to admit though that my favorite part of this painting is the two small imps looking from behind the main character. Wonderful, stormy painting.

River Crossing
Photoshop
Erwin Madrid,
USA [above]

Don Seegmiller
What a winning painting. It has all the right moves. You know what the story is, and the composition is perfect. The use of color and value has you looking right where Erwin wants you to be looking.

Nightsands
Photoshop
Client: Alderac Entertainment Group
Steve Argyle, USA [top]

Don Seegmiller
Great sense of impending action! Vertical space is nicely handled. A nicely painted, split complementary color scheme.

Indigo
Photoshop
Drazenka Kimpel, USA

Don Seegmiller
One of the toughest things to paint well is translucent fabric. Drazenka manages very well. You can feel the jewelry pressing on the skin. The figure is painted very well and the look on the girl's face is priceless. You are not quite sure if her intentions are friendly or not.

The lovingly lopsided cake for Mom
Photoshop
Jennifer L. Meyer, USA
[far left]

Don Seegmiller
The thing that most impresses me about this painting is the success Jennifer has painting something cute without becoming cutesy. The painting is successful on a number levels, but it is the stack of bunnies that I love.

Budhead
Painter, Photoshop
Scott Altmann, USA
[left]

Don Seegmiller
A very simple, intriguing character. Very well painted with just the hint of a story. What is happening with the buds? "She loves me...She loves me not...She loves me"?

Bill and Bob Muroidea
Photoshop
Kai Spannuth, GERMANY
[right]

Don Seegmiller
Probably the greatest pair, or single, of mutant rats I have ever seen. Rarely do I see a pink painting that I like but this is definitely the exception.

Spring's Gift
Photoshop
Patri Balanovsky, ISRAEL
[far left]

Don Seegmiller
Just a nice painting! Everything is working. Placing the fishbowl in the shadow to highlight the goldfish is perfect.

Boxer
Painter
Michael Kutsche, GERMANY
[left]

Don Seegmiller
Disturbing, and yet I can't take my eyes off the painting. One of the best animal/human combinations I have seen in quite a while. Very nicely done. I love the squinty eye.

MARTA DAHLIG

Marta Dahlig is a widely published young artist from Poland, born in Warsaw in 1985. She has been drawing and painting with traditional media since childhood, moving onto the computer at the age of 16, when she became a freelance painter. Doing private commissions initially and commercial book illustrations, Marta now works for Future Publishing, creating various painting tutorials for ImagineFX magazine. Marta's paintings feature bold characters in emotive and poetic settings, but what makes her style especially distinctive is the subtle symbolism found throughout all of her works.

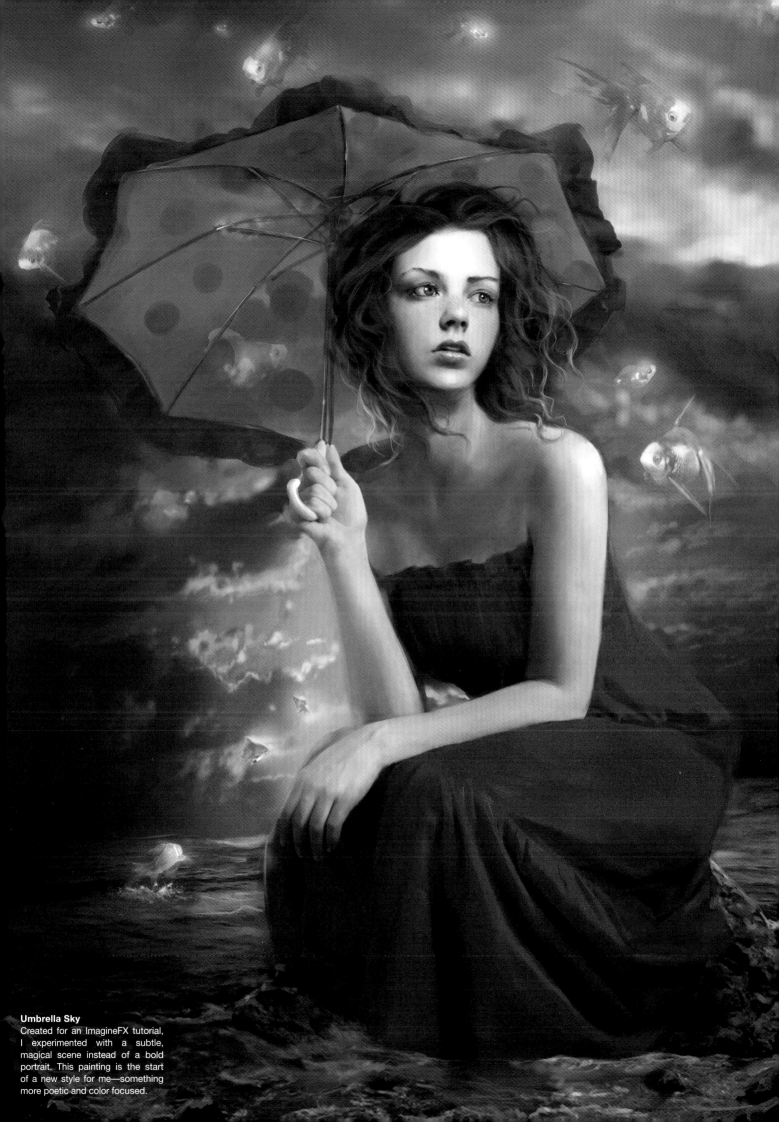

Umbrella Sky
Created for an ImagineFX tutorial, I experimented with a subtle, magical scene instead of a bold portrait. This painting is the start of a new style for me—something more poetic and color focused.

CONTENTS

Beginnings

My earliest art experience—which my parents still remember—is when I was so little that I couldn't even walk. I'd sit on the floor lovingly smearing crayons all over the paper, floor, or any other surface which I found especially attractive. My mom was always very attentive and cared for my creative development, and so she used to engage me in all sorts of manual activities, like creating things from clay or paper. Mostly I remember drawing with her—when I was a few years old I was so incredibly envious and overwhelmed by the beauty of the princesses she'd draw. They were so much better than mine! Art has been a great passion of mine during the vast majority of my life. However, perhaps due to being a "pessimistic realist", I have never actually associated my future employment with it. I considered painting a hobby—something I did off-time and nothing more.

This approach changed greatly around four years ago, when I finally realized I could never live happily without creating. Since then, I have focused greatly on improving my skills in most aspects and tried out many art-related jobs. My co-operation with ImagineFX creating tutorials has proved to be the most rewarding and successful to date.

Studies

None of my education was truly art-related. My high school only offered standard art tuition, and I am currently studying Marketing and Management at the University of Warsaw. I am a do-it-myself kind of person, and generally prefer to learn things on my own. I don't usually have the patience to follow detailed guidelines. While I advanced my painting skills through simply observing and trying to recreate what I saw, I wanted to develop other skills through education.

Going digital

I started using computers around the age of ten and discovered the horror of them by losing my files due to Windows crashing quite early. Of course, as all children, I liked to play games, but most of all, I used it for playing in Paintbrush in Windows 3.11 and writing papers for Biology for my high school class which, at the time, I was extremely fond of. From the moment I was introduced to Paintbrush, I kept drawing on the computer. However, traditional media remained my basic means of painting for many years to come. The subject of my works in Paintbrush were the same as on paper—I tried to draw people, animals, and different scenes, all using a mouse. Even back then I was so frustrated by not having enough control as I did with a pencil. I was so overjoyed when I discovered the existence of the graphic drawing tablet and the stylus at the age of fifteen.

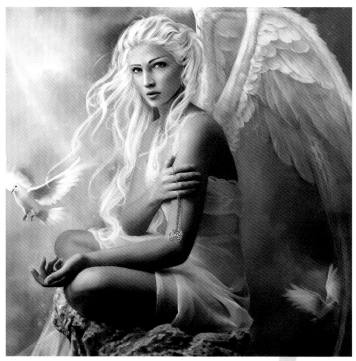

Doves: A commissioned project with dynamic cropping and strong highlights.

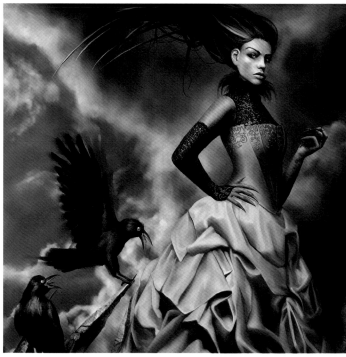

Ravene: One of the first images where I painted a fully detailed gown.

Commercial work

At fifteen, I started to treat digital art more seriously, mostly taking commissions from private individuals. My first commercial assignment came two years later—it was a cover for an RPG rulebook called 'Dreaming Cities'. To be honest, it was a tough learning experience. While working on private commissions, the artist is usually the one deciding upon the depiction and execution of a painting. Working under an art director proved to be quite frustrating, as I had to consult on every element of the painting, and was forced to incorporate every change, even when I considered it a mistake. I consider it a great learning experience where I could test myself in dealing with stress, communicating and working with others. Working to tight deadlines improved my workflow and motivated me to improve not only my painting skills, but also the technical organization of my working process.

Technique

I can proudly say I have learned a lot and improved with time. Aside from learning anatomy, composition, and color, I have discovered some tricks regarding detail hinting and texturing, which dramatically improved the realism of my work. However, the biggest lesson I have learned is patience and devotion—no impressive result can be achieved by the minimum amount of work. You have to work your way hard through every element and every process in order to improve. Discussing my painting subject progress is a harder task. As women are the main subject of my work, I used to joke that all little girls draw princesses but, unlike them, I didn't grow out of the habit. When I learned how to paint different kinds of textiles, my main subject of interest became gown design. After a couple of years, I realized that no matter what symbolism I put into a picture, a woman in a pretty gown is seen by the majority of the audience as a woman in a pretty gown. I wanted to show there's more to me and my works than attractive designs. That is why, a couple of months ago, I altered my style into something character-oriented, but mostly in the aspect of story and emotion rather than clothing.

Digital tools

For the majority of my works I use both Painter and Photoshop, switching between the two constantly during my working process. I am often asked which of the programs I find better and, to be honest, I still cannot decide. While Painter is much more intuitive and easy to master, Photoshop grants the user much more flexibility. The best effects, I believe, come from the programs being used simultaneously. I use Photoshop for sketching, then switch to Painter for basic blending, color enrichment and final shape defining. I then go back to Photoshop for texturing and final blending. In Photoshop I mainly use my own custom brushes, two being my definite favorites: the first looks like a typical Hard Round brush, but with ragged edges; and the second is a Spackled Brush, which consists of a few dots (some having soft, some having harder edges). The Hard Ragged brush I use for sketching and color blocking, as it grants the painting some texture from the very beginning. The Spackled Brush is used primarily for blending—aside from creating smooth color transitions, it also enriches them with subtle textures which are crucial when painting things like a character skin. Photoshop is also fabulous for creating lots of single-use custom brushes. For a more complicated painting, I usually create five to ten texturing brushes for specific needs, eg some adjusted paper folds work great as foamy waves of water, and the tree bark texture can also be used for creating skin deformities.

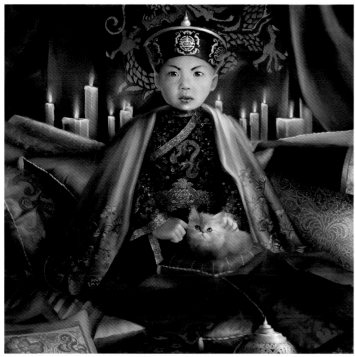

His Only Friend: A great challenge in terms of composition and texturing.

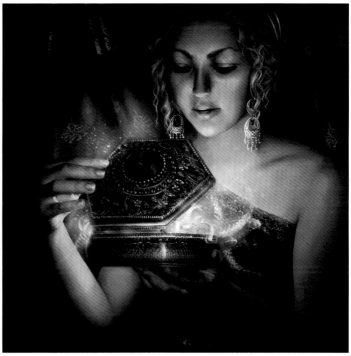

Pandora: Due to tricky lighting, this is the only painting where I've painted myself.

My favorite brush in Painter is the Simple Round one from the Blenders category. Aside from the extremely crispy color look, it also smudges the underlying color, allowing nice color transitions from the very beginning of the painting process. My second favorite in Painter is the Blender tool, which basically works like a very grainy smudge. This makes it fantastic for early stage blending, as it doesn't give that artificial, plastic feel that takes away all the realism. My first professional painting program was Procreate Painter 6 (which, despite its extreme simplicity I still use today). My digital beginnings were very similar to that of a traditional artist—my first digital tool was an Airbrush. Of course, airbrushes can be used in many different ways and often give wonderful results, but require some experience and thorough knowledge of other brushes, which I definitely lacked back then. My technique

was to paint everything with one tool—I was so focused on blocking the shapes, adding colors, and getting proportions right that I was oblivious to the existence of texturing. After thorough analysis of other artists' work and experimenting, I discovered the advantages of other brushes and soon started to work with the majority of tools offered in Painter 6. My real breakthrough around 18 months ago, was when I rediscovered Photoshop and custom brushes. The flexibility was almost too much to handle, and it took me a lot of time to figure out what brush settings worked best for me and my workflow. With technical experience, other aspects of my paintings started evolving as well. After I learned the programs and basic elements of any painting, I didn't feel so awkward about experimenting with the content of my work—I started to play with more original lighting, composition, and character posing.

The Seven Deadly Sins

The Seven Deadly Sins series came about from many factors including the movie "Se7en", and a Magnum ice cream commercial. During this period, I discovered some gown painting techniques through the influence Art Nouveau artist Alphonse Mucha. I wasn't determined to do the whole series of seven pictures and treated it as an adventure rather than a long-term project. It wasn't until the great feedback on the first piece, Vanity, that I decided to tackle the project. The biggest challenge was keeping the technique consistent throughout the whole series. I planned to finish all Deadly Sins within a year, but paid work took precedence. The last of the Sins was released exactly two years after Vanity was released. The gap between my technique during this period was tremendous, and I had to push myself back not to get too crazy and detailed about the last sin, or it would eventually ruin the project.

Career path

It is impossible to estimate the role of the Internet has played in my personal and commercial growth. Showcasing my work on various art communities gave me a lot of constructive feedback. The chance to receive criticism from many experienced artists has been invaluable both to my knowledge as well as motivation. By comparing myself to other artists, I became more and more critical towards my own work, which only made me struggle harder to boost the quality of my paintings. My commercial development relies fully on the Internet, but is also a matter of luck—recognition on digital art forums is often achieved by painting one image that suddenly becomes popular. This was the case for me with the Sins series. I was fortunate enough to paint something that the viewers liked. The impact of the series on my life is indescribable—it launched my commercial art career and I've enjoyed regular work since.

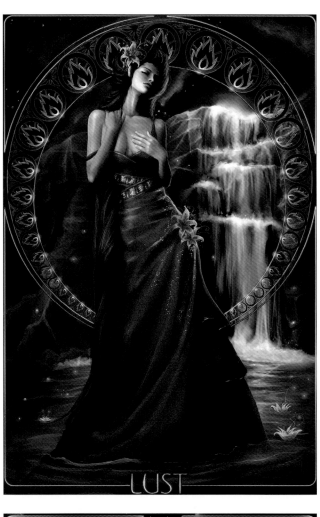

LUST

SLOTH

VANITY

AVARICE

Lust

I did lots of research before completing each Deadly Sins painting. Though I kept mostly to historical guidelines, I sometimes took a tangent. Surprisingly, the original color of this Sin is dark blue, which I found not too convincing so I painted in warmer tones.
[opposite top left]

Sloth

This Sin was a great experiment and challenge design-wise. I refrained from painting a clichéd sloth lying or sleeping, leaning towards a rather graceful representation of not doing anything useful—which is represented by blowing bubbles on a swing.
[opposite top right]

Vanity

The first of my Deadly Sins series. Painting this piece was such an experiment overall—this was my first time adapting a classical style (Art Nouveau, especially the work of Alphonse Mucha), and incorporating heavy symbolism into an image.
[opposite bottom left]

Avarice

Working on this Sin was a great experience to learn to paint satin— one of the harder textiles to depict. I also had a great time as a designer. Avarice's dress was my first design to be licensed and sewn in real life.
[opposite bottom right]

Wrath

Since the beginning of the Deadly Sins series two years ago, my technique and workflow has changed greatly. It was a great challenge to paint this Sin incorporating the new techniques, yet making it blend in with the other images.
[above left]

Envy

Working on this Sin was a very tough experience, mostly because I was so unprepared and overwhelmed by the great feedback I had received. Painting the background has taught me how to hint the details instead of actually painting everything. I also have to admit, I had lots of fun painting those ram horns!
[above]

Gluttony

This was the most challenging of all the Sins, due to the stereotypes of society concerning the overweight. To take a stand in this respect, I tried to depict a woman who would be chubby, but, most of all, still undeniably attractive and charming.
[left]

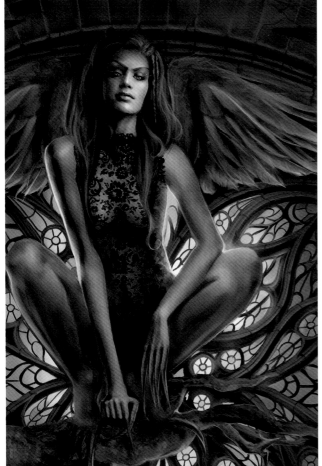

The Commodore

I went crazy with the character design, mixing the tribal and military style for fun. This image taught me a lot about custom brushes and texturing in Photoshop.
[above left]

Love

An older work in which I wanted to investigate the storytelling aspect of a painting. The challenge moved from technical execution to depicting a bold scene which would be understandable without reading the description.
[above]

The Predator

I still rather like this image. As it is one of my more spontaneous creations—unlike all other works—I have not planned this image at all. Moreover, this is one of the first images where I learned the true value of image lighting.
[left]

The Oracle

To me, hands were always the hardest elements to paint. One of the challenges I set for myself last year was to learn to paint them as photo-realistically as I could. It took months of intense anatomy, coloring and texturing studies to finally be satisfied.
[right]

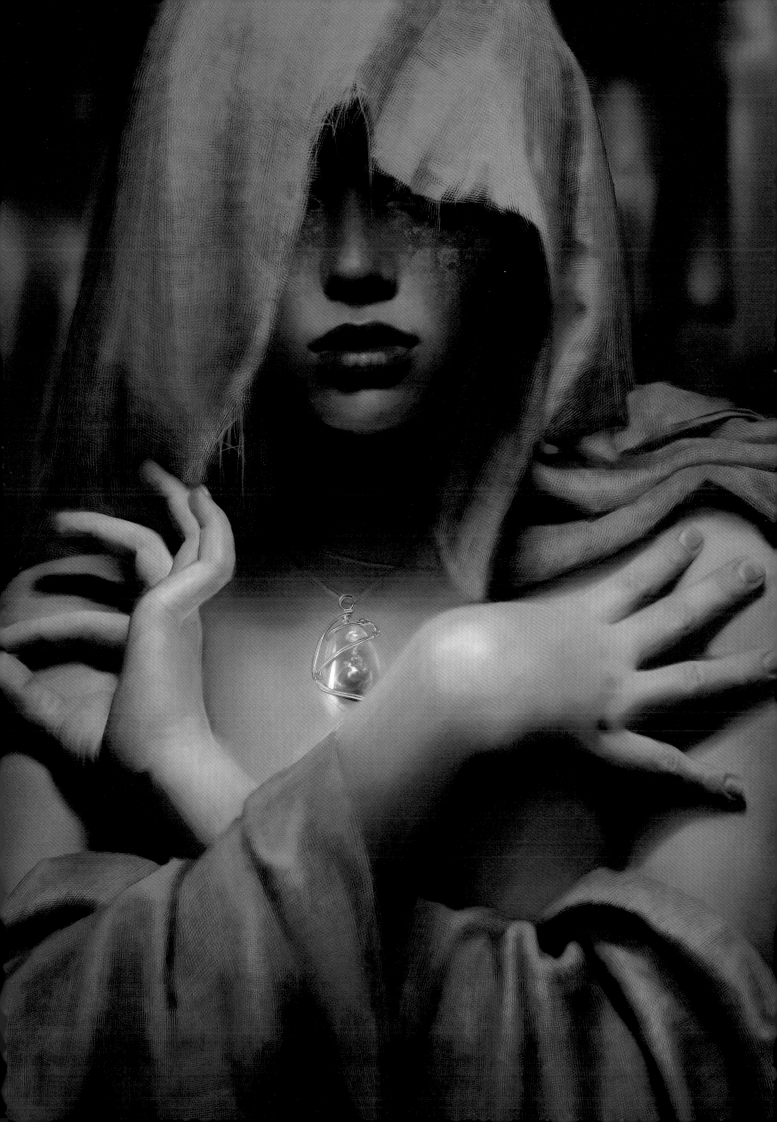

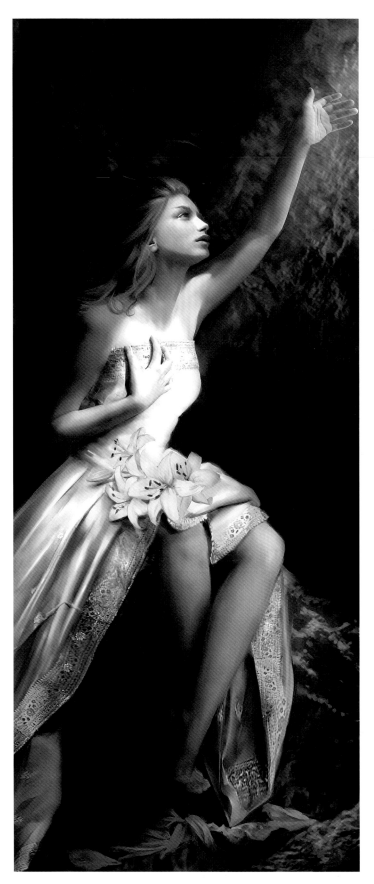

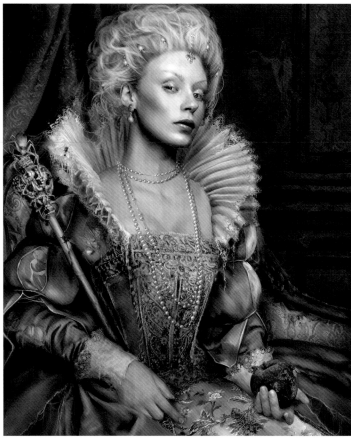

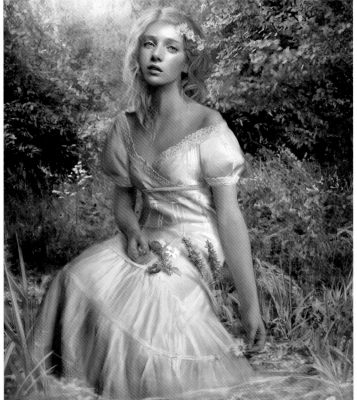

Persephone

Aside from improving my texturing skills, I have also learned to work with very bold lighting (especially how lighting affects the skin), which has proved to be extremely useful.
[above]

Foregone

A historical subject with a twist. The point was to paint a proud, royal looking character, which, when viewed closely, would prove to be falling apart—covered in spider webs, damaged clothing, and holding a rotting apple.
[top]

Ophelia

A take on this legendary theme was a huge challenge. I designed the piece to have a classical style, yet I wanted the character to look a bit more modern. The absent facial expression was very hard to get right.
[above]

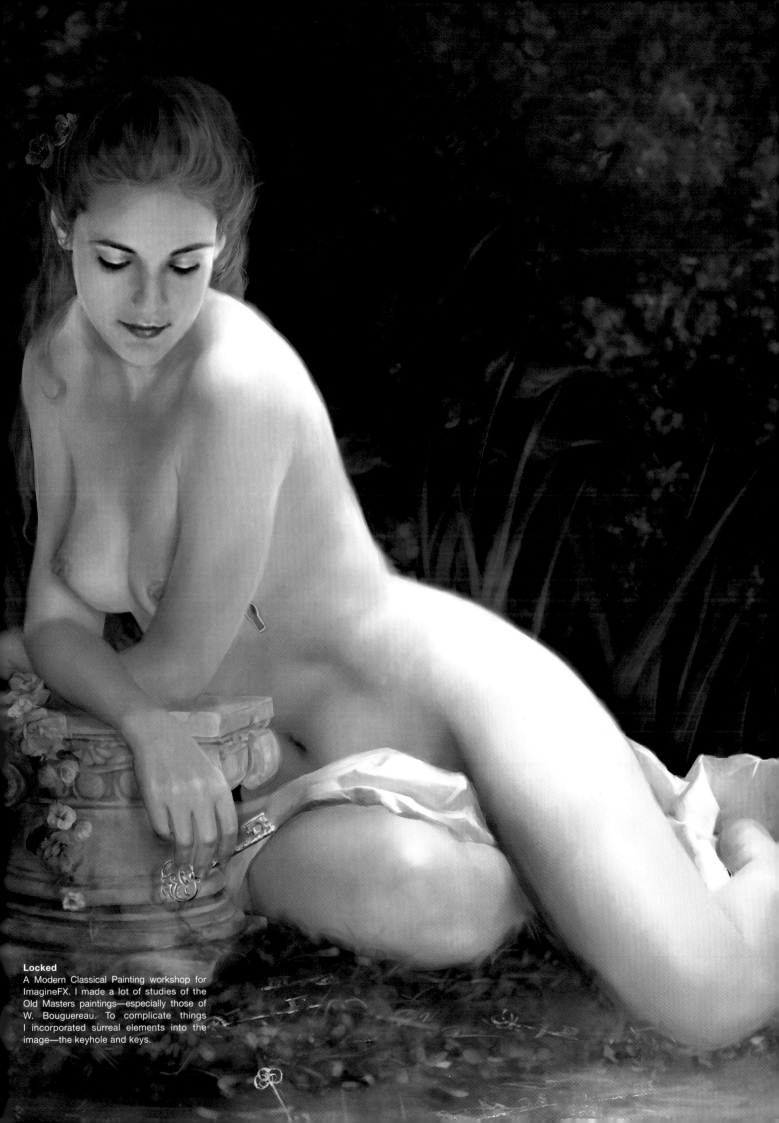

Locked
A Modern Classical Painting workshop for ImagineFX. I made a lot of studies of the Old Masters paintings—especially those of W. Bouguereau. To complicate things I incorporated surreal elements into the image—the keyhole and keys.

SPRING COLOR PALETTE: DELIRIUM

Inspiration and initial idea

While I believe that colors are one of the key elements to create the mood of a painting, I like to think that any atmosphere can be achieved with a broad range of color choices should the image be planned thoroughly. I set myself a challenge to use a very clichéd spring-like color palette and using it, create an image of a darker, ambiguous atmosphere. The general atmosphere I aimed for was a hazy, delirious scene, conveyed mainly by the character's facial expression.

Technique

While the subject of the painting was not very challenging as far as technique goes, from the very beginning I found it extremely important to find a balance between the colors, intense texturing of the character, and the painterly blurring of the background to ensure the right focal point concentration. Another challenge was modeling the face and specifying its distinctive features. Sometimes it is unimportant what character features or facial expressions are shown, so long as other elements of a painting are worked on. However, in Delirium's case, the most pressure was put on the character herself. To convey the mood that I aimed for and to avoid the color cliché, I had to make the face rather modern, features subtle, and the eyes drawing and appealing in a rather atypical, absent-minded way. As the actual character is the most vital element of Delirium and the object of my biggest efforts, I will devote most time in this tutorial explaining my workflow and technique regarding this subject.

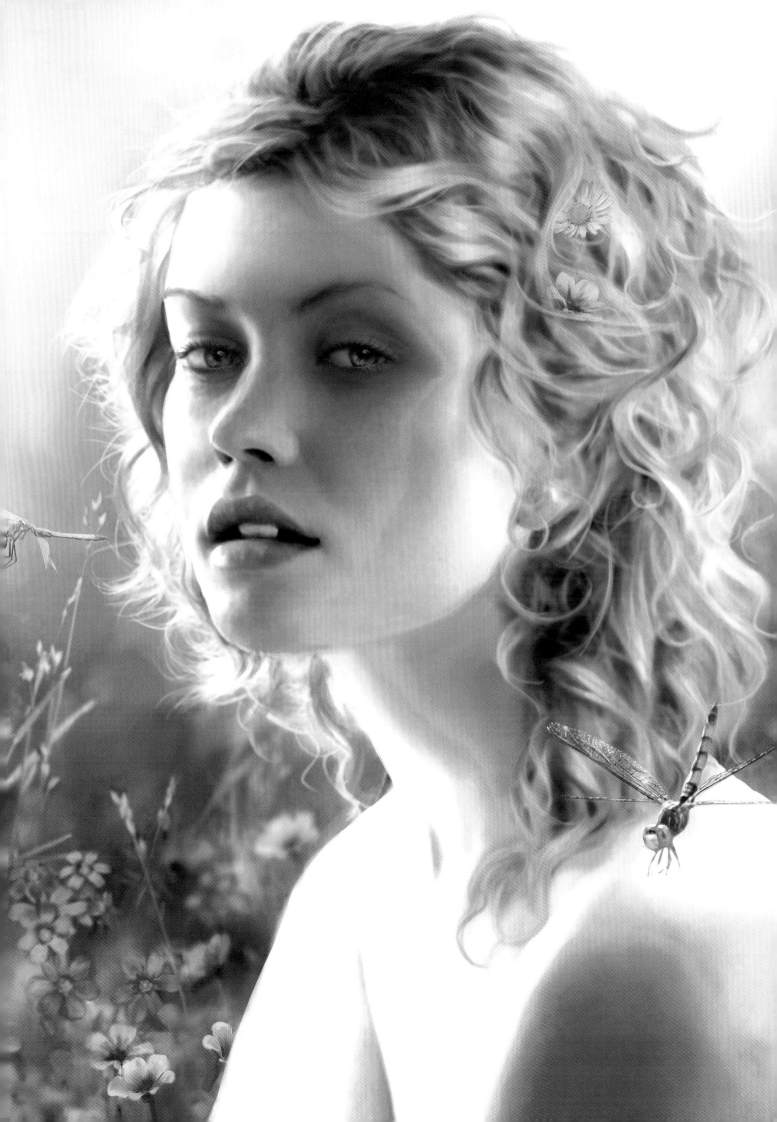

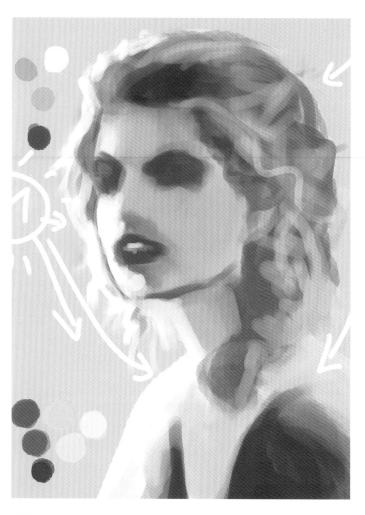

General sketch

As usual, when starting an artwork, I quickly choose a background color and immediately decide on the light-source type (warm daylight), and direction (at the back and front of the character). After picking warm-hued skin tones, I chose a typical Hard Round brush in Photoshop. I then quickly blocked in some basic shapes to sketch out the general idea and define the character concept. On a separate layer, I also quickly marked other palette colors which I intended to use later on for different parts of the image.

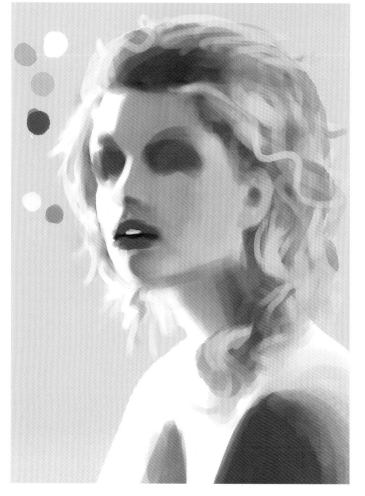

Defining facial features

Immediately afterwards, I enriched the color palette slightly and, using the same Hard Round brush, defined the cheeks, chin, mouth, and nose further. I also strengthened the left side highlight, to give the character a bit more personality. I like my characters to be distinctive and have something special about them. At this point I already knew that the type of expression I would go for would be a rather dazed, absent look.

Adding expression

For this step, I moved to Painter and blocked in some colors with a Basic Round brush and smoothed the whole body with the Blender brush. Using a Grainy Blender helped me achieve a bit of texture due to the rougher color transitions. I then proceeded to define the outer lines of the character's mouth with the Ragged Hard Round brush in Photoshop as well as adding some small highlight on the most convex areas of the lower lip. With the same brush, I also quickly blocked in the eyebrows and eyes, to define the character's focal point.

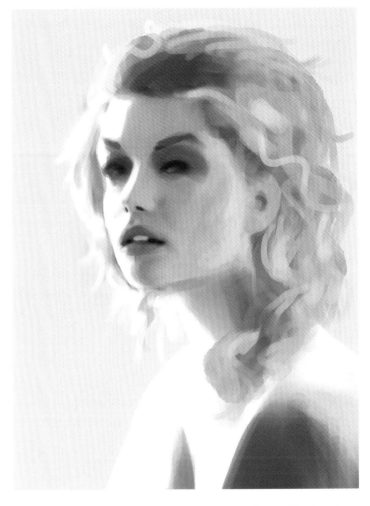

Early designing

In this step, I started marking distinctive facial features of my character—I sharpened the eyebrow line and defined the eyes. Most importantly, on a separate Overlay layer, I airbrushed in some red makeup around the eyes to be the focal point of the whole image. The character finally gained some edge and personality.

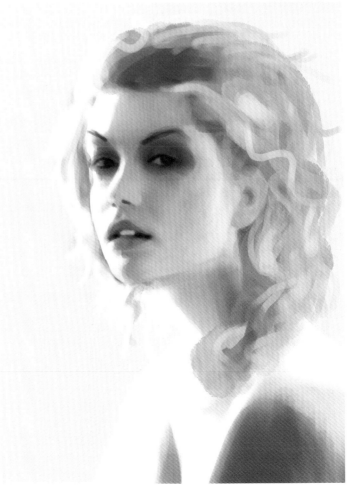

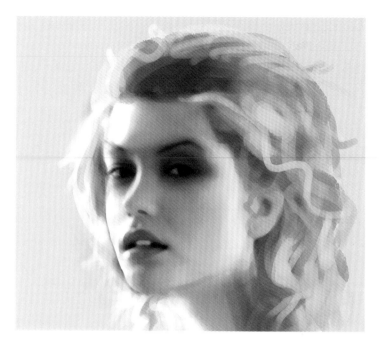

Defining the face

I started working mainly on the eye area to determine the final look of my character. I did lots of airbrushing to define the area around the eye socket and the lid. I also strengthened the right light-source effect, applying more highlights on the left cheek. Afterwards, I opened up Painter again and smoothed the whole face with the Just Add Water tool. Its seamless blending created a wonderful basis on which I could later apply some texture.

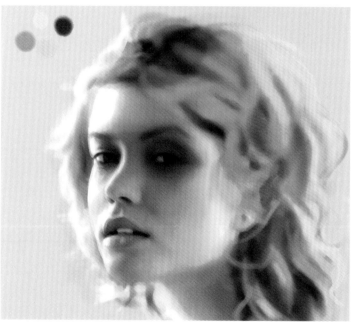

Sketching the hair

After some experimenting, I tilted the character's face a few degrees clockwise, for a more daring look. With an airbrush, I then further defined the lids and iris as well as added some plumpness to the left side of the lip for a natural look. Afterwards, I erased the previous messy hair sketch and did a new one on a separate layer with the Airbrush tool. Messy hair is extremely hard to paint—as it cannot be done as systematically—so I tried to keep the true sketch clean and logical.

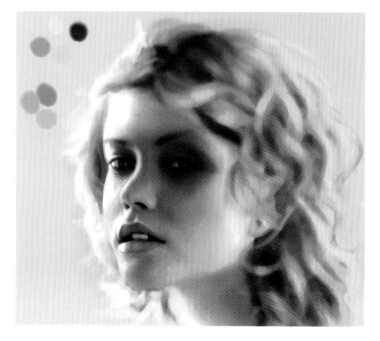

Hair definition

While it is tempting to texture hair really early on, defining bigger hair strands is extremely important when painting messy hair. Instead of painting particular hair strands, as I often do, I continued defining the general look by adding some shadows and highlights to the bigger strands, with the enriched color palette.

Finishing the basis

After having the basis done, I added some depth to the hair shadows with the Burn tool and airbrushed in a few very simple strands to create a basic texture and mark additional highlights. With the general strands being clearly separated from each other, I could then move onto the actual texturing process.

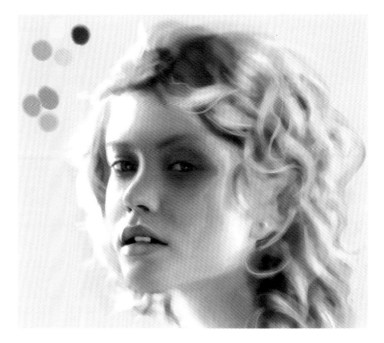

Basic texturing

I started texturing the hair very softly with a 10-40% opacity brush. I placed the first dozen hair strands, eye-dropping the color from the existing basis. I only used the Airbrush brush throughout this step to ensure the soft, flowing feel of the hairstyle.

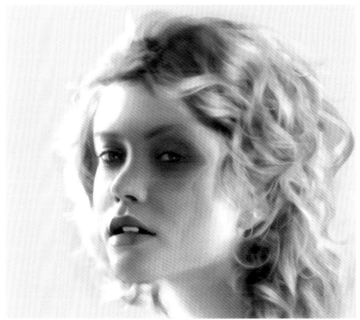

More texture

I continued texturing the hair, but this time chose a Ragged Hard Round brush. Varying its size throughout the process, aside from creating new strands, I ran with it over the previously airbrushed ones to give them some definition and strength. I used many brush modes, such as Lighten, Color Burn, Soft Light, and Hard Light to automatically enrich the hair palette as I proceeded.

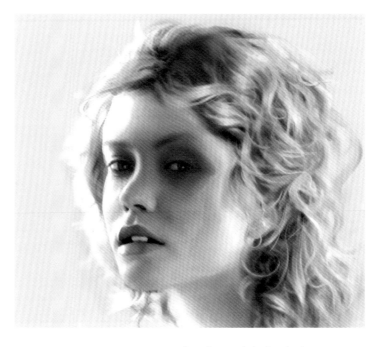

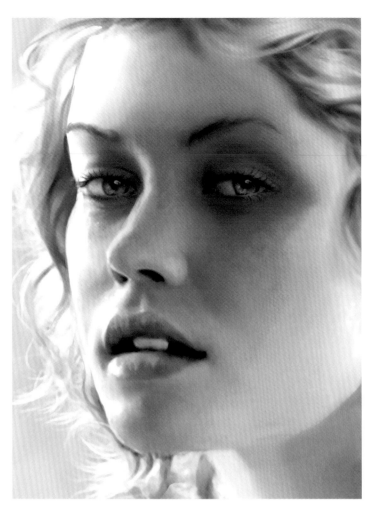

Finishing the face

For a change of workflow, I then switched to finishing the face. I colored the iris and highlighted it slightly with the Dodge tool. I painted the eyelashes and eyebrows with an Airbrush brush and added some texture to the lip with a mixture of Airbrush and Ink brushes in Painter. I also used a highly transparent Spackled brush in Photoshop to imitate the face pores effect on the cheek and above the nose.

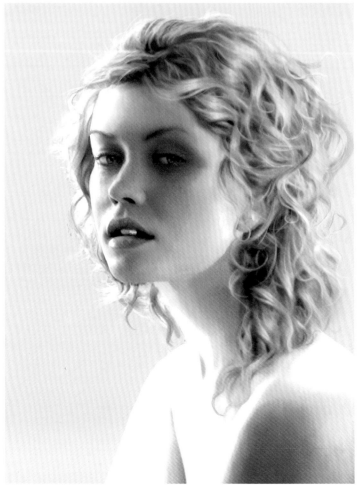

Final character detailing

I dimmed the red makeup for a softer look and finished texturing the hair at the top of the character's head. I also finished the most highlighted part of the hair (left side) by painting in some regular strands and highlighting them with the Dodge tool. Afterwards, I blocked in some small messy strands with pure white color, which I later blurred. On the blurred strands I painted in additional strands for a "camera zoom" effect.

Working on the background

After finishing the character, I proceeded to paint the background. I wanted it to be very colorful and lively, yet simple enough not to distract any attention from the character. I took an Airbrush brush, and using the palette specified in the first step, blocked in some colors which would simulate field flowers.

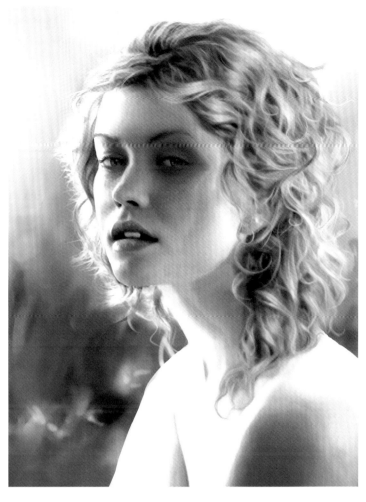

Adding flowers

I then painted in two very basic flowers, which I used to construct my flower field upon. I copy/pasted them, creating groups, varying their size, ratio, and color. Afterwards, depending on their distance from the foreground, I used an adequately adjusted Gaussian Blur filter on them, blurring the flowers farther away from the viewer.

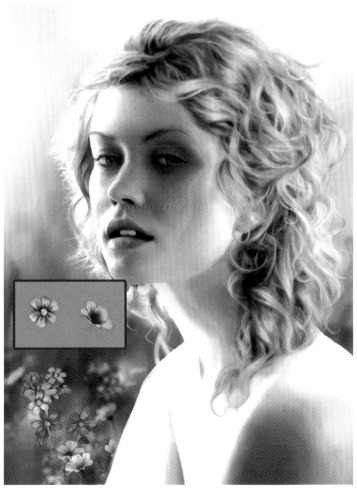

Dragonfly

I proceeded to the final step of the image—painting the dragonflies. After digging around for some reference photos, I painted them in, concentrating on the dragonfly sitting on the character's shoulder. I used a Ragged Hard Round brush for the body and an Airbrush brush for the wings. The delicate wing effect was created by drawing in some lines of darker color within the wing shape and then, on top, and between them, running with an Airbrush brush of light color placing small dots in the area.

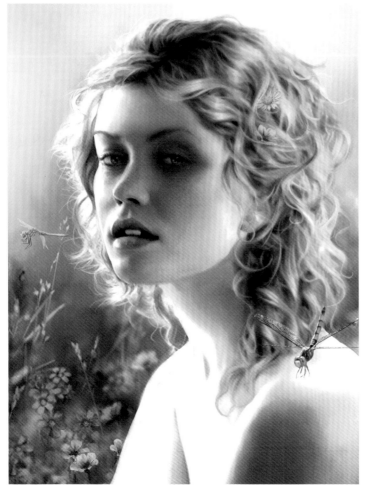

Final touches

To finalize the image, I placed some flowers in the character's hair, to merge her further with the surroundings. I also blurred the dragonfly in the foreground and lowered its opacity. I textured the background slightly and added some grass blades in the farther distance for an extra detail.

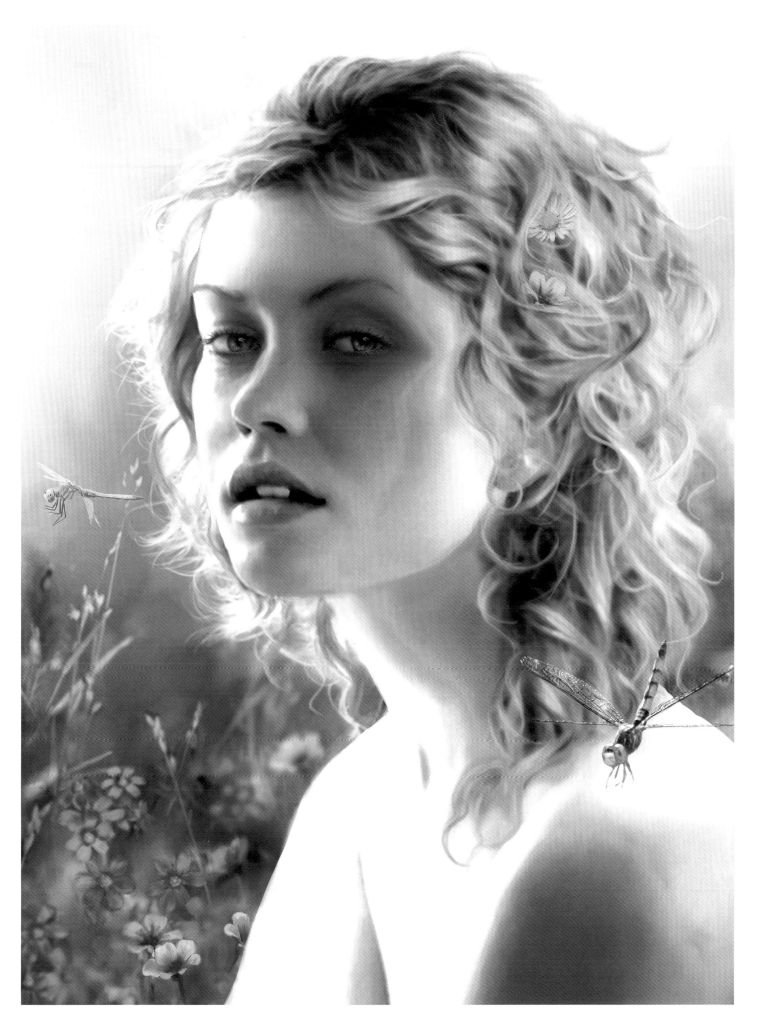

PAINTING A SCENE: NOCTURNE

Inspiration and initial idea

Violinists have always been a great inspiration to me, and I had the idea for Nocturne creeping in my head for quite a while before I actually depicted it. I wanted the piece to be extremely atmospheric and, in comparison with my typical works, be a whole scene depiction rather than a character portrait. My aim was to convey a very bold, dark, yet mystic mood mainly through color, composition, and pose. Violinist poses are extremely difficult to paint correctly, and I was lucky to possess a good proportion reference. This let me concentrate my efforts and worries on conveying the mood.

Technique

One of the biggest technical challenges I encountered during my work on Nocturne was definitely constant self-control when it came to details—I had to concentrate on hinting them rather than painting everything. Moreover, the details had to be painted in such a way that the painting would seem realistic when viewed from a distance, but very painterly when seen up close. So, I reverted my usual working order and started painting the image from the background, moving onto the character at the very end. This let me control the general look of the piece from the very beginning, as well as adjust the level of detail as I proceeded with my work. Also, while explaining my workflow in this example, I mainly concentrated on the elements that are not included in any other images in my tutorial section, and so I will try to mostly outline my work when it comes to preparing the background—especially cloud and wheat field texturing techniques, which form the very essence of this picture. My character and textile painting methods are more thoroughly described in my other tutorial sections.

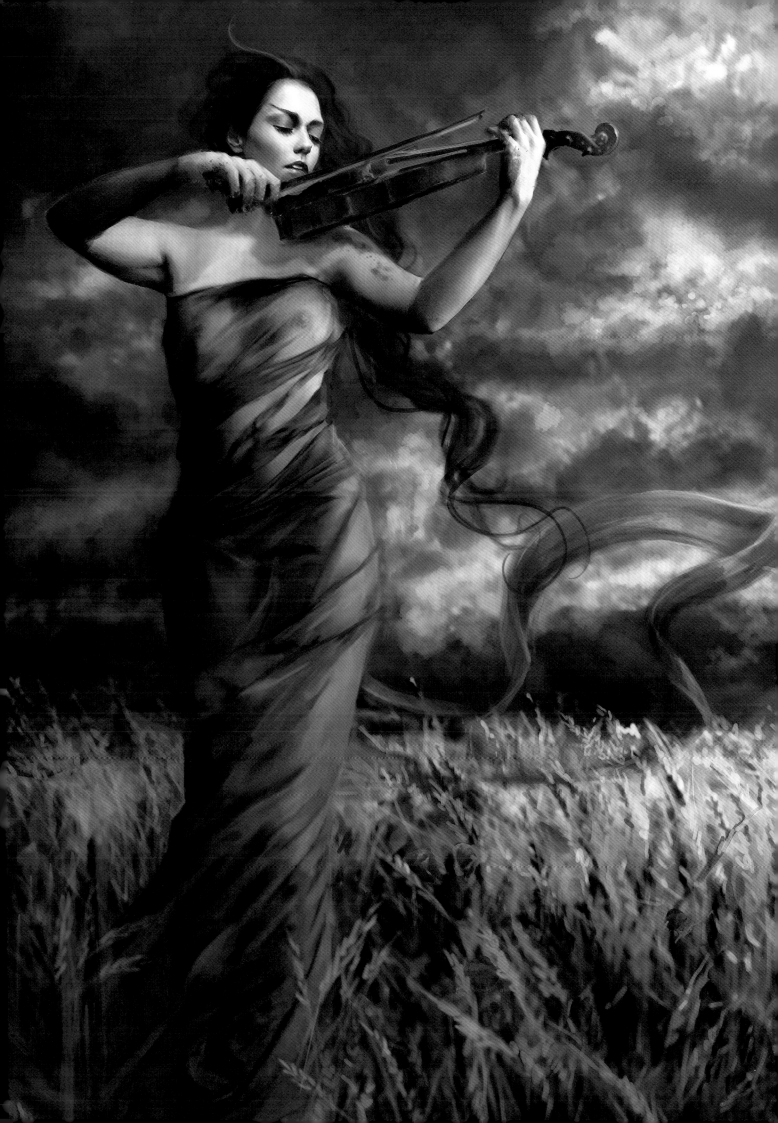

Palettes and brushes

As I believe that colors are the most vital element of any painting and the best way to convey a mood, the first thing I always do when starting a new artwork is decide on the palette. Firstly, I chose the general color theme for the artwork, which I'd later detail. I chose skin tones by combining the main midtone with the colors chosen for the background and the lighting effects by applying them on top of each other with various brush modes in Photoshop. I have also included some Photoshop custom brush presets which, aside from the default tools, I used throughout the painting process.

Color sketch

After I had the palette chosen, I did a general sketch with a simple brush to place some colors around the image. I don't care about proportions or perspective at this point, as this step is simply needed to outline a general composition and quickly picture the idea I had in mind.

Concept sketch and light settings

After letting the idea sit in my head for a while, I changed my initial concept around slightly and did another sketch. I strictly defined and marked the light source for easier color blocking. I also decided to go with a less saturated color theme, but enriched the palette in some blue hues instead. This would later allow me to achieve a more painterly and mystic feeling to the piece. I also sketched out the idea of the character's clothing—an ethereal textile wrapped around the body rather than an actual dress.

Detailing the concept

I then added some details to the sketch, to define the composition and the character to a higher level. With the basic Hard Round brush in Photoshop, I sketched out the character's facial features being zoomed out throughout the whole process. In the early painting stage, I usually avoid working on a close-up of the image. I often get sucked into painting unnecessary details too early on, rather than defining the whole concept.

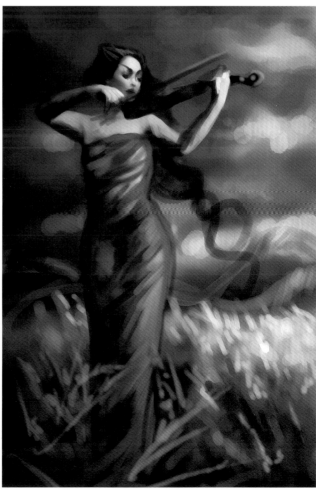

Sketching the sky

To give my character a setting, I started working on the background. First, I concentrated on the sky. I started off by placing some colors with the airbrush tools from my basic palette. I then used the Ragged Round custom brush to add some volume to the clouds and blurred the effect with the Blender tool in Painter.

Airbrushing the clouds

I am not a fan of the Airbrush tool, but I find it marvelous for painting clouds. I slowly painted in some details, adding smaller and bigger puffs here and there, to add a soft, pillowy feel to the clouds. I also defined the final shapes of particular clouds as well as their structure.

Initial sky texturing

As my clouds were lacking texture, I chose a Rotating brush (no. 3) and so, by eyedropping the existing cloud colors, I put in some additional highly transparent brush strokes for a detailed, yet painterly look. The point is not to paint every single detail, but rather hint at it. This gives the viewer an impression of a realistic piece when seen from afar, but a painterly piece when viewed closer.

Final cloud detailing

Now, I put in the final details with the Camel Hair brushes and Loaded Palette Knives in Painter. These brushes are highly textured and so, when viewed up close, give the painting a very traditional feeling.

Reworking the field

I deleted the initial field sketch and disabled the character sketch layer so as not to distract myself during this task. After laying the initial color scheme out all over again, I painted in some color blobs with a Ragged Round Brush in Photoshop to create some simple texture. I then blurred it fast using the Gaussian Blur and Median filters. This helped me create a wonderful basis to paint the actual wheat-ears upon.

Blurry wheat-ears

I sketched out a basic wheat-ear with the Airbrush tool. As I wanted the whole piece to have a painterly feeling to it, the sketch is very blurry and not detailed at all. I wanted my field to be very sketchy, with details hinted instead of painted precisely. The first thing I did was to copy the wheat-ear multiple times, varying its size, color and flipping it horizontally from time to time. I also blurred some of the wheat-ears for a "camera focus" look.

Achieving a realistic field

After playing with the Dodge and Burn tools in Photoshop, I merged all of the wheat-ears to one layer and then duplicated it. I placed the copy on top of the original layer, flipped it horizontally, and gave it a 30% opacity. Thanks to this easy trick, I managed to achieve a realistic effect with rather little effort.

Detailing the field

Still using the Airbrush tool, I proceeded to paint in some details, such as separate wheat-ears to avoid a generic look to the field and give it a personal touch. I also highlighted the wheat-ears at the far end of the field, to underline the light source.

Poppies

For a wilder look and a bit of color, using a Basic Round brush in Painter, I painted in some poppies. I also detailed some of the existing wheat-ears with some additional brushstrokes. Afterwards, I merged all of the layers and applied some last minute effects with the Dodge and Burn tools.

Defining the character

I then moved to defining the body and face to a higher extent and repainting the textile wrapped around the character. The transparency effect I aimed for was mainly achieved by choosing a right basis and fold colors, which are a mixture of the skin tone and the textile hue. I achieved this by painting one shade on top of the other with a transparent brush. Minding the light source, I started by covering the character's body with a gradient color, lighter in the breast and the left hip, and darker on the thigh and knee area. Later, I painted in the folds in the form of darker inclined strokes with a Ragged Round brush, which I later highlighted with an airbrush.

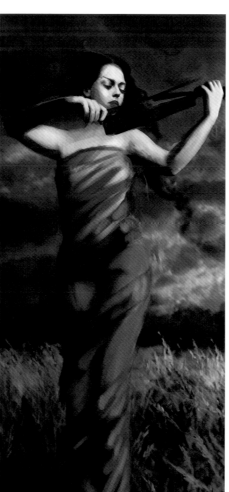
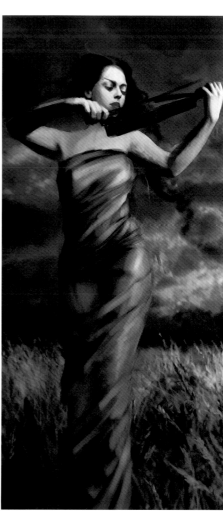

Detailing the textile

Next, I smoothed the color transitions with the Blender tool and enriched the color palette with deeper blue and brownish shades. Furthermore, I marked some folds with an airbrush to make the fabric seem more natural. I also worked on the character's body, darkening the shades, adding details to the hands and smeared blood to the fingers.

The body and facial expression

At this point, I added some additional brownish hues to the textile and smoothed it with a mixture of the Blender and Airbrush tools. I then proceeded to push the work on the character—I defined the face with the Ragged Round brush and smoothed and enriched the shading with the Spattered brush. In order to add some extra emotion and dynamism to the painting, I opened up the character's mouth as well as underlined the cheekbones and eyebrows.

Finishing touches

At the last stage, I added a shadow cast by the violin, defined the hair strands and some smeared blood on the character's arm. I also quickly painted the flying textile in the background as well as enhanced the bottom of the dress for better composition balance. I kept those parts rather sketchy, as high detail would kill the dynamism of the piece. At the very end, I put in some wheat-ears at the front of the character, to merge it better with the rest of the painting.

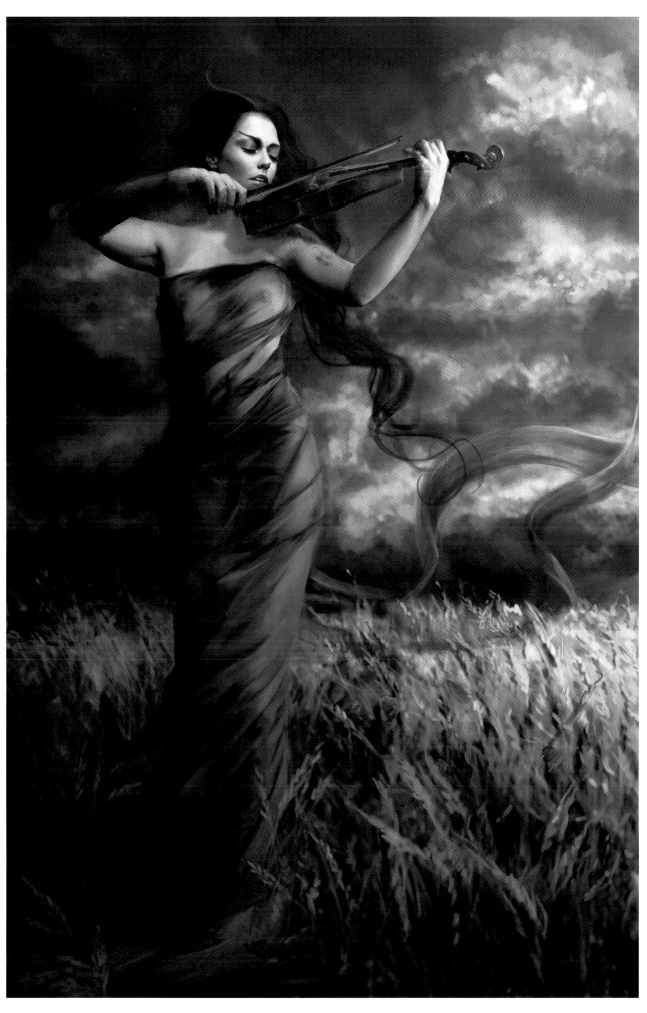

TELLING A STORY: REFLECTIONS

Inspiration and initial idea

What I believe is the most challenging and interesting aspect of painting—aside from conveying certain emotions—is to paint images that manage to tell a story without any description or explanation. I do not really enjoy obvious or over dramatic accents that stand out too much. I prefer subtle hints to solving the whole image which are visible only after a moment of looking at the painting. In this case, the title Reflections suggests to the viewer the key to solving the image, which is studying the reflections in the mirror and seeing what is obviously wrong and disturbing.

Technique

To keep the general look of the whole painting consistent and rather classical, despite the variety of details, I had to do some web research of the 19th and 20th century styles and define a matching color palette. However, one of the biggest challenges in this piece, was creating a believable mirror reflection. I have done tons of research and experiments to learn how the reflection looks, and how a mirror works. That is, the way it reflects objects farther at its side, and completely different from the way it reflects objects in front of it. It was definitely the hardest task

to make the lack of character reflection look like an intended idea rather than a mistake. In order to get this point across I had to make everything surrounding the girl reflect in the mirror, which forced me to use every available millimeter of the canvas. As my workflow, due to the amount of painted elements, was rather hectic, this tutorial concentrated on showing my approaches and techniques when painting textiles and designing their patterns. It also serves to outlinie the logic and reasons behind bringing additional elements into my paintings.

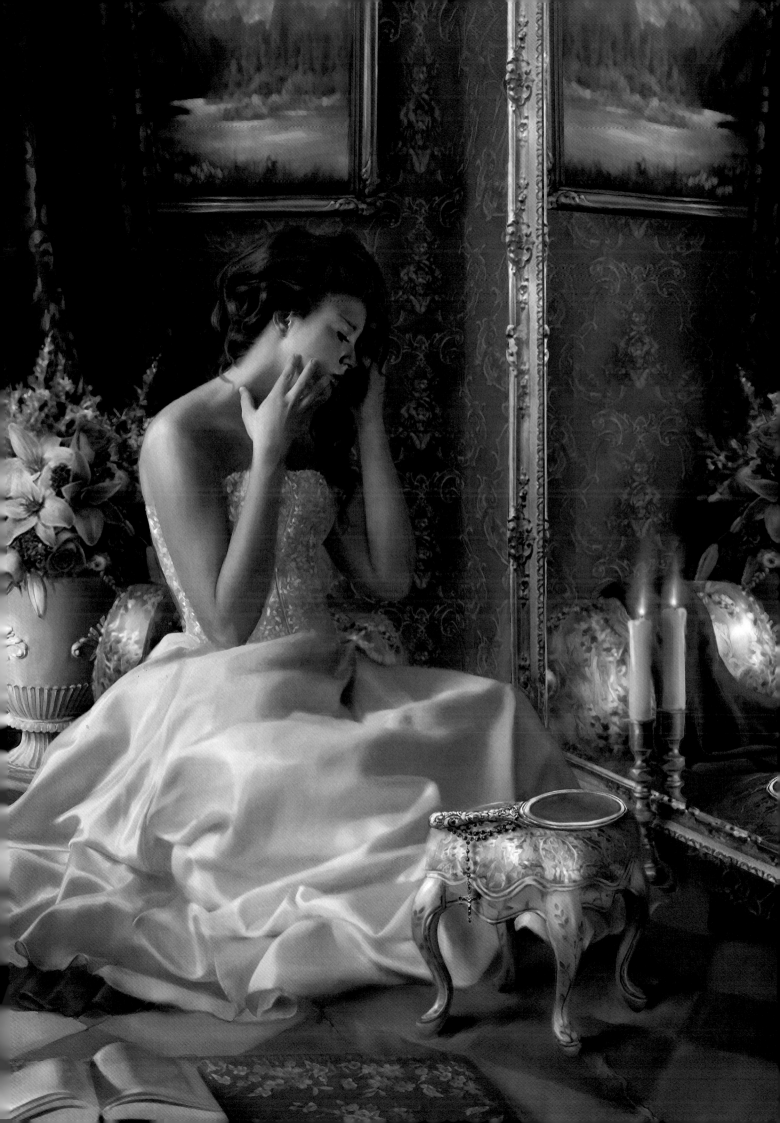

Defining the color palette

First, I specified the color palette that I would use throughout the painting. I divided the chosen colors into three categories: character skin; dress; and background. As there are many elements of the image that would require special texturing, here are some custom Photoshop brush presets that I used in this piece along with the brushes displayed in my Nocturne tutorial.

Starting out

After specifying the colors and tools, I chose a Ragged Hard Round brush in Photoshop and placed some color blobs in order to visualize the general idea. I placed two mirrors—in front and on the side of the character. I aimed for a dark red and brown theme contrasted with pink and gold accents. At this point, I also defined the light source by giving it a very light blue color and placing it behind the character.

Horizontal flip

It was clear from the start that there was something wrong with the image. As we view images from left to right, there was no sense in showing the mirror—the actual point of the whole image—at the very beginning. I flipped the whole image horizontally and worked on defining the character and background slightly with the Ragged Hard Round brush, while using colors from the palette. I also dropped the idea of painting two mirrors. Instead, I placed a painting above the character's head and quickly blocked in a shape simulating a hand mirror.

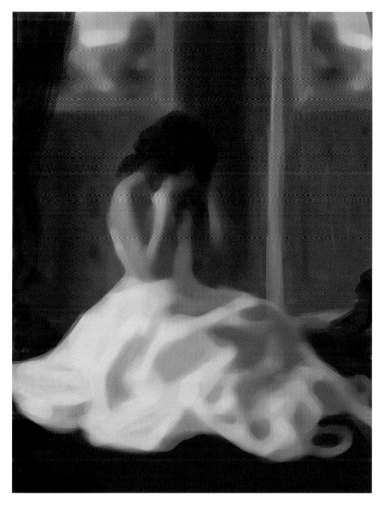

Further definition

The type of material to paint has to be decided at the very beginning, as the kind of textile defines not only the texturing technique, but most importantly the way its folds behave and the way it reacts to light. My choice to paint a satin gown determined all of my further steps—satin isn't too thick and is characterized by rather rough, sharp folds and therefore concentrated highlights and rapid shadow-to-highlight transitions. I proceeded to define the dress by marking the folds with a Hard Round brush, with some Airbrush for a softer effect, and a smoother satin feel. I marked the most convex areas with a light color and then placed some shadow underneath them to underline the gown's structure.

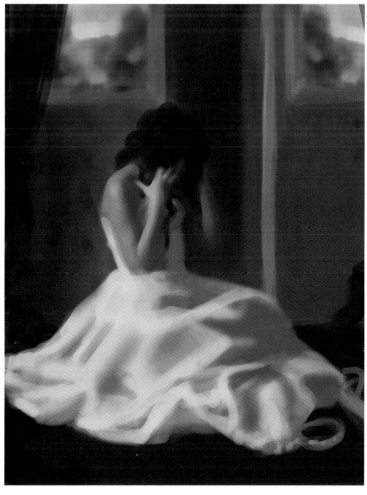

Softening the gown

I darkened the whole gown, so as not to use the specified highlight color too early. As I had a Rough Hard Round basis, I now switched to an Airbrush to soften the general look of the dress. In order to do so, I simply ran with it over the existing hard-edged folds and smoothed the transitions.

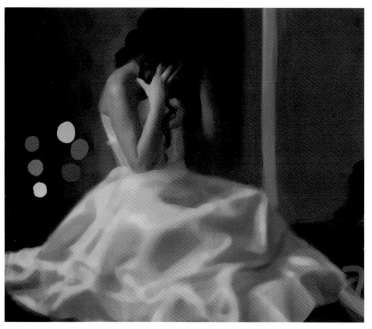

Satin look

To make the satin look recognizable at this early stage, I took the Hard Round brush again and, with the lightest color from my palette, marked the most highlighted folds of the dress. It's rather dangerous to change the dress structure at a rather advanced shading stage, as one extra fold may ruin the actual logic of the draping, so I defined some last small folds on the lower left part of the dress.

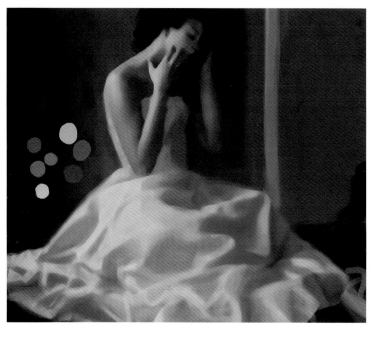

Character changes

At this point, I was rather unhappy with my character and changed the posing to show off a bit of the face—gaining a new means to convey the mood of the image. I quickly sketched out a new torso with a Ragged Hard Round brush and proceeded to define the highlights and shadows of the smaller folds with the same tool. I placed colors on top of each other, not bothering to blend them yet.

Fold polarization

I painted in the character's face as well as some small dots on the chest to create a basic texture for the future corset pattern. Most of all, I concentrated on polishing the folds, by airbrushing in some soft, bold highlights and strengthening the cast and form shadows. While the folds themselves should be smooth (1), the borders between particular folds should be rather rough (2).

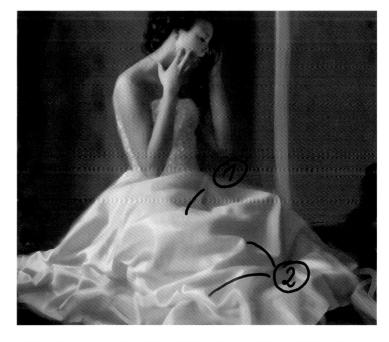

Finalizing the gown

One of the most important elements when painting any gown is to remember to make all of the folds logical. The line where the gown touches the floor needs to match the way the material is draped. Also, it is a great way to add some extra realism to the gown by roughly defining the edges. I painted in the edges carefully with a Hard Round brush, keeping the color transitions rough and adding a very small highlight along the outer edge of the material. This underlined that slight thickness that is usually created by the thin margin for sewing purposes.

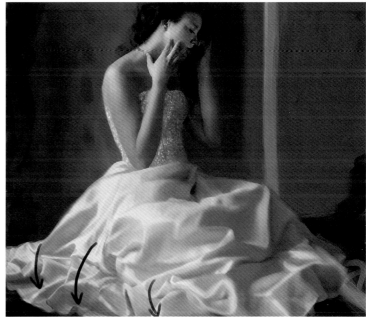

Designing the wall-paper and curtains

I still needed to work on the environment. Using historical reference, I sketched out a classical looking element which I then placed in rows to create my wallpaper texture. I also textured the floor by using the texturing brush over it and then blurring the color blobs. The curtain and flowers were my basic elements which I intended to reflect in the mirror later on. I airbrushed in a very blurry vase with some flowers in it, and defined the curtain folds with a mixture of Hard Round brush and an Airbrush. The curtain looked a bit too plain for my taste, so I took a fully opaque Hard Round brush and sketched some classical looking flower patterns. I then created a huge pattern out of them by copy/pasting and rotating. Afterwards, I duplicated the layer and changed one blend mode to Color and the other to Hard Light.

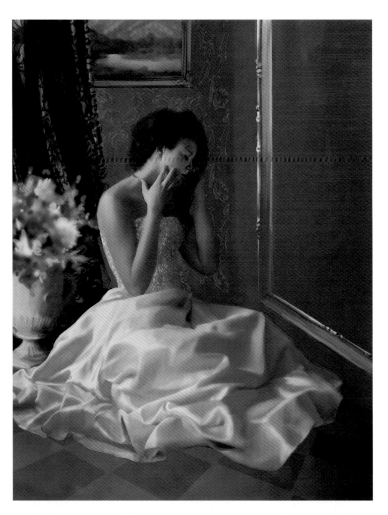

Floor definition

To work on the scene as a whole instead of particular elements, I once again enabled the character layer. I created a new layer with a diamond-shaped tile layer to give it some character and enrich the boring look by breaking the dull beige-brown color of the floor.

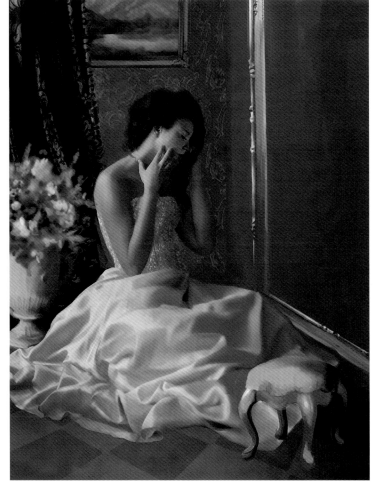

Scene defining

I slowly proceeded to work on other elements of the image. I sketched in a small, classical looking stool which I intended to place a hand mirror upon. While the curtain and flowers would guarantee the mirror reflection on the left side of the character, a chair at the right side would be the first means to underline the lack of my character's reflection (as it should appear between of those elements in the mirror).

Further scene enrichment

I continued working on the stool by airbrushing in some golden embroidery basis and a floral pattern on the chair's legs. To break the floor's uniform look and enrich the color theme, I introduced some additional elements—the book and a carpet.

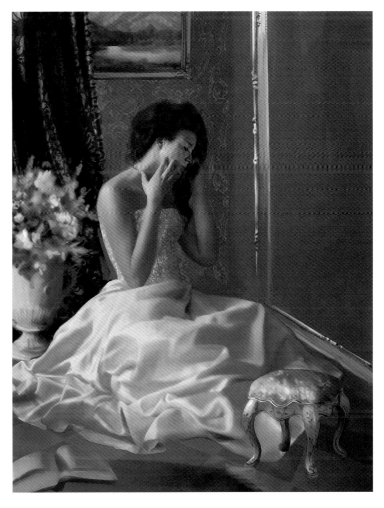

Wall adjustments

As the floor and the wall looked a bit too similar color-wise, I darkened the wallpaper to make the character stand out a bit more. Using a Ragged Hard Round brush I then blocked in some basic mirror frame and wall painting details. I also blocked in the rest of the simulated embroidery to the stool and added some cracks to the floor's surface.

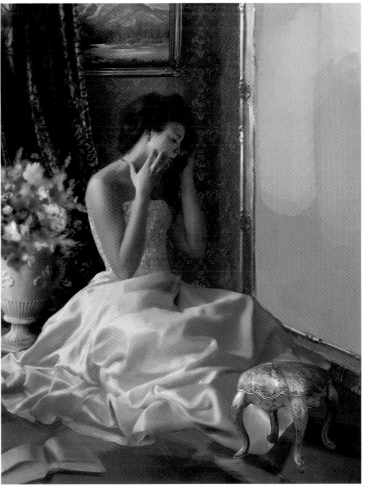

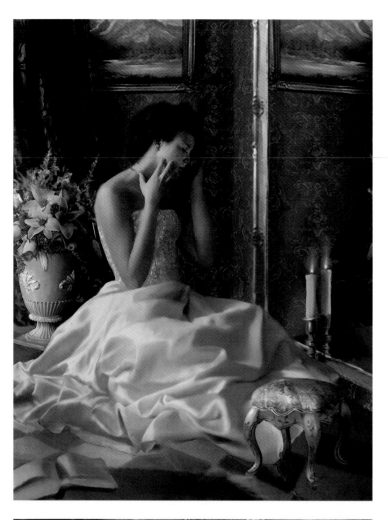

Flowers and a candle

The flowers I sketched out before, aside from taking a bit too much attention, looked too informal for the classical look of the painting. To address this, I painted a few lilies on top of the existing bouquet. At the end of this step, I merged the flower, curtain, and wall layers, flipped them horizontally and, after adjusting the perspective, I achieved a very basic mirror reflection. Introducing the candle was one of the most important moments in working on this image. It was in the direct vicinity of the girl, so immediately showed her lack of reflection in the mirror.

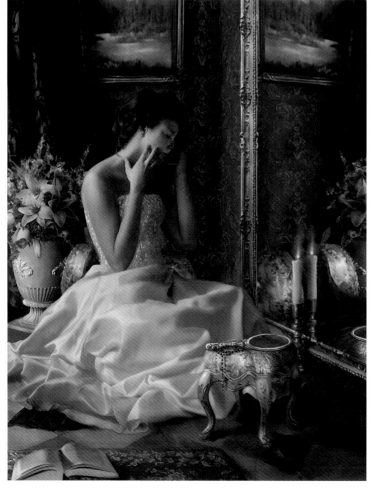

Final adjustments

Finally, I quickly retouched all of the elements that were previously sketched. I added the hand mirror with a rosary as some additional narrative elements to enrich the scene and allow different interpretations. To define the lack of mirror reflection as much as possible, I placed an embroidered pillow directly behind the character, which would be fully visible in the mirror. To strengthen the light-source impression, I highlighted the floor and added cast shadows to all of the elements of the painting.

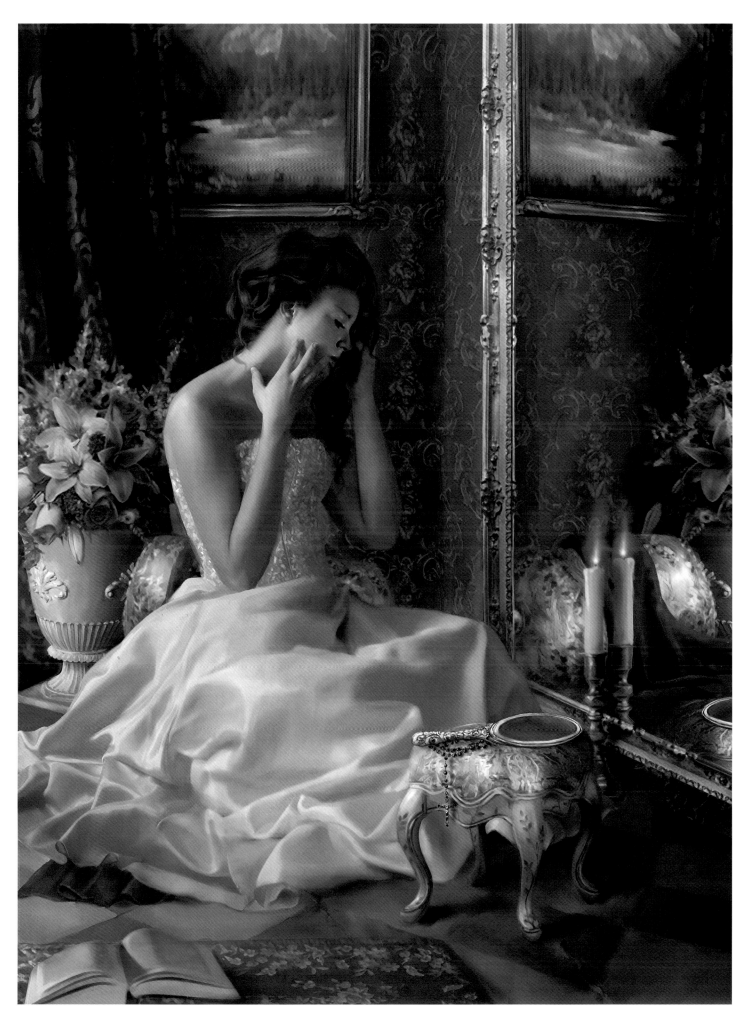

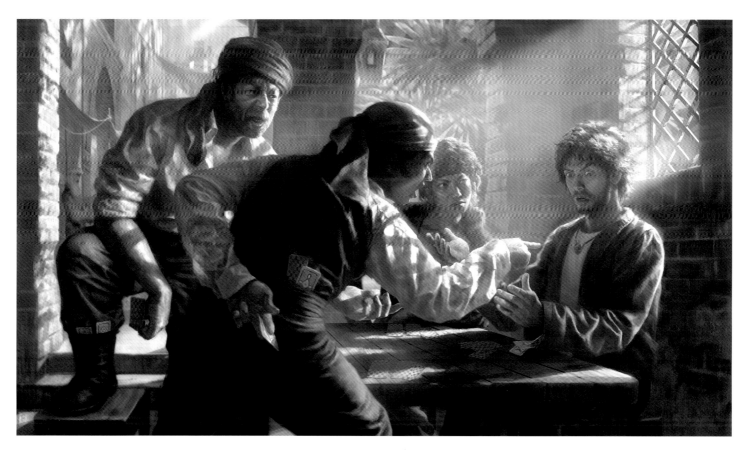

The Global Flooding of 2010
Photoshop
Frederic St-Arnaud, CANADA
[above left]

Marta Dahlig
I love artworks that tell the viewer a story without any description, and Frederic's painting is exactly that. It has a wonderfully epic, extremely captivating look. The red color accents are a wonderful touch and a very interesting contrast to the grayish color theme.

Lady Jessica Atreides
Painter
Andrew 'Android' Jones, USA
[far left]

Marta Dahlig
What caught my eye in this piece was the phenomenal contrast between the face's classic and delicate look and the modern, slightly technical, graphic elements. It is a very uncommon mixture, as the balance is very hard to maintain. Andy pulled this off remarkably well.

Amends
Photoshop
Erwin Madrid, USA
[left]

Marta Dahlig
The clean look of Erwin's piece and its simplicity made me love it from the very first moment. The composition is masterful, and the colors harmonize perfectly. Noticing the crows in the far right corner was such a great surprise!

You Cheat!
Photoshop
Alon Chou, TAIWAN
[above]

Marta Dahlig
Alon's painted characters always show so much emotion. This richness of facial expressions, detailed environment definition, and the remarkable use of lighting. His artworks resemble movie stills—the scenes are so natural and captivating.

Plague Doctor
Photoshop
Michal Lisowski, POLAND
[right]

Marta Dahlig
There is something fascinatingly disturbing in Michal's piece. The already dark and uneasy atmosphere is underlined by the character's mask, and the bold lighting makes this piece truly unique.

Desolation
Photoshop
Patri Balanovsky,
ISRAEL
[top]

Marta Dahlig
The thing that caught my attention here was the remarkable color palette. The light yellow and orange accents add so much life and character. The wonderful play of shadow creates a true feeling of depth.

Day subsiding
Photoshop
Daniel Alekow,
GERMANY
[above]

Marta Dahlig
The wonderful lighting and the purple and blue color choices create a very moody, mystic atmosphere. A close look reveals many wonderful details that add a great storytelling aspect to the piece. A truly inspirational work.

Koschei the Deathless
Photoshop
Client: Wales
Michal Ivan, SLOVAKIA
[top]

Marta Dahlig
What I especially like in Michal's work is the fact that he managed to depict a scary subject in a very attractive way. The color palette is interesting, and the light turquoise accents create a beautiful glowing, haunting effect.

Alice
Photoshop
Client: Cubicle 7
Natascha Röösli, SWITZERLAND
[right]

Marta Dahlig
One of my favorite work's by Natascha. It has a slight Burton-esque feel which I really love. Natascha also shows one of her strongest skills—a fantastically depicted feeling of depth, created by the slightly blurred mushrooms.

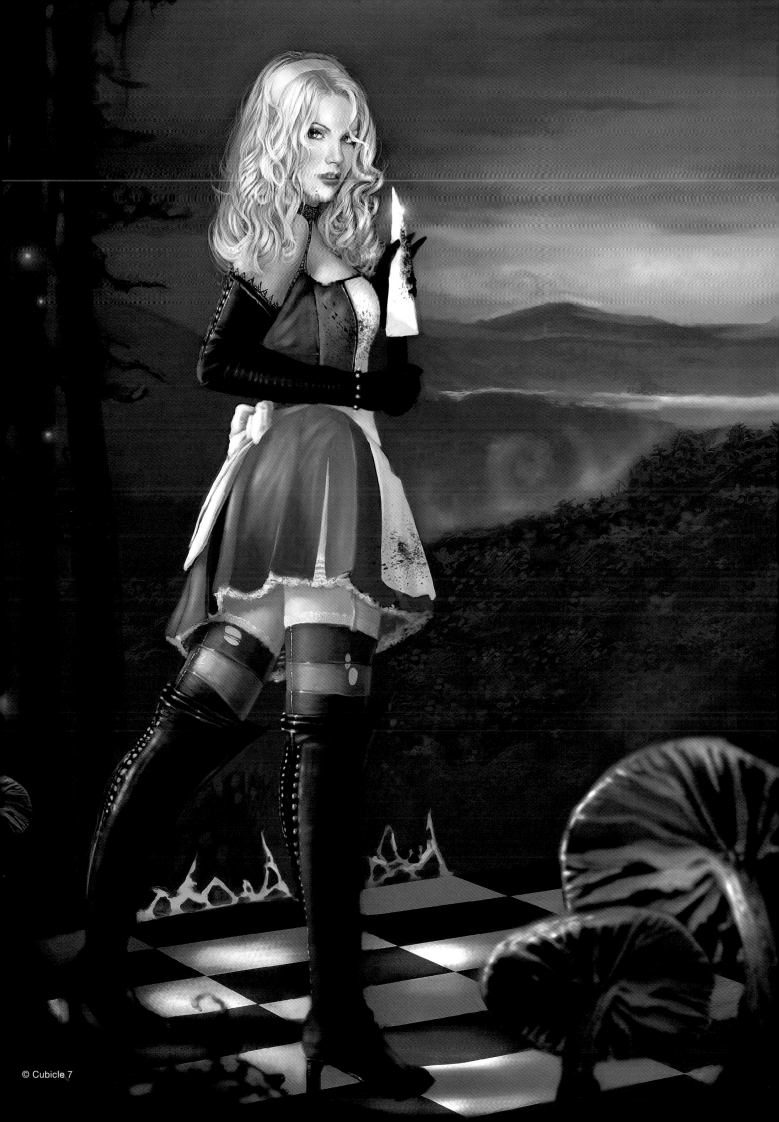

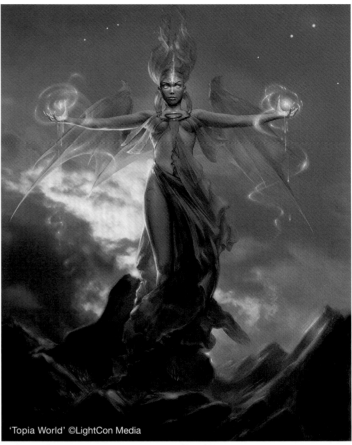

'Topia World' ©LightCon Media

© Cubicle 7

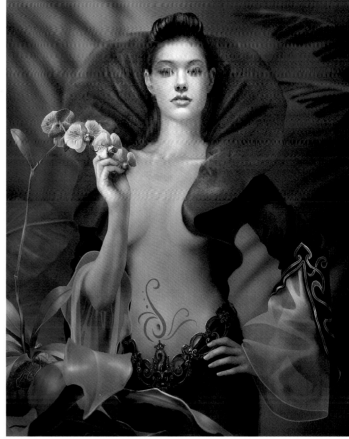

Monarch
Photoshop
Drazenka Kimpel, USA
[far left]

Marta Dahlig
Drazenka's painting has so many wonderful elements—the blue color palette with orange accents, an original siren-like character, and fabulous storytelling elements. The hands coming out of the bars are an absolute killer!

Topia World: Rhea Dragonsblood
Painter
Client: LightCon Media
Liiga Smilshkalne, LATVIA
[above left]

Marta Dahlig
All of Liiga's works feature exquisite lighting. The colors of the background, balanced by the lighting effects of the character are astounding. What impressed me the most in this piece was the fabric. Transparent textiles are absolutely the hardest to paint well.

Pyetra
Photoshop
Client: Cubicle 7
Natascha Röösli, SWITZERLAND
[left]

Marta Dahlig
Sometimes a character makes a piece. This is the case with this Natascha's painting. I find the character's face among the most captivating I have ever seen—so tough and dangerous, yet extremely feminine, and subtle. The Russian military-influenced costumes are also an interesting touch.

Meeting of Land and Water
Photoshop
Dan Phyillaier, USA
[above]

Marta Dahlig
It is rare to see a truly magical work, but Dan's painting surely qualifies. It has such a subtle, classical feel—something that would fit perfectly in a fairytale book. My favorite part of this painting has to be the lantern and the way the light spreads onto the characters and waves. Truly masterful!

Purple Orchid
Photoshop
Drazenka Kimpel, USA
[above right]

Marta Dahlig
This is one of those paintings that left me absolutely speechless. The original idea, expressed through a feminine color theme, and a very unique design are simply to die for. The trendy hairstyle gives the piece an interesting modern twist.

Atlas and Dione
Photoshop
Client: mdev
Diane Özdamar, FRANCE
[right]

Marta Dahlig
The dynamic feeling created by the flowing hair gives this character portrait the quality of a full scene. I also love the way Diane balances fine detailing with shape hinting, creating exquisite depth-effects and managing the viewer's focal points perfectly.

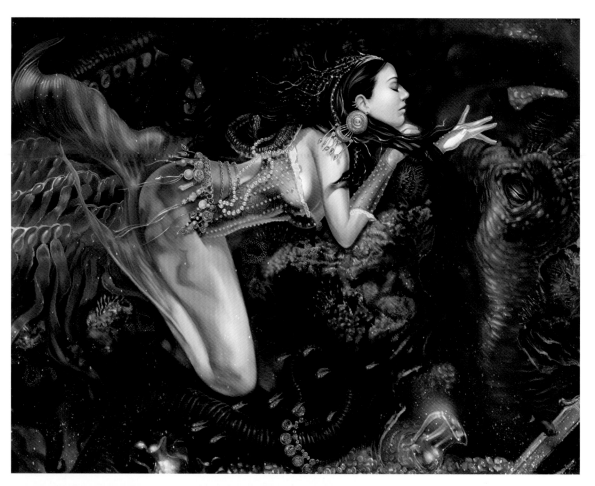

The Devil's Mermaid
Photoshop
Kurt Williams, USA
[left]

Marta Dahlig
It is really hard to manage many colors in one painting, but Kurt has done it perfectly. The richness of hues and different designs created an intricate effect that is absolutely stunning and unmissable. A truly inspiring work of art.

Am I Beautiful?
Photoshop
Diane Özdamar and
Aaron Sikstrom, FRANCE
[right]

Marta Dahlig
It is a huge challenge for an illustrator to color someone else's line art, but Diane's coloring of Aaron's sketch resulted in an absolutely wonderful outcome. The vivid hues and bold contrasts give this painting a lot of character and make Diane a true master of color management.

Fallen Beauty
Photoshop, 3ds Max
David Edwards,
GREAT BRITAIN
[left]

Marta Dahlig
David's work has graced my desktop for many weeks. The atmosphere of this painting is absolutely unbeatable. The ancient, mystic feel, strengthened by the use of light and subtle color accents, result in a truly unforgettable masterpiece.

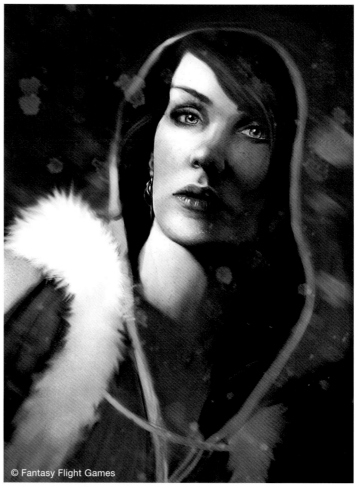

© Fantasy Flight Games

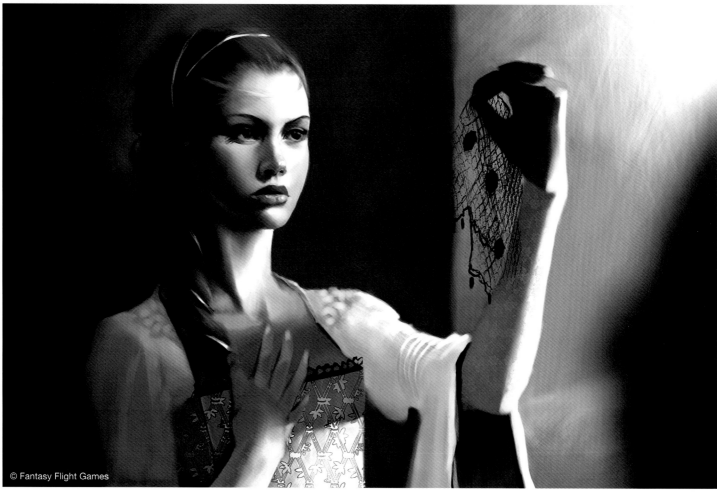

© Fantasy Flight Games

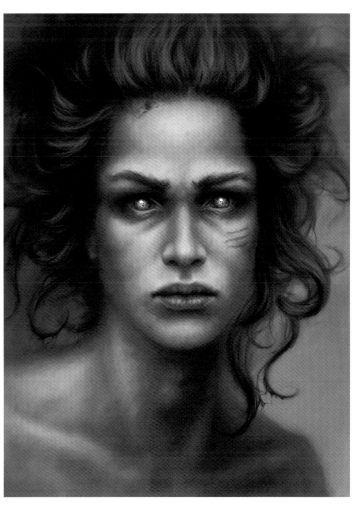

Nuri
Photoshop
Model reference: JR Gallison
Inspired by Andrew E. Maugham's 'Convivium'
Nykolai Aleksander, GREAT BRITAIN
[far left]

Marta Dahlig
Nykolai has done a wonderful job to convey a lot of emotion with minimum elements. This character's face is absolutely stunning. The technical execution is also superb.

Catelyn Stark
Photoshop
Client: Fantasy Flight Games
Natascha Röösli, SWITZERLAND
[above left]

Marta Dahlig
I like the rough feeling of this piece. The character isn't a typical female—she looks strong and proud and has a powerful aura to her. The snowflakes are a wonderful touch making the portrait more dynamic and natural.

More Game of Thrones
Photoshop
Client: Fantasy Flight Games
Natascha Röösli, SWITZERLAND
[left]

Marta Dahlig
Natascha is a masterful portrait author. The visible brush strokes harmonize with the strong lighting perfectly and only add to the beauty of this piece.

The Wild
Photoshop, Painter
Lauren K. Cannon, USA
[above]

Marta Dahlig
This piece is among my absolute favorites of Lauren's work. It is dynamic and lively, yet very poetic and subtle. The tough feel of the body, balanced by the spattered water and delicate shapes of the flying fish create a truly unique composition.

Ogre Portrait
Painter, Photoshop
Scott Grimando, GrimStudios, USA
[above right]

Marta Dahlig
Scott's auto portrait isn't just any other painting. It has a very aggressive design, bold forms, and strong lighting contrasts. The monochromatic color theme only adds to the originality of the piece.

Khuiia
Painter, Photoshop
Lauren K. Cannon, USA
[left]

Marta Dahlig
Lauren's portraits are very bold and immediately recognizable. Her characters aren't what you usually see in fantasy works. The bold facial features and a certain wild, chaotic quality, make this artwork a treat.

DANIEL DOCIU

Daniel was born in Cluj, the capital of Transylvania, Romania. He studied art and architecture from an early age and got his Masters Degree in industrial design in 1982. For the following five years he worked as a product designer, then moved on to teaching composition, visual communication and drawing at the Ion Andreescu Fine Arts Academy in his home town. He worked as an art director for Squaresoft, Zipper Interactive, and Electronic Arts. Currently Daniel oversees visual development for NCsoft's North American projects, with particular focus on ArenaNet—the Seattle-based developer of Guild Wars.

Destroyer
This piece proposed an ending scene for a level in Guild Wars.
For a brief moment the player would enjoy the illusion of having
found refuge in an isolated cave, when suddenly the bizarre rock
formations covering its walls and ceiling start reconfiguring into
a menacing dragon, towering over scene—lava erupting from
countless gaping crevices.

CONTENTS

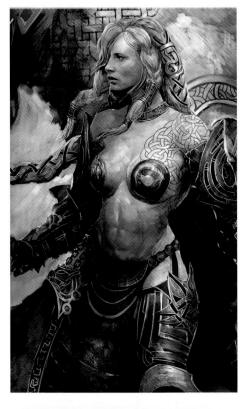

Beginnings

I grew up in Cluj, the capital of Transylvania in Romania before the fall of the Iron Curtain. From an early age, I was drawing a little bit of everything. I was interested in structures and architecture, objects and furniture. My father was a university professor, and he and my mother wanted me to become a doctor or an orchestra conductor, but I was really attracted to building, designing, and imagining things. One of the reasons I think I chose images over words to communicate is that words were a dangerous thing behind the Iron Curtain and typewriters were considered weapons and therefore very strictly regulated. My dad, being a professor, owned one but had to keep it locked, much like you'd keep a gun. He would have to submit it periodically for samples for identification. He never allowed me near it, for my own good. So, by the time I was in my thirties and got out of there, it was kind of late to hone my writing skills. That's a major reason why I'd rather paint an image than type up a page. My art got me into a high school that

specialized in art and design, and from there I attended the Ion Andreescu Fine Arts Academy in Cluj, where I specialized in industrial design. I graduated from my masters degree with the highest grade point average in the country, so I had the pick of the jobs in the area I'd studied. It was a bit like the NBA draft, except that the best job was still pretty shitty. I worked for five years at Eastern Bloc Enterprises in product design before moving back to Cluj as a teacher of composition, visual communication, and drawing at the Fine Arts Academy. My wife and I left Romania in the summer of 1989 right before the shit hit the fan in Eastern Europe. We moved to the USA in 1990 after spending two years in Athens.

Working in the US

After two years as a toy designer for a less-than-glamorous manufacturer before I moved into the games industry. I've been working in Seattle as an Art Director ever since for companies like Squaresoft, Electronic Arts

(twice), Zipper Interactive, and I've done consulting for Microsoft, freelance work for Wizards of the Coast, Digital Anvil, and a fair share of small developers who have come and gone over the years. Finally I joined ArenaNet, a fully owned subsidiary of NCsoft, where I've been working on the Guild Wars series for the last few years. I also oversee all of the NCsoft North American development efforts in a Chief Art Director capacity. In the Art Director and Lead Concept Artist role, I've had the privilege to be associated with and work with an exceptionally talented team. The abundance of young talent at an unprecedented caliber mixed with the experience of seasoned industry veterans makes for a development culture that is truly inspiring. The greatest challenge in my current position is finding the right balance between time spent generating high-level concepts, providing art direction for a team of about fifty artists, and the necessary evil: meetings!

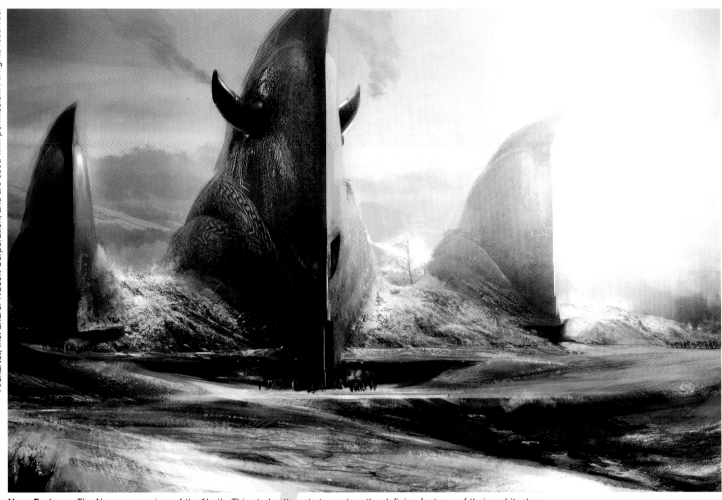

Norn Fortress: The Norn are warriors of the North. This study attempts to capture the defining features of their architecture.

Entertainment
I got into the game industry for the money, but I stayed for the fun. I could barely make ends meet as a toy designer when a young and very talented punk (Dev Madan, of Sly Cooper fame, currently founder of Loose Cannons) opened my eyes to the opportunities in this exploding industry. The early years felt a little bit like being at the source of a Big Bang and ever since it's been like riding the shock wave. We need to keep in mind at all times that what we are developing should, first and foremost, qualify as entertainment. I truly believe that what you experience during the journey that is a development cycle is reflected in the entertainment value and the quality of the finished product. Truthfully, you have to keep things in perspective—we're grownups making games! You have to have a sense of humor and remember that we aren't finding a cure for some horrendous disease or a way to prevent global warming.

Approach
What I try to pursue in my work is generally an emotion or a high-level (at times rather abstract) idea, rather than a technique-driven process. Although as an industrial designer I have over time honed my ability to design relatively complex systems entirely in my head, I try to avoid that approach because I find myself losing interest in the subject if I have it all figured out before starting to illustrate it. I therefore allow for a good amount of searching for shapes and connections to happen in the drawing phase to keep myself curious and entertained by surprises. I believe style should not preoccupy one's mind at all. It should happen naturally over a long period of growth, as an evolution towards finding the means of expression that best resonate with one's sensibility. I remember struggling as a young art student to find a style of my own, only to fall into one trap or another. I was fortunate enough to find a mentor who exposed the shallowness of my search and prompted me to dig deeper. You have to get yourself genuinely charged emotionally (and/or intellectually, depending on how you are wired) vis-à-vis your subject. You need to take a stance and have the urge to share. Manifesting that position through direct, raw forms of expression you will find yourself "stylistically".

Technique
In my opinion, technique should be an extension of one's thinking processes and sensibility. It should be a natural fit that best serves one's communication needs. Mechanically learning and adopting someone else's technique usually leads to a partial match at best. Exposure to as many other ideas as possible is important, but it is just as important to filter what resonates and works for the way you are wired.

Architecture in game design
Architecture has always made a strong impression on me, although I can't pinpoint one era or architect that encompasses all of my influences. I just sort of store everything in my memory that has ever made an impression on me, and I let it simmer there and blend with everything else. Eventually, some things will resurface and come back, depending on the particular assignment I'm working on. I look back all the way to the dawn of mankind—to ruins, and Greek architecture, and Mycenean architecture, all the way up to the architecture of the Crusades, and castles in North Africa, and the Romanesque and Gothic and Baroque and Rococo—even to neo-Classical and art deco and Bauhaus and Modernist. There are bits and pieces here and there that make a strong impression on me, and I blend them—but that's the beauty of games.

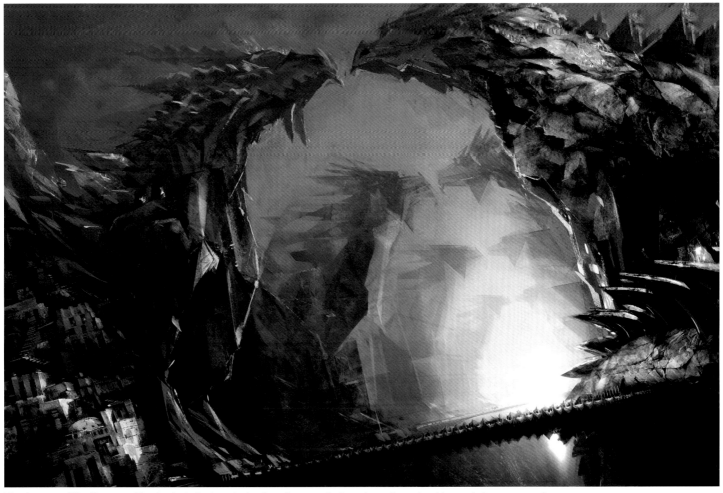

The Avenue of the Dragons: The product of a long-lost culture these ancient carvings of awe-inspiring scale tower over a deep canyon.

You don't have to be stylistically pure, or even coherent. You can afford a certain eclecticism to your work. It's a more forgiving medium. I can blend elements from the Potala Palace in Tibet with, say, La Sagrada Família, Antoni Gaudí's cathedral. I take a lot of liberties with what I can use, wherever I find it.

Concept Art
A lot of what I do is a reaction to a trend I see in concept art. There's a tendency to use every trick in the book—a "more is more" mentality. In most of what I consider my better work I try to restate the merit of clarity and achieve a monumental quality through simplicity. Wherever my intuition tells me there might be something hidden under the surface, that's where I dig. I often miss architecture and industrial design, so any occasion to dabble into these areas feel like coming back to a familiar playground. I don't have favorite

subjects. Inevitably though my work and my interests gravitate towards a vibe or sensibility that I'd have a hard time defining in words (which is why I choose imagery as my form of expression). I just try to satisfy my own yearning for something I haven't been able to identify yet, an attraction for something quite vaporous that's out there but should remain elusive.

Design on demand
Usually, I don't put pen to paper, figuratively speaking, until I have an idea. I don't believe in just doodling and hoping for things to happen. More often than not, I think about a sentiment or an emotion that I'm trying to capture with an environment. Then I go back in my mind through images or places that have made a strong impression on me, and I see if anything resonates. I then start doing research along those lines. Only once did I have a pretty strong formal solution—an actual

design or spatial relationship, an architectural arrangement of the elements—before that emotion crystallized. But do I want something to be awe-inspiring, daunting, unnerving? That's what I work on first— to have that sentiment clarify itself. I don't start just playing with shapes to see what might result. Most of my work is pretty simple, so clarity and simplicity is important to me. My ideas aren't very sophisticated, as far as requiring complex technical solutions. They're pretty simple. I try to achieve emotional impact through rather simple means.

Breaking into the industry
Getting your first job in the industry can be difficult, since many studios look for artists with previous industry experience. Of course, if you're just getting started, you don't have that previous experience, but you can't get that experience until you land your first job. It can be

a brutal process. Networking is extremely important in the games industry, so get your name out there, attend conferences, and meet as many people in the industry as you can. Do your research and make sure you have a firm understanding of the state of the industry. Before you submit your portfolio for review, make sure you have researched the studio and fully understand their artistic style. Perhaps most importantly, don't give up after your first rejection. Try to establish communications with potential employers and periodically check in with them asking for their feedback on your submissions. Try to apply that feedback to your work. Take on all the work you can get your hands on and approach every assignment as a portfolio piece—even if you feel underpaid or downright ripped off. Over-deliver for your own good and don't rearrange your standards according to the price you've been forced to accept.

The Straits of No Return

A coast of mythical infamy for its hostility. Feared even by the most seasoned sailors for its turbulent surf and the razor-sharp shards of giant barnacles.
[top]

Siege Kite

A loose preliminary sketch for a flying siege machine. The finished piece depicts it preparing to drop a huge gothic spire upon a fortification.
[above]

Game Over

Meant to be the final encounter in one of the Guild Wars games, we tried to add challenging game play mechanics by working around limitations of the game engine.
[top]

The Well of Faith

The sacred epicenter of an ancient faith. Its fanatical followers believe in becoming one with their deity by diving off the structure into the bright abyss below.
[right]

Wooded Dragon

Big constructs employing rather primitive technology are a recurring theme in my work. These hopelessly ambitious projects stand no chance without the intervention of magic, a central notion in fantasy worlds.

[top]

The Edge of Land

A perpetual fair has outgrown its grounds, forcing the peasants dwellings to cling onto the massive buttresses of the lord's castle.

[above]

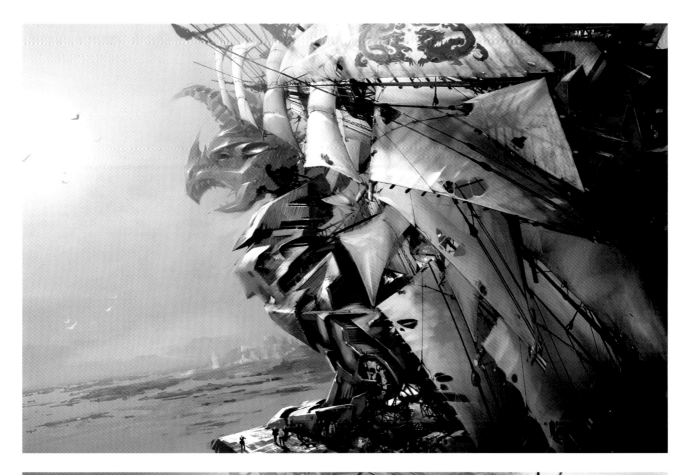

Griffon
A culture exploring the synergy of magic and technology has been striving to master flight. The contraption is undergoing preparations for the launch on its maiden test flight.
[top]

Wounded Siege Machine
This piece once again allows me to indulge in my fascination with eclectic, improbable building technologies.
[above]

Swamp
A look-and-feel study.
[far left]

Prince
At one point in the preproduction phase of one of our titles we toyed with the idea of a Mesoamerican setting. Warming up to the idea and familiarizing ourselves with the new aesthetics often require generating a few pieces that are outside of the game context.
[left]

Golem
A light-hearted comment on the Master and Servant theme: a powerful magical stone creature subjugated by the beauty of a delicate peasant girl.
[right]

Undead Dragon
This piece served me well as a pretext for some textural experimenting.
[left]

PAINTING A SCI-FI SCENE: SHOWDOWN

Inspiration

There's really no fascinating story behind the piece. Inspiration, as is most often the case for me, comes from a well-aged brew of influences that have been tossed to the back of my mind for too long to remember. This piece started as a thirty-minute preparatory charcoal sketch for a speed-painting demonstration. It was intended to have a whimsical—sci-fi meets fantasy—sensibility to it.

Method

I sometimes think that I don't set a good example to follow—my creative process is too unpredictable, my thinking patterns are too personal, and my craftsmanship is too questionable to be relevant to others. My work often involves significant changes done on the spur of the moment, as I allow intuition to overwrite logic. In this piece, the swings in direction were especially wide because it was re-purposed a couple of times.

Techniques

As a speed-painting exercise in front of a live audience, the initial concept and execution were fairly abbreviated. Once in front of my own workstation, I settled into the process combining photo reference to direct the evolving design. I used Photoshop's Selective Color to control the color scheme, but for the most part this was a straight painting excercise.

Charcoal sketch

I don't bother with details at this stage—all it needs is a base for the digital painting that follows. I build in a generous amount of grit in case I decide to let some of that show through in the final piece. In this case, not much survived.

Old-school

The next two steps were done in front of an audience as part of a seminar. The first thing that struck me as soon as I started were the clumsy proportions of the ship. I address this right away by stretching it for a more elongated silhouette. I add some color, and the saturated red over the neutral charcoal grays seems to be a safe bet in the context of the high pressure of a live performance. On the downside, it's giving the piece a turn for a somewhat "old-school" look that may not resonate very well with my very young audience.

Exhaust fire

It wouldn't be a good time to change my mind right now, as there's a time limit to my demo and a power failure on my laptop doesn't help either. I'm committed to wrap this up for now on the whimsical note I started, but decide to rework it later. The exhaust fire is a crowd-pleasing touch and I'm relieved when my time is up and I can put this away for a while.

Reworking

A couple of weeks later I reopen the file. I decide to rework it quite extensively, although I don't have a design in mind. I add bulk to the ship and replace the delicate sails with more menacing shard-like metal surfaces. It is likely an over-reaction to the indecisive results of the demo. In the process of painting the surface almost all of the original drawing's charcoal texture is lost though.

The bruiser quality

I venture into some experimenting with compositing bits of photo reference in an attempt to get away from the fragility of the ship in its early design. I figure a broad, blunt massive front might give it the bruiser quality that's tempting me at this point. I also use the photo collage technique as a starting point for the treatment of the ground. I enjoy this part a lot and make a mental note to attempt a piece centered around a similar planet.

Selective Color

This is the first and one of the more radical in a series of chromatic shifts. It isn't exactly a cleverly planned step, but rather intended to revive my fading interest in the piece as the result of stretching it over too long a period of time. My preferred tool for such alterations is Photoshop's powerful Selective Color feature (Image > Adjust > Selective Color). It allows very precise control over the individual colors. More control than Color Balance, which operates primarily on a value basis. I find that altering the neutrals in a piece gives it a certain cohesion. It seems to be the one adjustment that affects to various degrees all less than fully saturated colors.

Subtle color adjustment

A much more subtle color adjustment cuts down the amount of yellow in the neutrals, affecting mostly the bloom in the sky but also the terrain

Structural integrity

I start wrapping the perimeter of the ship in a trellis frame to increase its perceived structural integrity. I also add a cool glow to couple of areas as I feel a need some blue to bring a punch to the somewhat chromatically flat image.

Unconventional power source

I'm having so much fun with the metal scaffolding, it's hard to stop. I also add more of the glass treatment, as I find the blue to be conveniently hinting at an unconventional power source for the ship. I'm starting to get tired of the soft curves in the ship's body. I need to build up some courage to revisit the shapes drastically.

Déjà vu

I increase the area of the cylindrical glass shape that runs through the middle of the structure. For contrast, I replace all rounded body panels with sharp, angular shapes. I'm tempted to go for a rusty metal surface treatment, but I quickly cross the line into déjà vu territory. The overall look is also becoming too fragmented.

Newfound complexity

I scrap most of the metal panel armor and replace it with a treatment reminiscent of cooling fins. This gives it a newly found complexity that I like—for now. It is challenging for me to find moderation when I get excited about a promising direction. I decide to put it away for now and come back to it with a fresh perspective later.

Zooming in

I need to clarify my own position on how to deal with details. How much of it do I care to enhance and when does it become just a source of noise. At a rational level I know I've already crossed that line, but it is a challenge for me to find the strength to renounce some of the detail in favor of the overall clarity of the piece. Yet another shift in color temperature will turn out to be short-lived.

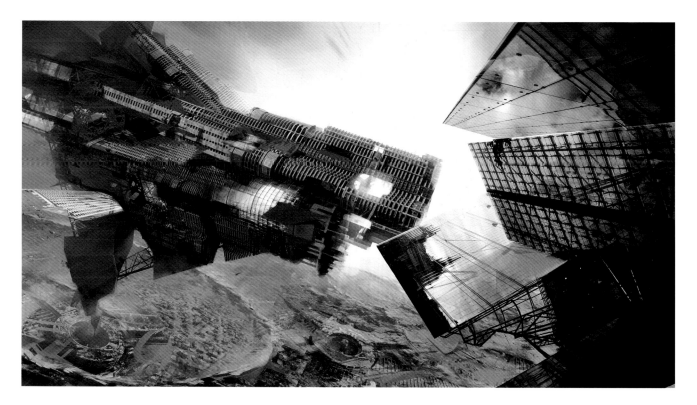

Revisiting the aspect ratio

As soon as I reopen it a few days later it strikes me as boring—not telling a story and lacking tension. I had chosen an aspect ratio for the wrong reasons: I simply started with a template that fit the paper I most commonly print on. I revisit the aspect ratio and add more canvas area to allow for the introduction of some new compositional elements. I also tweak the colors again, desaturating the rusty reds and pushing the overall hue of the neutrals towards cyan.

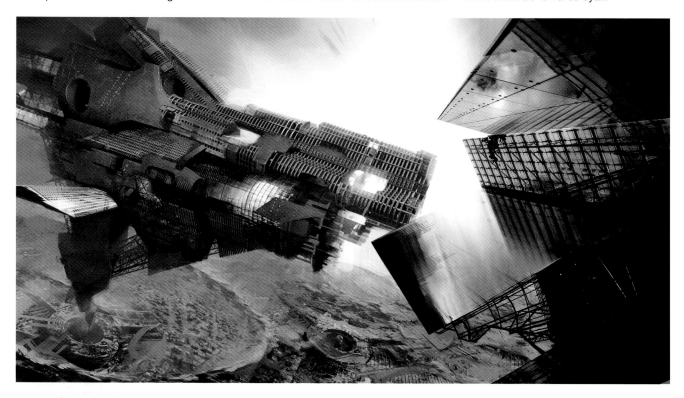

Pushing the tension

I find that the foreground components are adding a tension to the scene that is worth exploiting more. I'll be exploring the idea of pushing the tension to the brink of conflict in a literal sense, depicting the moment preceding two ships engaging in battle. I re-evaluate the design of the spacecraft from the perspective of its new purpose and decide to go back to a more heavily-armored treatment, but retaining some of the vulnerability it had in the previous step.

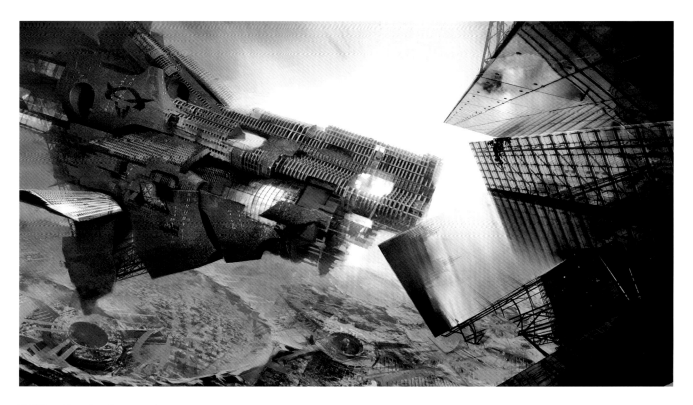

Shifting the dominant color

Yet another shift in the overall dominant color takes the scene from cool grays and blues into the warm grays territory accented by rusty reds. I simplify some of the unnecessarily busy shapes even more, in preparation for the final step. I use masks created with the Lasso tool and varied degrees of feathering to blur the unnecessary detail from the photo material. I don't worry about the reflections being geometrically incorrect. I'll be adding another foreground layer.

Final steps

I overlay an intricate looking tangled network of mostly linear elements intended to hint at a high-tech targeting mechanism. The components are a mix of extreme close-ups of scaffolding as well as some oversized custom brushes. Finally, I run the layer through the Dust & Scratches filter (Filter > Noise > Dust & Scratches), and do some blurring as well as some color processing intended to bring out the greens and reds that occurred accidentally in the filtering process. I move the top layer around, and rotate and scale it until I settle on its final positioning. I then call it done.

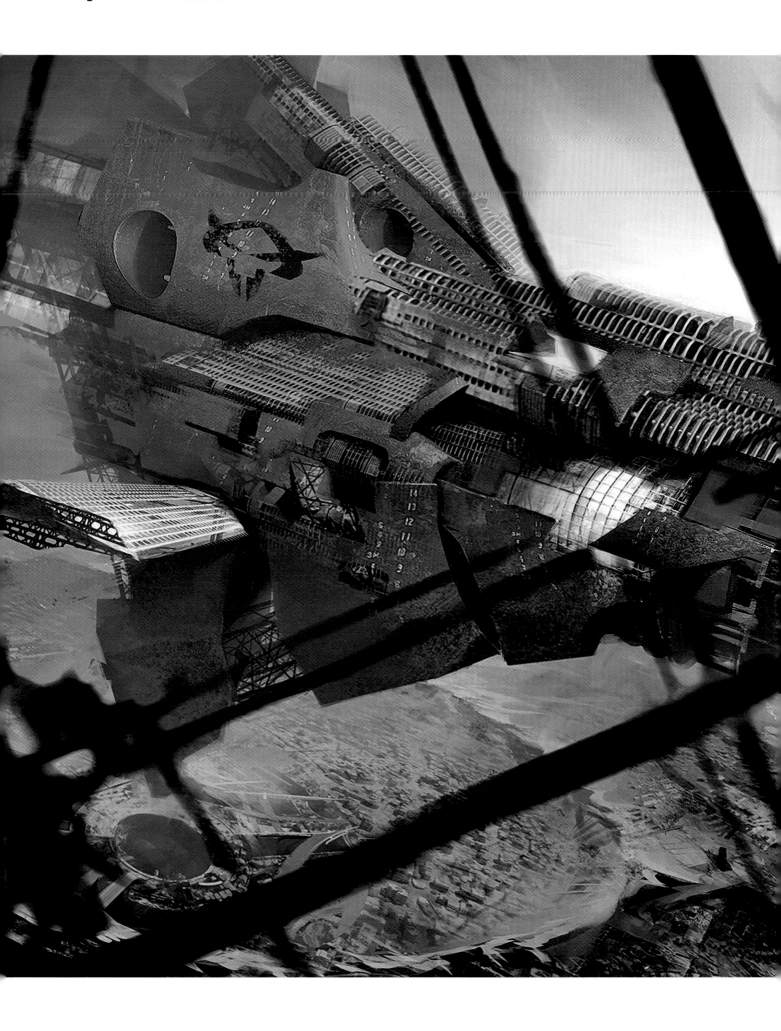

PAINTING A SCI-FI ENVIRONMENT: THE HUB

Inspiration

The idea is to depict a mechanism of quasi-cosmic scale, with disc-shaped gears that engage and spin very slowly and are populated by distinct cultures. The slow yet continuous change of the world's layout would affect the dynamics of the interaction between all these cultures. Smoke stacks will contribute an "Industrial Revolution" feel which aligns well with the gears theme. They will also help to establish the grand scale envisioned for the space. I will give the urban conglomerate on the main disk a curvature, and a convex bulge, which I'll then top with another industrial looking detail. The result is intended to be reminiscent of an aerial view of downtown LA, with its skyscrapers erupting out of the monotonous visual noise that stretches as far as one can see before fading into the smog.

Technique

I started out the basic gear shapes with a several hundred pixel brush to create the ellipses. I then began overlaying photographic material, primarily for inspiration. Another aspect that I've become increasingly preoccupied with lately is atmospheric perspective. I worked hard to maintain this throughout the process as it's especially important when depicting vast spaces.

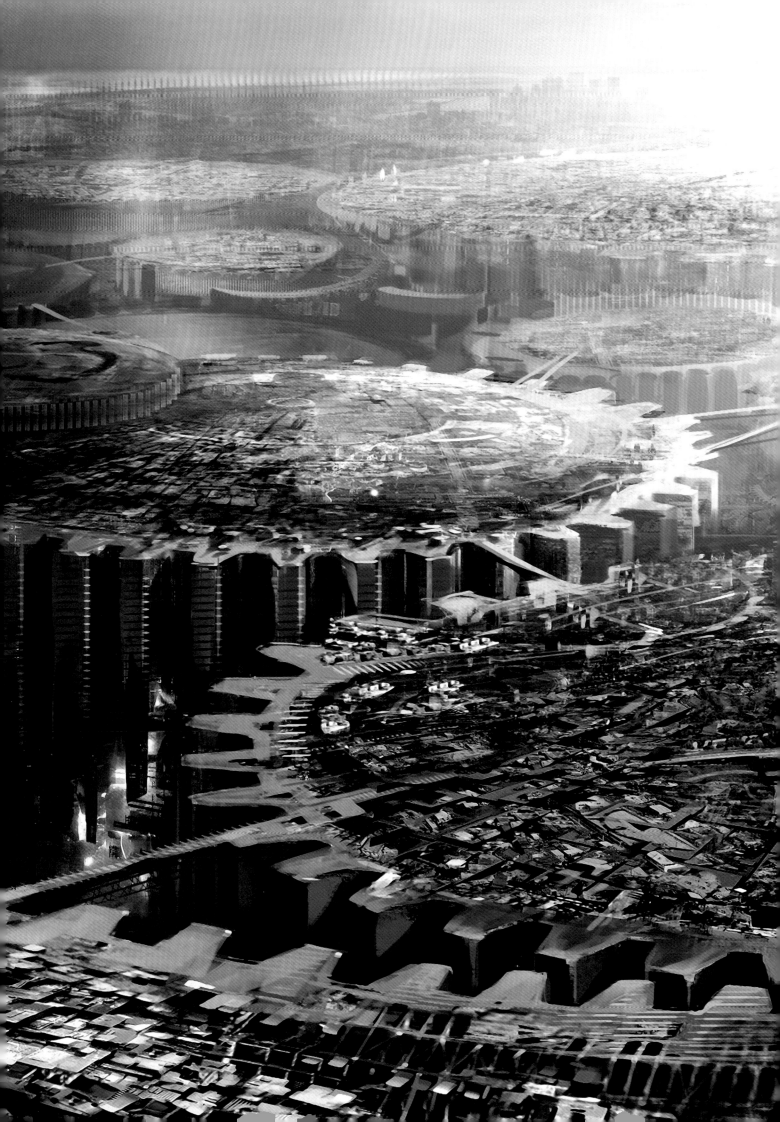

Elliptical

I use a Basic Round brush that is oversized to several hundred pixels in Airbrush mode. Hardness (under the Brush Tip Shape menu) is cranked up all the way, and both Shape Dynamics and Other Dynamics are turned off. I flatten the brush progressively as the ellipses are farther away towards the horizon and scale them up or down for variety. One tap of the stylus with these settings gives me an instant ellipse. Another way to get the same results would be to use the Ellipse selection tool, tweak the proportions of the selection, and the give it a flat or gradient fill.

Blend modes

I start overlaying photographic material, primarily for inspiration. I'm aware that most of what I'm doing in this early phase will get painted over, which is why I'm not too concerned with neatness. I cycle through the layer blend modes and more often than not find that Overlay, Soft Light, Multiply, or Luminosity are good bets as a starting point.

Mechanical components

I keep digging through my reference folders for mechanical components and paste them into the piece, liberally moving, scaling, and distorting them. For the ribbed treatment on the sides of the discs, I use a Round brush flattened to a Roundness of 0, but with the Spacing adjusted to give me the desired distance between the vertical lines. This way it takes only one left-to-right stroke to get all this treatment in place.

Evaluation

Before committing to the distribution of the compositional elements I make sure to zoom out and evaluate the overall balance of the piece. Color still isn't a concern, although I'm starting to get a feel for how I want the scene lit.

Grunt work

From this point on there's a lot of grunt work to be done: searching through reference folders, cutting/pasting, adjusting Brightness/Contrast and/or Hue/Saturation. Layers are starting to build up. Every now and again I consolidate everything onto a new top layer (Ctrl+Alt+Shift+E). Unless the image is intended for a tutorial, as this is, I frequently delete invisible layers to boost my machine's performance. In this case, I have to put up with some lag as the final number of layers exceeded one hundred. Another workaround for ballooning file size would be to periodically save the file under a new name—but that's too much of a disruption in my workflow.

Atmospheric perspective

I'm starting to pay attention to color and lighting. I do most of the color adjustments through the Selective Color tool. Another aspect that I'm increasingly preoccupied with lately is atmospheric perspective. It is especially important when depicting vast spaces, like this one is intended to feel. I often use a Huge Round brush, several hundreds of pixels in diameter, in airbrush mode, set on Soft, opacity way down, in Screen mode. It is preferable to do this on a separate layer to avoid irreparable mistakes as well as to allow for erasing areas of full clarity into the layer if needed.

Hot spot

I feel the need for a hot spot of reds to counteract the overall green dominance. I reduce the brightness level of the entire scene to increase the impact of this point of interest.

Painting in the detail

I zoom in and start painting over the noisy collage of photo reference. A flattened Basic Round brush at full opacity will work much like a palette knife would in oil painting. I have the Hardness dialed up to 100%, and Other Dynamics on while I toggle Shape Dynamics on-and-off.

Smoke stacks

The smoke stacks added in the left upper corner contribute an Industrial Revolution feel which aligns well with the gears theme. They also help to establish the grand scale envisioned for the space.

Restoring atmospheric perspective

While the dark areas frame and showcase the hot reds effectively, I find the strong contrast they provide to flatten the scene, annihilating the atmospheric perspective I was aiming to achieve. Using the same approach and brush settings described in "Atmospheric perspective" I try to bring back the lost depth. The effect is especially evident in the area to the immediate left of the fire.

Urban conglomerate

Using the Warp feature (Edit > Transform > Warp), I give the urban conglomerate on the main disk a curvature, and a convex bulge, which I then top with another industrial looking detail. The result is intended to be reminiscent of an aerial view of downtown LA, with its skyscrapers erupting out of the monotonous visual noise that stretches as far as one can see before fading into the smog.

Toning down the noise

For the next few steps I go back-and-forth between the photo-collage technique and painting with a flat brush to tone down the noise level that resulted from the number of layers building up. I jump around to different areas of the painting looking for spots that catch my attention as crude or excessively busy.

Detail in the haze

A side effect of drowning the far plane in haze for increased depth is an unpleasant, chalky effect that needs to be addressed. I resort to loose, long strokes with a flat brush, to suggest a network of highways cutting across the gears' surfaces.

Zoom out

It is dangerous to work on details while you're zoomed in. There's a high risk of losing the overall balance of the piece unless you get in the habit of frequently re-evaluating the details in context by zooming out to full-screen view. Small course corrections are preferable to the unpleasant surprise you may set yourself up for by working up-close for too long. Photoshop's Navigator window is a useful tool to make sure the image reads clearly at thumbnail size. I have it open at all times and check it often.

Working the foreground

I shift focus to the foreground and work towards altering its feel from a city in ruin to a construction site. The quick layering of crude elements helps me figure out what direction I want to pursue. Once I find something that appeals to me, I flatten the newly added layers and paint towards that direction.

Texture in the distance

The far plane is still lacking texture. I add more grit to it and also do another subtle color adjustment. Selective Color is a powerful yet addictive tool. It is hard to resist tinkering with it every other step of the process.

Painting the old-fashioned way

I decide to resist the temptation of adding more layers of photographic material. When zoomed in it becomes apparent that what I have has already amounted to a rather sloppy mess—lacking a handcrafted surface quality. I spend some time painting the old-fashioned way. Once again I use a basic flat brush at full opacity, with no texture to it, as there's already too much noise that needs to tempered.

Final adjustments

I can't resist adding some more faint silhouettes of buildings along the horizon. I also do one last color pass, this time on an adjustment layer in Selective Color. I push the left upper corner towards cyan and warm up the foreground by cutting on the cyan level in the neutrals. Increasing the level of yellow and magenta would yield a similar result but likely increase saturation which I don't want in this case. I then switch to whites in the same menu and increase the amount of yellow, magenta and black, again cutting the cyan for a slightly darker but warmer light. It is all I want to do for now, but I do not rule out the possibility of coming back and reworking it, possibly quite dramatically some day.

TRANSPORT CONCEPT: WIND-POWERED TRAIN

Inspiration

I imagine a tribe that has built its own habitat in the form of a gigantic wind-powered train. Although it moves at the pace of a lazy walk, over centuries it has covered vast expanses of the flat and arid surface of this imaginary planet. Crews of workers would level the ground and lay the rails ahead of the massive structure, barely keeping up, as the train never stops inching away. It is following the course of a dry river bed in search of water—its wide stance bridging the river's banks. Under the train, protected from the inclement winds, the nomads would be feverishly digging and drilling for water. The materials for the trains' primitive rails would be religiously reused. Every plank of wood iron bracing that's left behind is quickly disassembled and rushed to the front of the train: a perpetual closed-loop of recycling precious commodities. In its journey along the river bed, the train would come across sedentary tribes settled around the scarce watering holes. Intense commerce and complex social interaction would take place between the nomads and the locals for the months it takes for the train to pass by.

Technique

My creative process was different for this piece. Therefore, the tutorial will cover the development of the idea for the first part and gradually move onto the technical aspects once the concept crystallizes and focus shifts to execution. As far as brush work goes, rarely do I cut their opacity. I prefer to adjust the pressure sensitivity of the Wacom stylus (setting the Tip Feel, under Wacom Tablet Properties in the Control Panel to Hard or Medium-Hard). I also have Other Dynamics turned on, with Opacity Jitter set to Pen Pressure. These settings give me a painterly effect for areas like the wings in this piece.

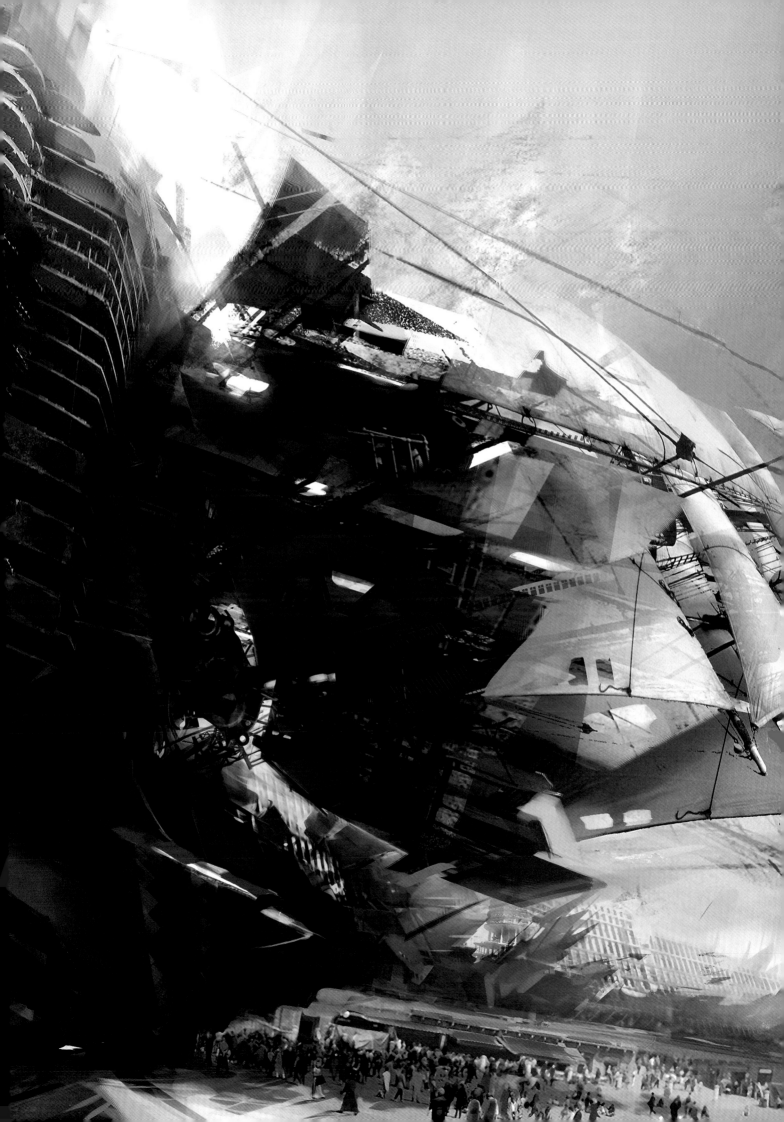

Concept

Very early in my process I switch from charcoal to digital, as I find it more conducive to the daydreaming that's guiding me through the early stages of this piece.

Dominant dimension

I want the train to be tall and imposing, yet it also needs to be wide for stability which leads to somewhat indecisive proportions. I will have to give it one dominant dimension, whether the vertical or horizontal—I can't decide yet.

Under the structure

I think a bit deeper about the purpose of the train and how it works. Under the train, protected from the inclement winds, the nomads would be feverishly digging and drilling for water. The materials for the trains' primitive rails would be religiously reused. Every plank of wood iron bracing that's left behind is quickly disassembled and rushed to the front of the train: a perpetual closed-loop of recycling precious commodities.

Going vertical

I'm starting to favor the train's verticality over its width. I will be pushing this more in the following steps. Replacing the canvas sails with more robust, wooden panels results in a painterly look I should try to preserve

Art Deco sensibility

Although I remind myself that this train isn't built for speed, my subconscious seems to be feeding me subliminal imagery of a vague Art Deco sensibility. I won't try to resist this slant. I stick to huge, flat brushes with a fine, grainy texture for the sky and no texture for the body of the structure.

Lighting

My lighting needs a clear hierarchy. I will have to sacrifice the idea of having the underbelly of the train lit to imply intense human activity because it is distracting from the bright horizon, which I'd rather keep. This means I also have to start defining the silhouette of the train against the bright sky.

Pressure sensitivity

I bring back the light under the train but I'm shifting its color to orange, hoping that by having it be perceived as artificial light it may not compete with the exterior cool light. Rarely do I cut the opacity of my brushes. I prefer to adjust the pressure sensitivity of the Wacom stylus (setting the Tip Feel, under Wacom Tablet Properties in the Control Panel to Hard or Medium-Hard). I also have Other Dynamics turned on, with Opacity Jitter set to Pen Pressure. These settings allow me to achieve a painterly effect in the wings and top area.

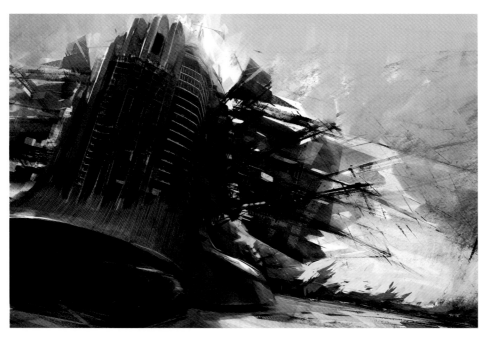

Bringing in photographic material

This is where the fun factor picks up. The introduction of layered photographic material of most varied and unrelated provenance always provides for surprises and rekindles my interest in the piece. I scale, rotate, skew, and warp the imported pictures, cycle through the layer modes, erase the superfluous, until the newly added elements align with the perspective of the original drawing.

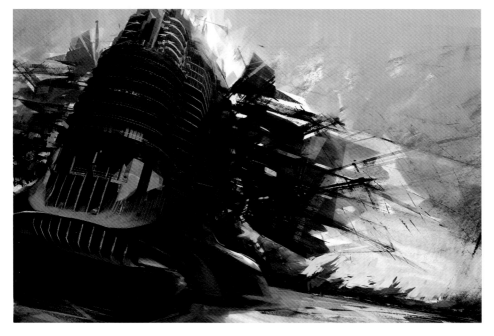

Back to the horizontal

The vertical rhythm I was enforcing in the previous step is quickly forgotten and buried under new elements that bring a predominantly horizontal layering. I find this to be more suggestive of a densely populated structure. The introduction of the saturated red is experimental at this point. It brings a decorative nuance to the design reminiscent of Mezzo American art which is perfectly compatible with the story I'm proposing.

Tweaking the color and design

As this direction is growing on me I continue to explore it, both through color (adding red quite boldly and hinting at some gold elements), and the design itself (which is taking on this ritual mask or headpiece quality). Concentrating on the wing area is very tempting, as it provides a great opportunity to mix shapes and textures, but I make a deliberate effort to put it off until other elements solidify more. It will turn out to be a short-lived decision.

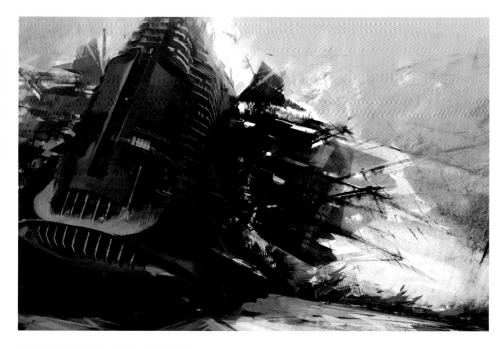

Bringing back the contrast

While I definitely like the mechanical feel of the wooden wings, I miss the contrast of hard and soft that the original sails contributed. I restore that contrast in a decisive way, again using manipulated photographs, which I'll later paint over.

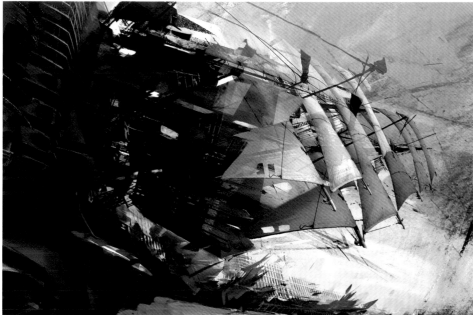

Evaluation

This step doesn't involve any spectacular changes. I zoom out and evaluate the piece as a whole. Every now and again I need a break from the focused approach to work and just freely jump around all over the canvas and add a touch of paint here and there. It is not just a liberating experience—it also leads to gradually figuring out what I should be concentrating on next.

Decorative trim

I add some decorative trim elements to enhance the artisanal look of the structure. I use a Solid Square brush in Soft Light mode, with both Shape Dynamics and Other Dynamics turned off, Airbrush turned on, and Hardness (under Brush Tip Shape) cranked up to 100%.

Working on the grill

The gray front of the train is lacking material definition. I opt for a corroded sheet metal treatment which I achieve by overlaying a grainy texture from my reference library. As always, I cycle through all the layer modes. Again, Soft Light seems to work best. Using the Warp tool (Edit > Transform > Transform), I give the texture a slight curvature to better follow the shape it is superimposed over. If the increased saturation resulting from the added layer is distracting, it is easily adjusted before merging the layer down.

Repairs

Looking for a justification for a hot spot under the train the idea of repair work comes up. I keep the scene loose and deliberately vague so it doesn't steal the show.

The wing

I go back to the area that has been the most rewarding for me to work on—the wing. It's the mix of ingredients, and a diversity of elements of visual vocabulary that just keeps my interest peaked—the contrast of flat panels and linear beams, hard and soft materials, intricate mechanical components and primitive shapes. A few bold strokes of saturated red are placed to make a stronger statement on the relationships between some of the elements, especially focusing on marking some of the angles which I consider important compositionally.

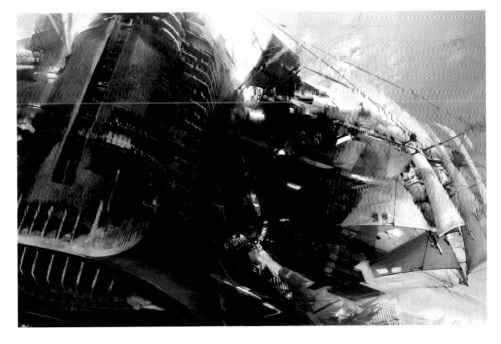

Crowd control

Adding the crowd serves primarily the purpose of establishing the scale, but it also enforces the story, implying intense interaction between the travelers and the indigenous settlements.

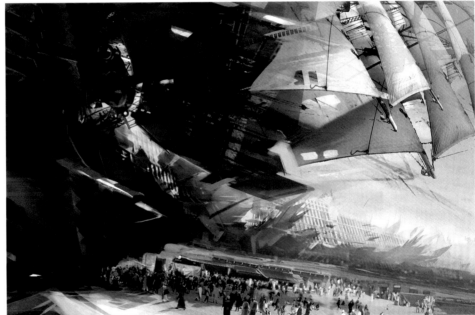

Finishing up

I make a few corrections to the curvature of the mask-like portion of the train's frontal area. I scan the image one last time for any blatant omissions or problems and make a few minor touch-up interventions.

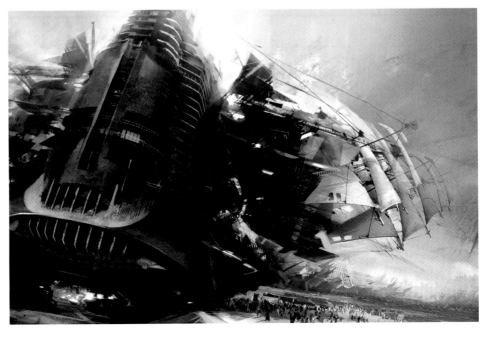

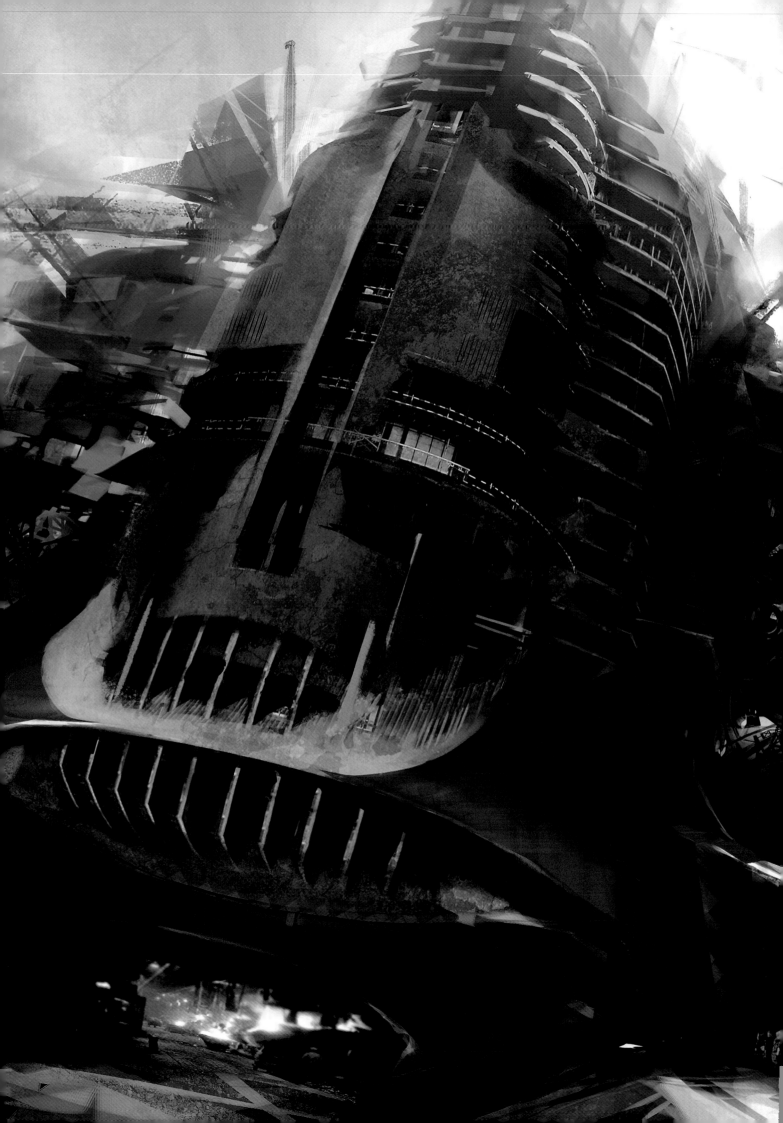

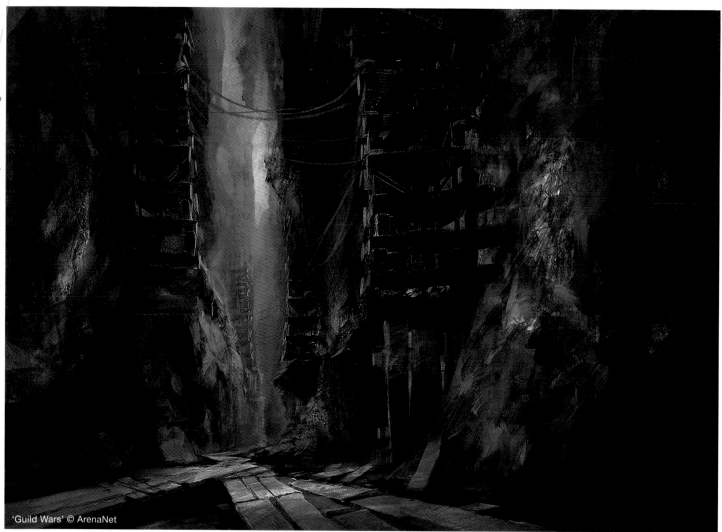

'Guild Wars' © ArenaNet

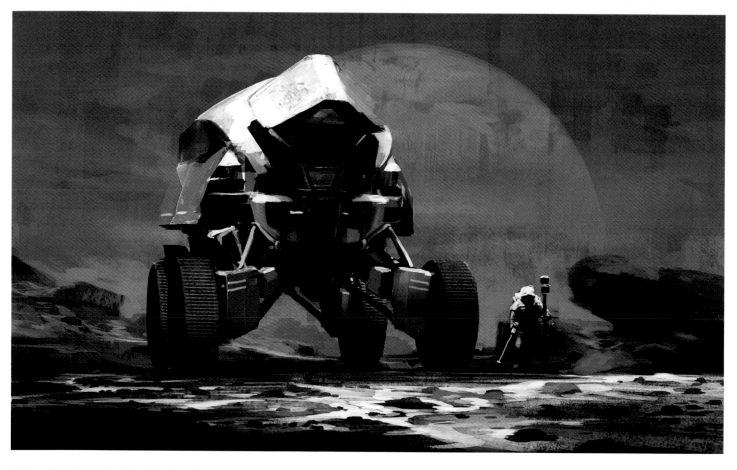

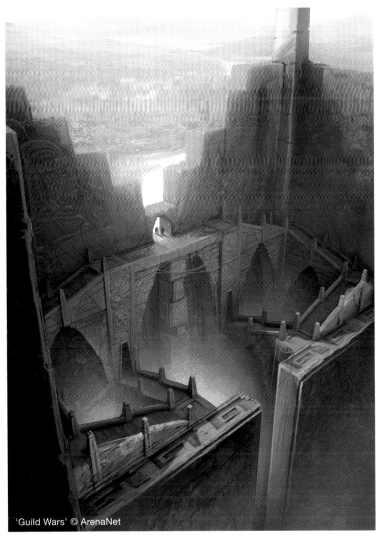

'Guild Wars' © ArenaNet

Mole mine shaft
Photoshop
Richard Anderson, ArenaNet, USA
[top left]

Daniel Dociu
Richard is one of those artists with uncanny instincts who will courageously dig into subjects of intimidating simplicity and achieve complexity through his intuitive approach to crafting form.

Rover
Photoshop
Matt Barrett, ArenaNet, USA
[left]

Daniel Dociu
Matt achieves a well-balanced, purposeful composition with a deliberate economy of means. The verticality of the vehicle states its presence more powerfully against the strong horizontal of the flat terrain. The slanted rock formations in the background give the piece a natural left-to-right flow, while the pale planet contains all major compositional elements into a whole.

Stair room
Photoshop
Jason Stokes, ArenaNet, USA
[above]

Daniel Dociu
There's a much needed monumental presence to Jason Stokes' robust structures which balances out well the somewhat delicate, painterly environments in the world of Guild Wars.

Green Space
Photoshop
Matt Barrett, ArenaNet, USA
[top right]

Daniel Dociu
For me, there's an allegoric aspect to this piece. The depth of the space that opens below the surface of the landscape reminds me of Matt's mind—intricate, technical, and mysterious.

Temple Pit
Photoshop
Jason Stokes, ArenaNet, USA
[right]

Daniel Dociu
Again, it is the simplicity of this concept that makes it powerful—the way the primitive geometric shape of the pit cut into the planar landscape is violently counteracted by the jutting obelisk.

'Guild Wars' © ArenaNet

Rebirth
Photoshop
Wei-Che 'Jason' Juan,
ArenaNet, USA
[left]

Daniel Dociu
Although employing a different visual vocabulary, the sentiment of eerie silence that exudes from this piece reminds me of Chirico's surrealist spaces.

Warrior Possessed
Photoshop
Kekai Kotaki, ArenaNet, USA
[right]

Daniel Dociu
Compositionally Kekai uses a concentric arrangement of dark, thorny elements to frame the head of the creature. The chromatic and textural richness complement the toughness of the design.

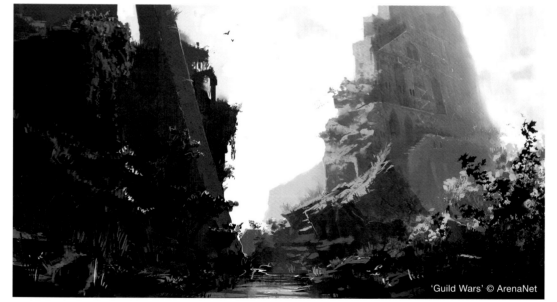

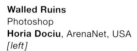

'Guild Wars' © ArenaNet

Walled Ruins
Photoshop
Horia Dociu, ArenaNet, USA
[left]

Daniel Dociu
It almost feels that it was light itself that blasted the gap in the monumental wall which is cleverly curved and slanted as if to contain it. The cool-warm contrast also serves the cause well.

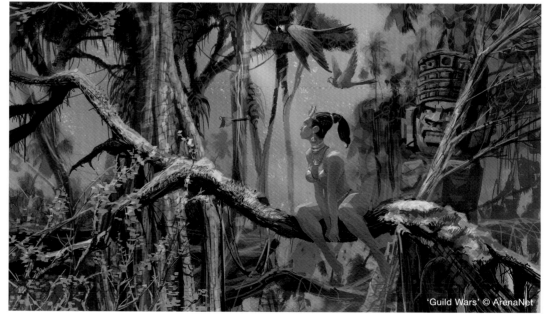

'Guild Wars' © ArenaNet

Scent On The Wind
Photoshop
Jason L. Wiggin, ArenaNet, USA
[left]

Daniel Dociu
Sometimes I run into a black and white piece of art that invites my mind contribute color to. In the case of this illustration it is the rich, exotic sounds of the jungle that I can almost hear piercing the dense, humid air. The alert pose of the character may also have something to do with it.

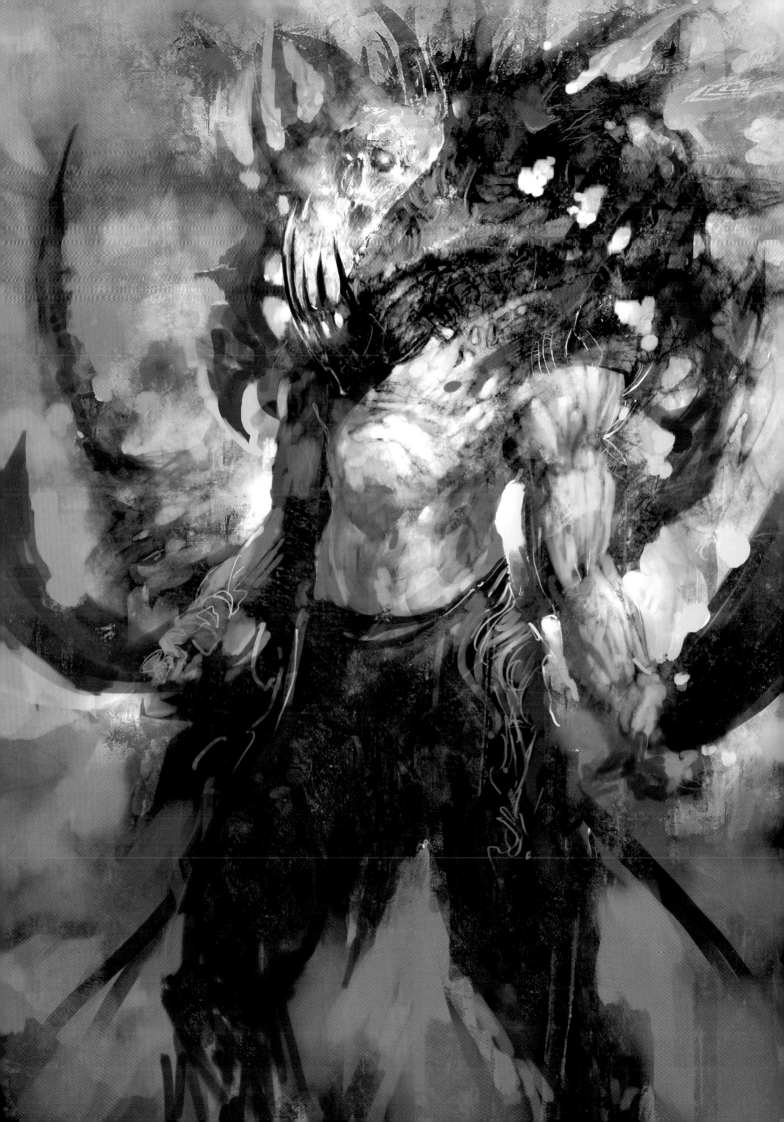

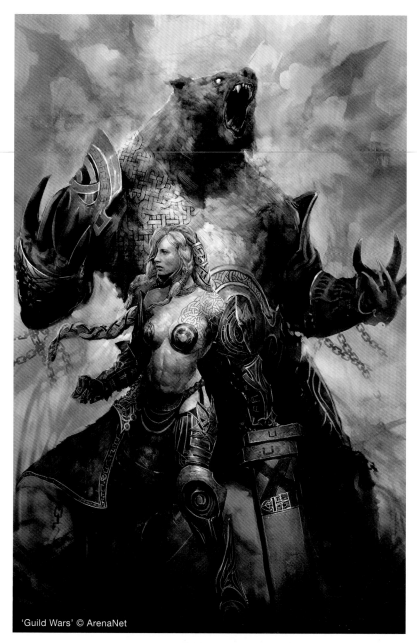

'Guild Wars' © ArenaNet

Building
Photoshop
Levi Hopkins, ArenaNet, USA
[far left]

Daniel Dociu
Levi leads the ArenaNet prototyping team, using mainly 3D programs as part of the job. Therefore, he sticks to a rigid, self-imposed discipline of daily lunchtime digital painting. In this study the well-controlled perspective grid coexists well with the strong verticality of the structure.

Norn Group
Photoshop
Kekai Kotaki, ArenaNet, USA
[left]

Daniel Dociu
Also known as "Jora" for the strong female character in 'Guild Wars: Eye of the North', this piece has resonated strongly with the game's audience, becoming what is likely the single most iconic image in the Guild Wars gallery.

Journey to the West: Ox King
Photoshop
Wei-Che 'Jason' Juan,
ArenaNet, USA
[right]

Daniel Dociu
A favorite subject of fantasy artists—the burly brute and the petite princess—sees yet another interpretation here. The reds appear more vibrant in the context of desaturated grays, both warm and cool.

Wander
Photoshop
Levi Hopkins, ArenaNet, USA
[left]

Daniel Dociu
The moody lighting and the atmospheric perspective successfully soften the harshness of the geometric architecture.

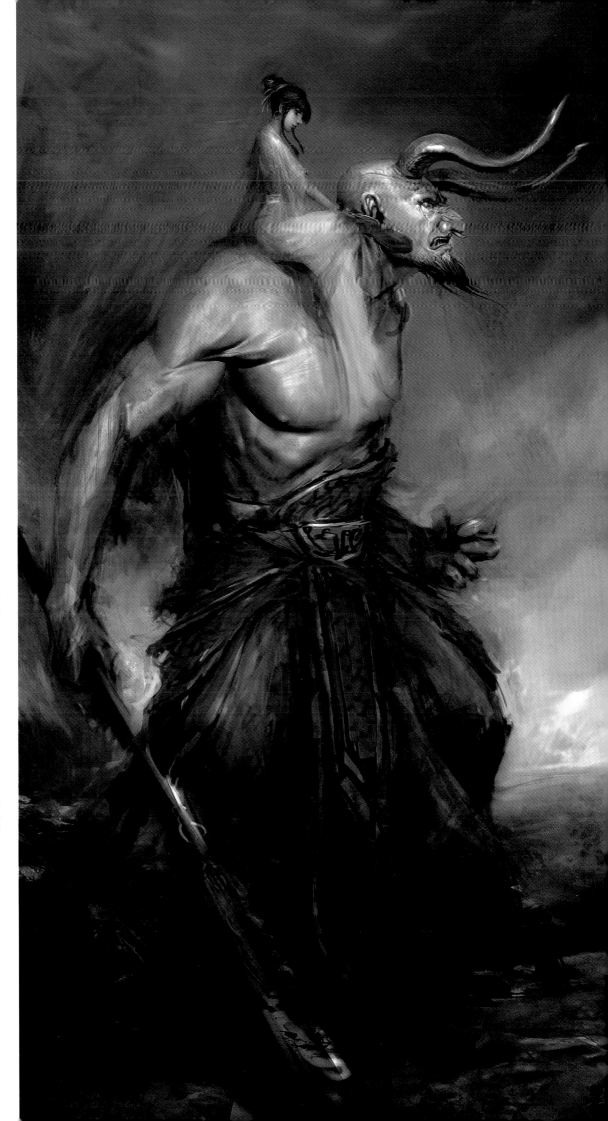

'Guild Wars' © ArenaNet

Char Siege Machine
Photoshop
Doug Williams, ArenaNet, USA
[left]

Daniel Dociu
I find the contrasts in this piece intriguing on multiple planes—the wide range of tonal values, the static dome shape, the dynamic perspective foreshortening, the soft outer tarp skin and the hard mechanical underbelly

Sword
Photoshop
Jaime Jones, ArenaNet, USA
[right]

Daniel Dociu
Loose, yet powerful, are the two words that for me best describe Jamie's work.

Riders
Photoshop
Jaime Jones, ArenaNet, USA
[left]

Daniel Dociu
Once again Jamie makes it look so easy—from the aridity of the landscape to the remarkable sense of weight of the lumbering beast. I am mostly amazed though by the freshness and purposeful spontaneity of the brush work in the background.

Cathleen
Charcoal on paper
Aaron Coberly, ArenaNet, USA
[right]

Daniel Dociu
I am huge fan of Aaron's drawings. They consistently prove the point that in art quality and depth are achievable with simple means.

Kendra
Charcoal on paper
Aaron Coberly, ArenaNet, USA
[far right]

Daniel Dociu
The command of composition, the control over values and line quality give these quick studies a richness which for me makes color unnecessary.

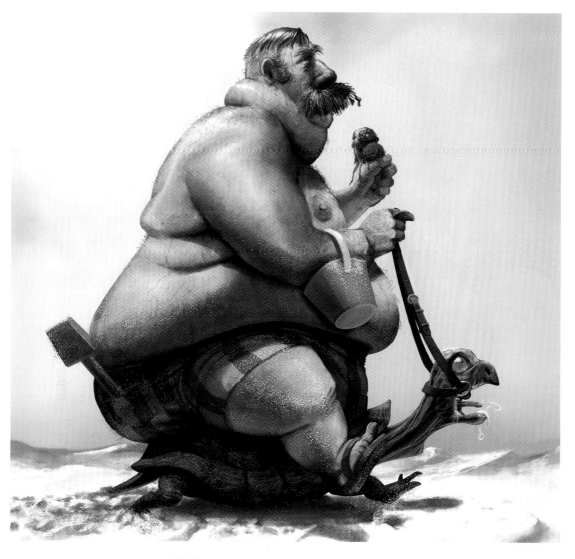

A Trip to the Beach
Photoshop
Sam R. Kennedy, USA
[left]

Daniel Dociu
I picked this piece for its sense of humor. It seems to be a reminder not to take ourselves too seriously. Whether we call ourselves fantasy, sci-fi, or concept artists, we are just entertainers of sorts after all.

Samurai v Deadly Killer-robot
Photoshop
Arne S. Reismueller, GERMANY
[right]

Daniel Dociu
Again, great sense of humor, beginning with the title, and carried through in the details. Compositionally everything works towards supporting the idea of the blade slicing through the air delivering one definitive blow to the victim.

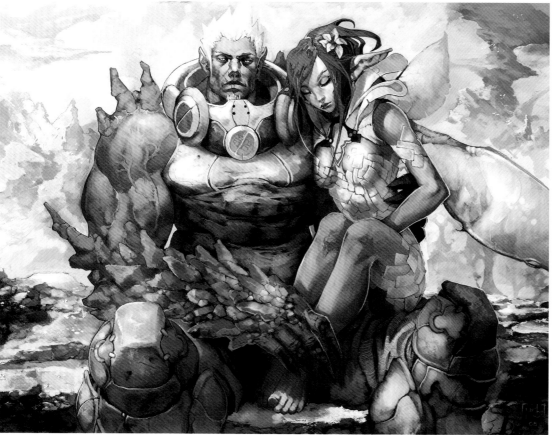

The Great Arch
Photoshop
Marc Brunet, Artificial Mind & Movement, CANADA
[left]

Daniel Dociu
I picked this piece not just for its courage to tackle a clichéd subject, but also for the craftsmanship of the execution. The vibrant colors almost radiate a glow reminding me of a delicate silk scarf dyed in the Batik technique.

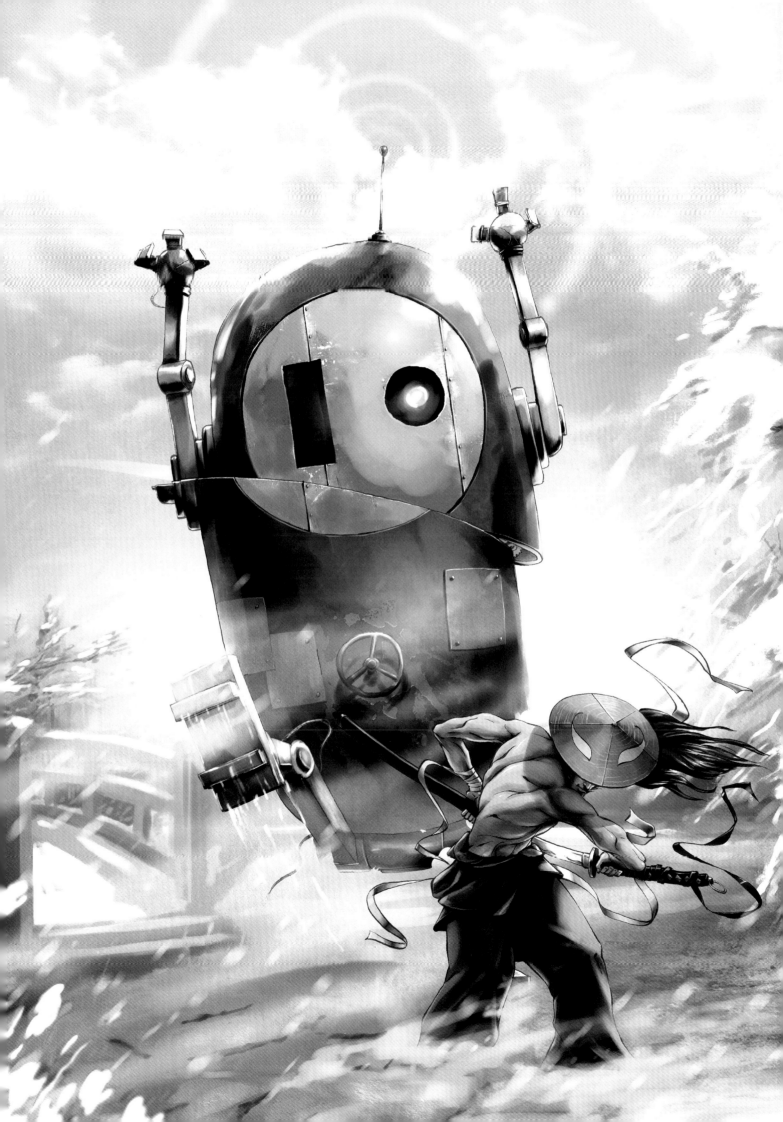

Index

SOFTWARE INDEX
Products credited by popular name in this book are listed alphabetically here by company

Adobe	Photoshop	www.adobe.com
Ambient Design	ArtRage	www.ambientdesign.com
Autodesk	3ds Max	www.autodesk.com
Corel	Painter	www.corel.com

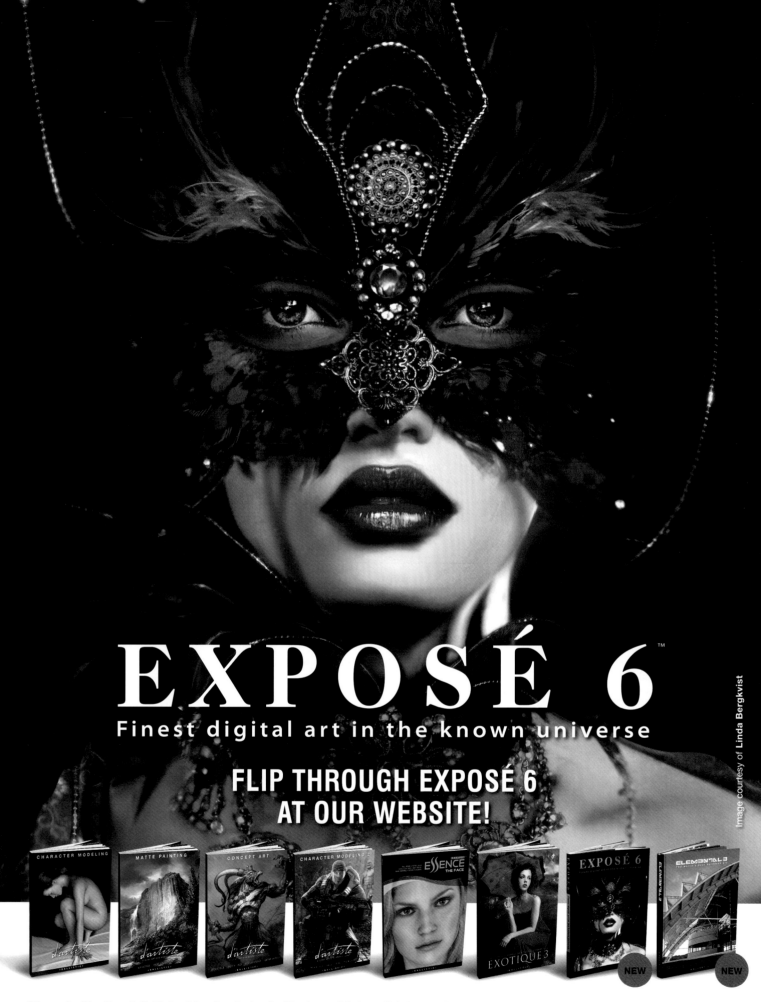

EXPOSÉ 6 ™
Finest digital art in the known universe

FLIP THROUGH EXPOSÉ 6 AT OUR WEBSITE!

Image courtesy of Linda Bergkvist